THE COMPLETE GUIDE TO
DIGITAL
ILLUSTRATION

THE COMPLETE GUIDE TO
DIGITAL ILLUSTRATION

Steve Caplin and Adam Banks
Consultant Editor Nigel Holmes

Watson-Guptill
Publications
New York

First published in the United States in 2003
by Watson-Guptill Publications
A division of VNU Business Media, Inc.
770 Broadway, New York, NY 10003
www.watsonguptill.com.

© The Ilex Press Limited 2003

This book was conceived,
designed, and produced by
THE ILEX PRESS LIMITED
Cambridge
England

Publisher: Alastair Campbell
Executive Publisher: Sophie Collins
Creative Director: Peter Bridgewater
Editorial Director: Steve Luck
Design Manager: Tony Seddon
Editor: Stuart Andrews
Designer: Jonathan Raimes
Development Art Director: Graham Davis

Library of Congress Cataloging-in-Publication Data

Caplin, Steve.
 The complete guide to digital illustration/Steve Caplin
 and Adam Banks; Nigel Holmes, consultant editor.
 p.cm.
 Includes bibliographical references and index.
 ISBN 0-8230-0784-7
1.Computer graphics. 2. Computer Art. I. Banks, Adam. II. Title

T385 .C359 2002
L60--dc21
 2002033190

Manufactured in China

1 2 3 4 5 6 / 07 06 05 04 03 02

For more information on this title please visit:
www.cgdigitalillustration.com

00

01

02

CONTENTS

INTRODUCTION

00

This book is about a revolution, and how to join it.

Until a few years ago, computer-generated art was not much more than a collection of slick, machine-made images. They were images that lacked any human interest, where everything looked pretty much the same; it was the only look that the available programs could produce. At first the novelty of this new form of image making was intriguing, but it wasn't long before it soured into cliché. When I saw my twentieth checkerboard grid stretching far away into the Dali-like landscape, reflecting the realistic clouds floating above it, I was sure that this medium was stuck in some kind of art hole where imagination doesn't get much play.

But the fascination with easy effects went away as the technology grew up. Technology started to listen to artists and designers; it invited them into software development discussions alongside the amazing engineers and programmers who had previously held sway over what a computer application of this sort could do.

In time, artists passed into a second era of digital image making: simply put, we made computers do what we wanted them to do, not what programmers suggested we do.

Now we've progressed to another stage of digital illustration: an era that I would not have thought possible those few years back at the clichéd dawn. This one is a revolution.

Throughout history, advances in technology have made complicated tasks easier to do, and in some cases they have enabled whole new areas of art to exist. Before the late 19th century, artists could make sketches outside, but needed to return to their studios to paint. The reason was very basic—the amount of paint needed for a day's work would dry up in the open air. As artists had to mix a new batch every day, this made painting outside of the studio impractical. This all changed with the simple invention of small metal tubes to hold the artists' colors: a seemingly insignificant advance, but one that enabled the early Impressionists to go outdoors to complete whole canvases. The change of tools was simple, but the effects changed the face of modern art.

Now computers, often derided as no more than a clever tool—especially in the context of art and design—are giving artists and designers actual ideas as well as new ways to draw them. That's a very different order of change from the way painting changed back in the 1870s.

Many of us have clung fiercely to the notion that the content of an illustration, diagram, painting, or animation is the most important part of it, and that the way the content gets onto paper, electrons, or film is secondary. Craft is good, and style is good, and balance and aesthetics are good, but they pale next to the idea behind the work. I think that we're finding out that a "mere tool" is making more of a contribution than we thought, and that there's some rethinking to do—and some respect to dole out, too.

Why do we want to create images that are, say, indistinguishable from photographs? Forget the "photograph." Nowadays it's just another word for an image. All images are images, however they are produced. The documentary nature of photography—the idea that the camera never lies—was debunked long before digital manipulation was possible. The techniques of manipulation were clumsier, but they still existed.

From cave painting on, image making
has followed technological advances and
will continue to do so. Digital illustration
is a way to make pictures. But this time
technology does more than simply enable
the artist to create startling, funny,
informative, beautiful images. This time
the power of computing itself—the speed
of the machine together with the
sophistication of the software—is making
more than a "mere tool" contribution.

Have you ever been working at your
computer and realized that you never
would have thought of drawing such-and-
such a thing before? Do you begin to realize
that the very means of producing the piece
suggests answers to the design and
illustration problems inherent in it? It's not
the same as having an idea in mind but not
knowing how to execute it. And it's not the
same as finding a cute filter or effect that
will dress up your idea, or make it shine that
little bit brighter. At what point can you say
that the computer is contributing to the art?
Yes, you are operating the machine, but it in
turn is working with you. It's the tip of
artificial intelligence.

This book will take you on a learning
journey into this revolutionary new world.
Here is a clearly delineated, step-by-step
look at every aspect of digital illustration
and how it's done. Digital painting,
drawing, 3D illustration, and animation
are examined and then showcased with
portfolios of amazing examples. Many
of these images were unachievable—in
fact would have been unthinkable—before
the new revolution.

Now we've progressed to another stage of digital illustration. An era that I would not have
thought possible those few years back at the clichéd dawn. This one is a revolution.

Nigel Holmes is the former Graphics Director of *Time* magazine

THE BASICS

Buying your first computer, or choosing the best software and applications for an existing one, can be a daunting task. But it does not need to be. Whether you opt for a PC or an Apple Macintosh, there's no need to understand all of the jargon; a basic comprehension of the hardware and the demands of digital imaging will suffice. The same goes for buying a scanner, printer, or digital camera. It doesn't get any more complicated when you come to choosing software. If you already know what you are trying to achieve, the information in this chapter should point you toward the right application for the job. If not, then you should get a few good ideas. Above all, there is no need to spend huge amounts of money on digital illustration—though if you have the cash to spare then there is plenty of opportunity to do so!

PART 01. THE BASICS

CHAPTER ONE

WHAT YOU'LL NEED

Buying a computer is your first step into digital illustration. Current models fall into two categories: PC or Apple Macintosh. They have similar capabilities, but inherent technical differences limit the choice of software and add-ons.

Macs are the standard choice for professional graphics users, having been developed with this task in mind; you will see them in most design studios, advertising agencies, and publishing houses. However, they are less popular as general-purpose machines, as they tend to be slightly more expensive than PCs and offer a smaller choice of office and leisure software. On the other hand, PCs can be more difficult to use and maintain, partly because they are governed by complex standards and built by many different manufacturers. Macs are made by only one company, Apple, which can therefore manage their specifications in a more straight forward manner.

The Apple Macintosh range, including the iMac, is a long time favorite of digital artists, having played a central role in the development of professional computer graphics both in print and multimedia.
Picture: Apple Computer, Inc.

The essential components of any computer include a processor, memory, a hard disk, and an operating system. The processor is the brain of the machine—while you are working, there will often be short delays as the computer catches up with what you are asking it to do, or "process"; a faster processor means less waiting. Computer adverts often quote processor speed, which is measured in megahertz (MHz), as an indicator of performance, but it is not a comprehensive arbiter. There are vast differences between the technology at work in the Motorola G3 and G4 processors used in Macs and the Intel Pentium 4 and AMD AthlonXP processors used in PCs, meaning that a direct megahertz-to-megahertz comparison will not accurately reflect the speeds involved.

Overall speed is also affected by other components in the computer system. The graphics card, which helps drive the screen display, is a prime example, particularly when it comes to intensive 3D work. Look at reviews in computer magazines for more meaningful performance ratings of different models.

While you are using a particular piece of software, or "application," such as Adobe Photoshop, both the application and the data it is working on—for example, your illustration—are stored in the computer's memory. This consists of banks of silicon chips, and is known as "random access" memory (RAM) because the processor can quickly get information in or out of any part of it at any time. When the computer is turned off, however, everything in RAM is lost. So applications and data are stored permanently on a sealed mechanical device, called the hard disk. This is why you must remember to save work at regular intervals, which is the process of copying it from RAM to the hard disk.

Memory and hard disk capacities are measured in bytes. One megabyte (1 MB) equals just over a million bytes, while a gigabyte (1 GB) is a thousand times as much again. For basic work, you will need at least 128 MB of RAM: around 1 GB is sensible for serious Photoshop and 3D work. Hard disks start at 40 GB, but for serious 3D and animation work, you are likely to use hundreds of gigabytes.

Always be aware that hard disks can fail. This does not happen too often, but it makes sense to keep a back-up copy of important data on a separate storage media, such as recordable CDs. Any work that is not in regular use can also be "archived" onto such media, removing it from the hard disk and therefore making room for new files.

The operating system is a piece of "permanent" software that is loaded from the hard disk whenever the computer is turned on, and is basically the platform on which all applications run. One of the operating system's main functions is to manage memory, so that several applications can run at once and share the available RAM. It can also make extra space available by swapping data temporarily to the hard disk, which is known as "virtual memory" (some applications also swap data independently between RAM and their own area of the hard disk, known as a "scratch disk").

PCs generally use the Windows operating system, developed by Microsoft, the latest version of which is Windows XP. Macs use the Mac OS X, created by Apple. You can only run applications labeled for the particular operating system you use.

Above: **There are significant differences between the Mac OS X (top) and the Windows (bottom) operating systems used on Apple Macs and PCs, respectively, but few are visible at first glance. Most professional applications are available for both platforms, but they are normally sold separately, so switching from PC to Mac or vice versa in the future would mean paying again for your software. Macs are the usual choice for the creative professions.**

Although it is important to choose a suitable machine in the first place, components can be added later. Most computers are designed to be "opened up" by the user, and minor upgrades should not invalidate the warranty. Processors and graphics cards can often be replaced, but a memory upgrade is usually more effective. RAM chips, usually known as "DIMMs," fit easily into slots inside the computer. If no slots are free, then you will have to remove an existing DIMM to add a larger one.

MONITORS The monitor, or screen, is arguably one of the most important pieces of equipment the digital illustrator will use. Screen size, resolution, and clarity can have a significant effect on the quality of not just your artwork, but also your working life. So getting the right one at the right price is important. With traditional media, your artwork is always in front of you. You can look at any part of it, tilt it, bend your head, or get close up for fine detail. Using a computer is quite different.

At maximum resolution on a 21-inch monitor (top), there is plenty of room for your artwork along with any toolbars, palettes, and dialog boxes in the application you are using. You may want to reduce the resolution a little, though, to increase the size of text labels and controls. In this picture, they are on the verge of illegibility. At the other end of the scale, with a 15-inch screen (bottom) it is hard to fit everything in. Palettes may have to be closed when not in use and reopened when needed, and you will not get a clear preview of the changes you have made to your artwork, since you cannot see the whole thing at the same time without shrinking it down considerably.

When your illustration is displayed on-screen at actual size, the level of detail visible is actually quite coarse. For close work, you will need to "zoom in" and show a small area at high magnification. This is one reason why, when it comes to monitors, bigger is better.

When you zoom in to, say, 200%, you are quadrupling the space you would need to keep the whole illustration in the monitor's view. Areas outside the screen can be seen by clicking scroll bars, which basically "slide" the artwork around. The larger your display, the less time you will spend zooming in and out and scrolling around your artwork.

A second demand on screen space comes from the software. To access all the commands and controls in your painting and drawing applications, you are provided with various toolbars and palettes. These can be opened and closed as required, but it is more convenient to leave them open permanently. However, with a small monitor, they may take up more space than the artwork itself. The problem is even more acute with 3D and animation packages.

In deciding what size monitor you prefer (and can afford), the first major consideration is whether to go for CRT or LCD technology. The former is the cathode-ray tube familiar from TV sets. It generates a bright picture with high contrast, but is very bulky. The largest CRTs measure 21 or 22 inches diagonally (the system of measurement is the same as for televisions), giving a viewable area similar to a magazine spread. This is an ideal size for the illustrator, with good-quality models starting at around $600. Half this amount will buy an adequate 19-inch model.

On the other hand, a liquid crystal display, which uses an array of tiny electronic components, is only about an inch thick, and is mounted on an adjustable base. In the past, LCDs have struggled to match the brightness, contrast, and color fidelity of CRTs, but today's models stand up well. Another limitation of LCDs is cost, typically being two to three times more expensive than a CRT. When comparing the two, however, bear in mind that LCDs lack the empty black border seen on CRTs, so an 18-inch LCD is equivalent to at least a 19-inch CRT.

A few computers come with integral monitors, and here you will need to consider the pros and cons of the whole package. The best-known example is Apple's iMac, originally launched with a built-in CRT and later revamped with an LCD. As long as you are satisfied with the screen size, this is a neat solution.

How much you can see at any one time, however, depends not only on the physical size of the screen, but also on the resolution you set. Resolution is measured in pixels, the colored dots generated by your

Until recently, the most vital piece of equipment for the digital graphics professional was a strong desk to hold the necessary large-screen CRT monitor (left)! But LCD units (right) now offer a slim, lightweight alternative in a similar range of sizes. While prices remain relatively high, most historical objections to LCDs—such as limited contrast, restricted viewing angle, and incompatibility with calibration devices (see Color Management, p172)—have been overcome by advances in LCD technology.
Picture: Mitsubishi NEC

computer to construct the screen image. The maximum resolution is dictated by the monitor, but most users will find it too high. This is because palettes, icons, and text labels are usually displayed at a fixed size, set in pixels.

As you increase resolution and pack more pixels into the same area, each pixel gets smaller, and items become less legible. Your artwork benefits, however, because you can zoom in to restore its physical size while seeing finer detail. Trial and error will find a resolution that balances these factors to your liking. But remember that LCDs have a fixed resolution, simulating alternative values by interpolation, which gives a noticeably less sharp image. Although native resolution is usually satisfactory, ask to see an LCD working before buying it, and check the quality of interpolation if you are likely to use it in your work.

Finally, there is the question of proportion, or aspect ratio. Monitors are traditionally set to a 4:3 format, like conventional TVs, but a few widescreen LCDs are available and CRTs may follow suit. There is no obvious benefit, but it may help to spread out the user interface components independently of your artwork. For similar reasons, a number of users prefer to work across two monitors simultaneously, with palettes and toolbars on one and the image itself on the other. The downside is cost. Unless your graphics card supports a twin-monitor display, you may need a second graphics card as well as the extra screen.

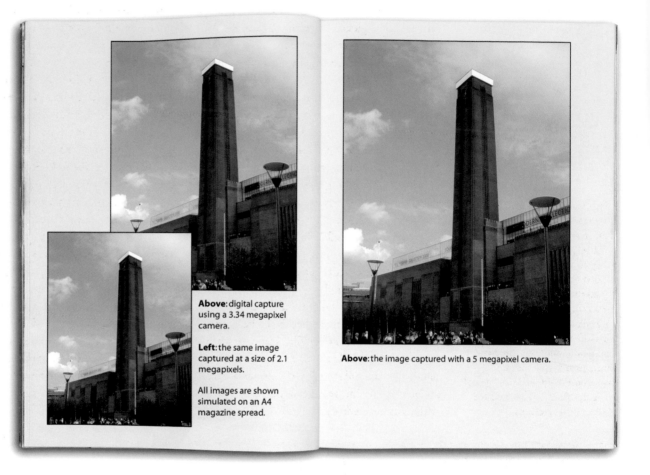

Above: digital capture using a 3.34 megapixel camera.

Left: the same image captured at a size of 2.1 megapixels.

All images are shown simulated on an A4 magazine spread.

Above: the image captured with a 5 megapixel camera.

The higher the resolution of your digital camera, the more detail it can capture, and the larger the file it will produce. Bigger files can be printed at larger sizes without compromising image quality. This graphic shows a standard, U.S. Letter magazine illustrating the maximum size at which images captured by 2.1-megapixel, 3.34-megapixel, and 5-megapixel cameras can be used.

Much of the work of a digital illustrator can be generated wholly on a computer, but there are times when you need to import artwork from other sources. You will need a scanner of some sort if you want to get flat artwork into your computer, as well as a digital camera to capture real-life people, backgrounds, and objects. At some stage, you are also going to need to print out your work —most illustrations intended for publication can be emailed directly to the client, but there are times when a proof print is invaluable. Even if you never print a single image, you will still need a printer just to print out your invoices.

SCANNERS

Scanners have come down in price tremendously over the last few years, and you can now pick up an entry-level model for less than $50. On the other hand, it is possible to spend a hundred times that on a high-end pre-press model. So what's the difference?

Essentially, the more expensive the scanner, the better the image quality. There is no need to spend too much, however. High-end scanners are required by professional publishers and repro houses in order to achieve perfect quality for print, but the needs of the illustrator are much less demanding. Usually, you will need a scanner only to scan in a rough sketch for use as a template in your favorite drawing or painting application. Even the cheapest flatbed scanner will be sufficient for this task.

If you need to scan transparencies, from 35mm slides to negatives to larger format images, there are two main options. The most cost-effective of these is to choose a flatbed scanner with a transparency adapter. In most cases this will be incorporated into the scanner lid, providing a light source that shines through the transparency onto the scanner head itself. The latest flatbed models, which can be picked up for as little as $250, offer sufficient resolution to magnify a 35mm slide to full-page size and beyond (although quality will be limited).

If you need to scan transparencies for positional or template purposes only, or if your work will involve substantial reworking of the scanned image, that option may be acceptable. However, if you need to scan for finished artwork, you might find that the output fails to measure up. If that is the case, you will need to invest in a dedicated slide scanner, which can cost anywhere from $700 upward. One low-cost alternative is a transparency adapter for a digital camera. Nikon, for example, makes an adapter that costs under $90, screws onto the lens mount of their cameras, and generates images as good as those that the camera can capture. You can also buy film scanners from around $150. While these are designed to handle 35mm and APS films, quality will vary and at the low end you might be better off with a decent flatbed.

A low-cost flatbed scanner may offer resolutions up to 4800 dpi, sufficient to magnify even the smallest pictures to almost any size you might need. But resolution is not the whole story. This scan of a 35mm slide (left) may have a lot of pixels, but its color and tone are very poor. Using the same scanner, a 6 x 4 inch photographic print of the same image (right) produces much better results. Slide scanning, other than for positional use only, is best left to dedicated professional machines.

CAMERAS

A digital camera is an essential tool for the illustrator. The ability to capture people and objects instantaneously, with no running costs, makes them a must-have accessory. Digital cameras range in price from under $40 to several thousand dollars. The main difference is in the size of the image captured, which is measured in megapixels (millions of pixels). Good mid-range cameras cost between $350 for a 2-megapixel version to around $750 for a 5-megapixel model. The graphic here shows the output size that can be achieved from such cameras.

PRINTERS

There are two main kinds of printer: ink-jet and laser. Ink-jets produce the best quality pictures and, surprisingly, are the cheapest option. A $200 ink-jet printer, when used with a high-quality photographic paper, will create prints that are virtually indistinguishable from photographic prints. They are, however, slow—a U.S. Letter print can take several minutes to produce. Ink-jets are also very expensive to run, with a single set of replacement cartridges, which last just a few hundred pages, costing up to $60.

It is mainly for reasons of speed that professional designers and publishers choose laser printers, even though their quality of photographic reproduction is nowhere near as good as ink-jets. A color laser printer of reasonable quality can cost from $2,000 upward, but running costs are just a few cents per page. Another reason for choosing a laser printer is that they tend to be PostScript devices. PostScript is the graphics language used by drawing programs. If you work in this field, you may find that you have to buy a software RIP (Raster Image Processor) to convert PostScript data into a form that ink-jet printers understand.

HARDWARE EXTRAS There is no limit to the number of devices you can buy to complement your computer—as long as you have the cash and the inclination. Here, we take a look at some of the add-ons that you may need.

GRAPHICS TABLETS

For the serious illustrator, a graphics tablet is a key component. While drawing with a mouse seems clumsy and artificial, drawing with a tablet is as natural as using a pen. Wacom, the main manufacturer of graphics tablets, makes a range of models. The cheapest of these is the Graphire 2 tablet, which comes not only with a pressure-sensitive pen, but also a cordless three-button mouse, making it equally useful for drawing as for web browsing.

However, spending more money does bring added benefits. While the Graphire has an active area of under 4 x 5 inches in size, there are models available in sizes up to 12 x 18 inches. At the higher end of the scale, Wacom also produces two graphics tablets that incorporate flat screen monitors. The ability to draw directly onto the screen removes the final barrier for those coming to computer illustration from scratch, but the $3,499 price tag of the larger, 18-inch model is a limiting factor.

A tablet is a useful accessory for the graphic artist. The lowest price model, shown here, includes not only a pressure-sensitive stylus but a cordless, three-button mouse with a scroll wheel as well.

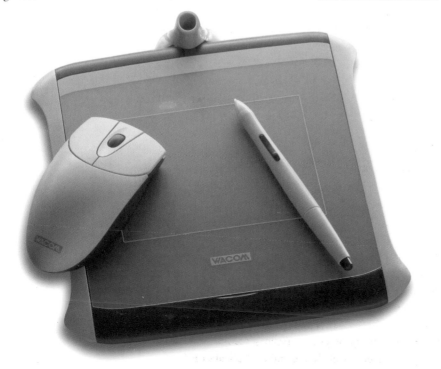

STORAGE DEVICES

In the early days, all computers were equipped with floppy disk drives. But as file sizes became larger—graphics files, in particular, can consume hundreds of megabytes—floppies increasingly became an irrelevance, to the extent that Apple has now dropped them entirely from their range. Many graphics files can be e-mailed directly to a client by saving them in a suitable format. A 100 MB Photoshop file, for example, can be saved as a flattened (composite) JPEG file that weighs in at under 1 MB, a perfect size for e-mailing (images produced by drawing programs tend to be smaller still).

At some point, however, you are going to need to back up or archive the files onto your hard disk—partly for reasons of space and partly to safeguard against crashed hard disks. One form, called Zip disks, enjoyed a high degree of popularity for awhile, but the high media costs of around $10 for a 100 MB cartridge made them fairly pricey compared to recordable or rewritable CDs, which can fit up to 700 MB of data per disk and cost only 30 cents.

Since all but the most archaic of computers are equipped with CD drives, this has become a cheap and convenient universal format. The only catch is that you cannot repeatedly change the contents of a CD as you can with a Zip disk. Some computers come pre-armed with a CD writer (or "burner")—otherwise, you will need to buy an external model, which start at around $150. At some point CD burners will be replaced by high-capacity DVD equivalents, but high prices and the lack of a standard format make this unlikely to happen in the near future.

DIGITAL TRANSFER

The Internet has put digital communication in the hands of everyone, and for many it is the perfect way of exchanging files. Standard modem (or "dial-up") connections tend to be slow, so it may be worth looking at the three other options: ISDN, ADSL, and broadband cable.

While popular in mainland Europe, the ISDN option has not had the same impact over here. It offers direct computer-to-computer links that enable you to send your files directly to your client's desktop, and can also be used for Internet access. However, the standard connection might be twice as fast as a conventional modem, but the line rental is high and you pay a premium rate for every minute online.

ADSL, or Asynchronous Digital Subscriber Line, is a far more realistic option, and one that is getting more popular all the time. Designed for home Internet use, ADSL lines offer a standard speed of 512 kilobits per second (Kb/sec) for downloads (that is, web browsing or receiving files), which is 10 times faster than a modem. However, only half of this capacity is available for upload (the speed at which you can send your files to other people). Higher speeds are available at extra cost. Be aware though, that the ADSL signal deteriorates the further you live from your telephone exchange, to a limit of about 3 miles (5 km), so both availability and speed will be geographically limited in some cases.

Broadband cable is an option similar to ADSL, available wherever digital cable TV services are provided. Download speed is the same, but upload speed is usually halved again, to 128 Kb/sec, although speeds can vary dramatically depending on your service provider. Both ADSL and cable have a fixed monthly fee and are "always on."

One DVD disk will hold the same amount of data as eight CDs, 52 Zip disks, or 3,611 floppy disks. Given the large size of modern files, floppies have become so inadequate that Apple, for one, has stopped including floppy drives in their computers.

01.02

Illustrators working with traditional media are used to having a range of materials with which to work, and whichever they employ for a particular project will depend on their own skills, medium, preferences, and the requirements of the particular work in hand. It is no different in the world of digital illustration. In fact, the range of tools and options available is bewildering. However, once you get past the barriers of terminology you will find that the different methods and applications break down into a handful of groups, and you are never restricted to just one. By understanding the basic concepts, then mixing and matching techniques, you can exploit the full potential of your art.

PART 01. THE BASICS

CHAPTER TWO

DIFFERENT ILLUSTRATION METHODS

BITMAP VS. VECTOR VS. 3D

Digital illustration falls into three main categories: bitmap (also known as "painting"), vector (also known as "drawing"), and 3D modeling. Although the end results can often look similar, they are three very different disciplines, and the professional digital artist needs to be adept at working in all three styles.

BITMAP ILLUSTRATION (PAINTING)

A bitmap is an image that has been broken down into a regular array of tiny squares, known as pixels. Each pixel may be one of over 16 million different colors, and for illustration purposes the pixels are generally so small that you see the final image as a continuous tone, rather than as a grid of squares. With painting applications, you create marks on the screen just as if you were painting on paper or canvas. Modern painting applications provide multiple layers, which can be used for different elements in your illustration, rather like painting on several sheets of glass overlaid on each other; each layer can be moved, scaled, colored, and distorted independently of the others.

Popular painting applications include Adobe Photoshop, Procreate Painter, and Corel Photo-Paint.

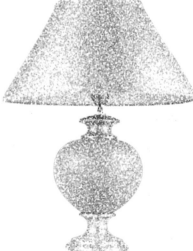
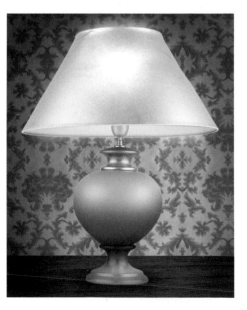

Left: **Bitmap (paint) applications include photographic elements such as this lamp, which has been cut out from its background.**

Right: **Once the image has been digitized, it is possible to apply a wide range of effects to it, such as this Pointillist filter.**

Far right: **The cutout object can be placed on another background— here, shading and a bright spot for the bulb have been added.**

VECTOR ILLUSTRATION (DRAWING)

Vector programs use a mathematical graphics language to define individual shapes. As well as drawing basic rectangles, ellipses, and polygons, vector applications can create smooth curves, known as Bézier curves, which enable the artist to draw any shape imaginable.

In drawing applications, each element of the illustration is a separate object. This differs from the layers model in painting applications, where an image of a telephone, say, may be on a different layer to the desk on which it stands. In a drawing application, each constituent part of the telephone—the outline, receiver, button shapes, numbers on the buttons, and so on—will be a distinct element. In a sense, it is a little like working with a large number of individual pieces of paper, each of which can be reshaped or re-colored at will.

Popular vector applications include Adobe Illustrator, Macromedia FreeHand, and Deneba Canvas.

3D MODELING

Whereas both vector and bitmap illustration involve drawing or painting artwork in a manner familiar to even the most traditional of artists, 3D modeling is a very different discipline. In most 3D applications, objects are created by extruding or revolving drawn outlines—in the most basic sense, it is like spinning a curve around a lathe axis to create a solid object. The more sophisticated programs offer a huge range of further distortion and modeling techniques, which enable skilled users to create an infinite variety of forms.

Unlike painting or drawing applications, 3D modelers create "solid" objects that can be manipulated within a virtual environment. Different textures can be applied to the surface —you can set it up to suggest a light is shining on it, for example—and the surface itself can be spun around and viewed from any angle. This may be a laborious process, but the object can serve a wide range of purposes once modeled.

Popular 3D applications range from simple dedicated programs, such as Corel Bryce and Curious Labs Poser, to high-end modelers, such as NewTek's LightWave and Alias/Wavefront's Maya.

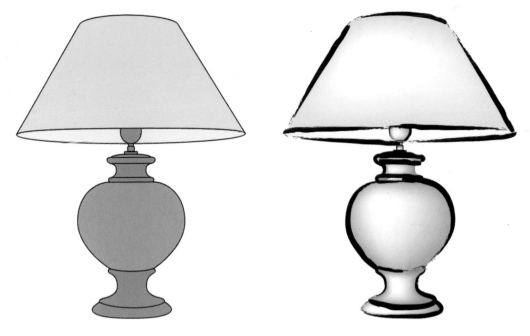

Left: **Vector (draw) applications treat each element as a separate object. This drawing has been traced over the original lamp.**

Right: **Some vector applications let the user apply natural-looking brush strokes to the outline, and add detailed shading.**

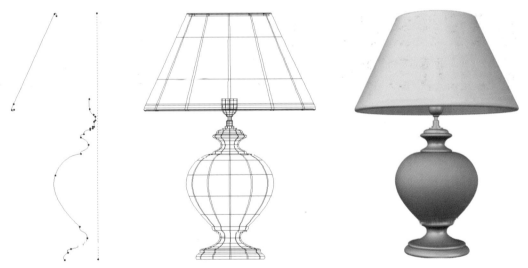

Above left to right: **The lamp is generated in a 3D application by drawing its outline in 2D and spinning it around a central axis (the dotted line). The lathe process results in a wireframe model, which describes the lamp as a three-dimensional object. Shading, texture, and color can be assigned to each individual element. Here** (above right)**, the focal length of the virtual camera has been changed to add perspective.**

ANIMATION

Computer animations can be based on any of the three disciplines outlined above, using a "timeline" that lets elements vary in position and size over time. Animation programs produce movies as their finished product, which can then be sent for TV broadcast, distributed on CDs or DVDs, or—at lower resolution—shown on the Internet. Typical animation applications include Macromedia Flash, Adobe After Effects, and Pinnacle Commotion.

PAINTING digitally is a very different proposition to the traditional method of using a brush and canvas. Resolution, pixels, masking, and style all need to be considered. Bitmap images, as we have said previously (page 18), consist of a grid of pixels, each with its own color value. When you first create a new document in a bitmap application, such as Adobe Photoshop, it is empty; all the pixels are set to one color, normally white. You can then use brush tools to apply color to this blank canvas by changing the values of the pixels under the cursor.

If you instead open up a digitized photo, you will see an image that is made up of varying color values. You can also apply adjustments and filters to all the pixels at once, changing the color of the whole image.

These two ways of manipulating bitmaps—painting directly onto them, and making global adjustments using numbers and sliders—provide the basic capabilities you need to alter images in just about any way you like. Two important additional elements, however, are masks and layers. Masks (as in conventional disciplines such as acrylic and airbrush) enable you to restrict changes to certain parts of your artwork, leaving others intact. Layers, on the other hand, enable you to create and manipulate different elements of an illustration independently, arranging them above and below each other within the visible canvas. We will explore these facilities in more detail in Part 4.

The number of pixels that make up an image determines its resolution. To fool your eye into believing that it is seeing a complete picture, rather than a grid of colored squares, there must be enough pixels packed into a given area. On the computer screen, where the monitor's glow helps pixels blur together, about 72 pixels per inch— that is, a grid of 72 x 72 pixels in each square inch of the image—is sufficient. If your illustration is for a website, you can simply make your image the required pixel size, and it will appear on the end user's screen pretty much as it does on yours.

But things are not as straightforward as that if your work is destined for printing. On the page, you need upward of 200 pixels, or dots, per inch, with 300 being the typical value. When you start an illustration, it is vital to take this into account when setting the document's resolution. Too low, and your work will be ruined by a blocky appearance when it is eventually printed. Too high is not such a big problem, as resolution can always be reduced, but excessively large files will slow down your software, waste hard disk space, and take longer to e-mail or transfer to storage media.

The same image, reproduced at 300 dpi, 72 dpi, and 36 dpi (left to second right), shows progressively more visible pixellation. When the low-resolution copy is resampled up to the highest resolution using interpolation (right), it loses much of its blockiness but does not regain the sharpness and detail of the original.

Resolution can be expressed either by a pixel count, such as "1,200 x 900," or by a combination of physical dimensions and dots per inch (dpi), such as "4 x 3 inches at 300 dpi." Your software will accept the information in either form, and convert between them, which can be helpful when using existing material. You can also enter larger or smaller values and ask the software to re-sample the image to that size. This will be successful when scaling down, but scaling up is another matter, as the software has to interpolate extra pixels based on the color values of the existing ones, and the result is always slightly blurred.

The leading bitmap application, used both for manipulating photos and for painting from scratch, is Adobe Photoshop. Corel Photo-Paint is a solid alternative, while on the PC a number of good low-cost programs,

When setting or checking the resolution of source material, do not forget to allow for cropping. This photo is a respectable 6 x 4 inches at 300 dpi, but when cropped to highlight a single object, it is reduced to a couple of inches.

Photoshop tells us the image's pixel size, physical dimensions, and dpi; changing any of these will adjust the others to match. Alternatively, click Resample Image to change the actual pixel size by interpolating.

such as JASC Paint Shop Pro, offer a more affordable entry point. A specialized area of painting is the simulation of natural media, including watercolors, oils, and inks. Photoshop now has brushes that behave more like their real-world namesakes than conventional bitmap tools, but the concept is taken much further in Procreate Painter, which simulates not only the initial effect of brush and pen strokes, but also the way paints and inks run together and into the surface of the paper.

Anti-aliasing: None
Anti-aliasing: Strong
Anti-aliasing: Crisp

Sometimes images are unavoidably reproduced at low resolutions—for example, within web sites. Their appearance can be improved using a technique known as anti-aliasing. The software detects strong boundaries between areas of different color value, and adjusts neighboring pixels to smooth the transition. This is especially effective on text, but care must be taken not to create a blurred effect. Photoshop's Type tool offers several different anti-aliasing options.

Colors are defined using various color models. Images are normally stored in RGB, a subtractive mixing model based on the primary colors of light (red, green, and blue). For printed output, they must be converted to CMYK, an additive model mimicking the inks used in the printing process (cyan, magenta, yellow, and black). While working on an illustration, you can specify colors using whatever model you prefer, but you should bear in mind that not all RGB colors can be faithfully reproduced on press.

DRAWING with a computer application can be a difficult technique to master, as it is far removed from its traditional process, and involves the manipulation of shapes and curves. However, mastery of the technique is essential for the digital illustrator. Drawing applications differ from painting applications in that you work with objects, rather than pixels.

Each object can be as basic as a circle or a rectangle, or a complex shape drawn with the Pen tool, which draws so-called Bézier curves—shapes devised by the French automotive designer Pierre Bézier in the 1960s. Each element of a curve is defined by four points: the starting and ending points, and two additional points that describe the shape and direction of the curve between its start and finish. You can read more about using Bézier curves on pages 73–74.

Each object created in a drawing application has two components: stroke and fill. The stroke is the outline around each "path," as the curves are known, and may be set to any color and thickness or given specific characteristics such as dotted lines and even arrowheads. Some applications, such as Illustrator, let the user wrap natural media and other brushstroke effects around stroked paths—see page 82 for more detail.

The fill element can be something as simple as defining a flat color for the interior

of the object, to something more complex such as a gradient or pattern. One way of creating shading effects is to draw one path in a dark color and another, inside it, in a lighter version of the same color, and then create a blend between the two. This blend will take the form of a number of interpolated elements between the two initial objects, each being a step in both shape and color between the first and last. By increasing the number of steps, an effective impression of a smooth blend can be achieved.

Each object in a drawing program is a mathematically defined curve—although the illustrator needs to know nothing of the math behind it. The end effect is that each object can be re-colored and reshaped quickly and easily, with no loss of quality, because each object remains a discrete entity throughout the illustration process. In addition, artwork created using a drawing program can be resized as large as you like without any loss of quality—unlike the pixel method adopted by painting programs, the curve is simply redefined at a bigger size.

The Bézier curve method is a clever, mathematically efficient way of representing shapes and adjusting them, but it can be difficult to get the hang of. Perseverance pays off; they are the fundamental drawing tool, and their mastery is essential for any aspiring digital artist. Some programs make the task easier. Adobe Illustrator, for example, provides a Pencil tool that creates Bézier curves as you draw with the mouse or on a graphics tablet. These can then be reshaped simply by drawing over them, without having to use the Pen tool at all.

There are several drawing programs available, including CorelDraw and Deneba Canvas, each of which has its own strengths. Canvas, for example, has a useful dimensioning feature that makes it invaluable for technical illustration. But in the professional arena, the only two serious contenders are Macromedia FreeHand and Illustrator.

FreeHand has the advantage of multi-page support and close links with the web animation program Flash, making it a useful all-around design application. For the specialist illustrator, however, Illustrator provides a solid working environment together with a custom brush technology that makes it hard to beat.

Drawing programs are ideal for creating information graphics, such as this illustration showing the constituent elements of the sun.

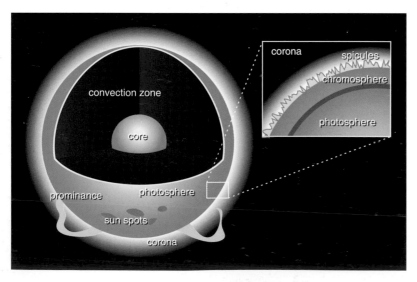

Right: In this simple path, points A and B are joined by curves. The shape of the curve from A to B is defined by the Bézier handles C and D: moving these will change the curve's shape. The lower curve, from B back to A, is defined by the handles E and F. The curve at point B is a smooth one, so the handle D to E forms a tangent to the curve at that point: where the two curves meet at point A, the handles C and F make a corner point.

Below: The stages in drawing simple artwork.
1. The outline of half the bottle is drawn using the Pen tool.
2. This outline is flipped across the vertical axis, and the two halves joined to make a single object.
3. The object's Fill is set to a dark green.
4. A smaller, brighter object is drawn inside the first to make the highlight.
5. The two elements are blended together to make a smooth transition from dark to light.
6. Other elements of the illustration are drawn as separate objects on top.

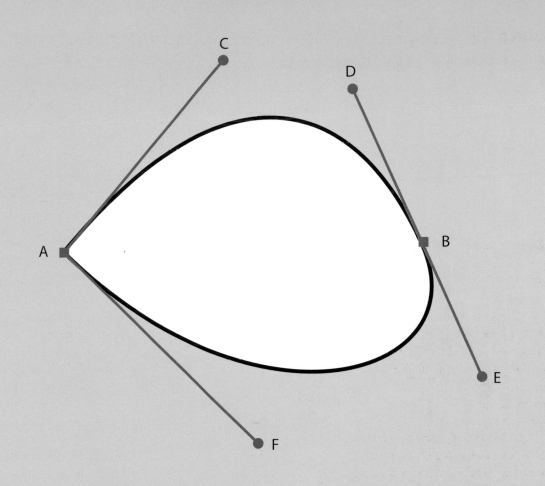

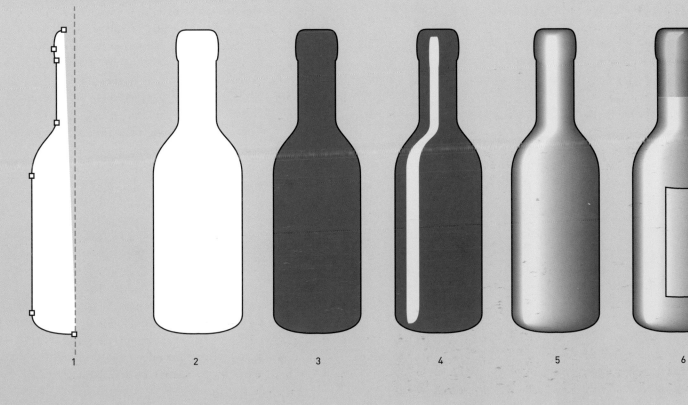

1 2 3 4 5 6

3D MODELING

Creating 3D models can be a laborious and time-consuming task, but it can produce some dazzling results. Scenes and objects of surprising realism can be viewed from any angle and manipulated to your heart's content. 3D modeling is a unique way of generating illustrations: each element is built as a separate object by defining its profile on each of the three-dimensional planes. Most modelers show the working view as either wireframe models or solid surfaces; in the latter case, these surfaces generally appear as if made of plastic to speed up the drawing process.

This is the rendered model, after surface texture and reflection maps have been added. An image of this complexity would be almost impossible to draw by any other means.

Once the objects are modeled, they can have textures applied to them, giving them the appearance of wood, glass, metal, or any of thousands of different surfaces. The more complex modelers enable the user to tweak and adjust the settings for each surface in a variety of ways. For example, scanned artwork, showing both natural materials (wood, stone, and so on) and flat artwork (such as packaging illustrations), can be wrapped around the models as well.

Lighting adds not only highlights and shading, but also casts shadows on other objects in the scene. Most 3D applications enable the user to choose from a wide variety of light source types, which can be customized and moved at will.

Although building the original models can be a time-consuming task, the end result is a scene that can be viewed from any angle, comprising objects that can be endlessly manipulated and moved relative to each other. After a model has been built, the finished scene is "rendered"—that is the finished artwork is generated complete with textures, reflections, and lighting effects. This process can take from a few minutes to several hours, depending on the complexity of the models involved. For example, complex surfaces, such as glass and metals, will add significantly to the rendering time. A technique known as "ray tracing" calculates the way objects in the scene reflect and refract each other, and is capable of producing a finished image of great realism.

3D modeling applications fall broadly into two categories: low end and high end. Low end modelers include dedicated applications such as Corel Bryce (see page 106), which creates artificial landscapes using a wide variety of land, sky, and water elements. Bryce also enables the user to create and position primitive solids, such as cubes, spheres, and cylinders, within the scene. These can then be combined and textured to simulate such diverse things as spaceships, architecture, or many other kinds of objects.

Other low-end modelers include Curious Labs Poser (see page 108), which uses poseable human and animal models to create realistic figures that can be manipulated into any position, and Electric Image Amorphium (see page 111), which employs a "virtual clay" technology that can be molded, distorted, and squeezed into any imaginable shape.

High-end modelers, such as NewTek's LightWave and Alais/Wavefront's Maya (pages 114–125), require far more skill on the part of the user. Creating accurate and convincing models from scratch is a tricky task, but the results can be impressive. These are the kinds of modeling applications that are used to generate scenes and objects in high-budget films, and—with expertise—can create scenes that are indistinguishable from reality.

As ever, the high-end/low-end divide is not absolute. Falling between the two are Adobe Dimensions (page 112), which uses basic modeling techniques to build simple objects, and Eovia Carrara, which combines the techniques of high-end modelers with a more approachable interface. The examples on these pages were created with Carrara.

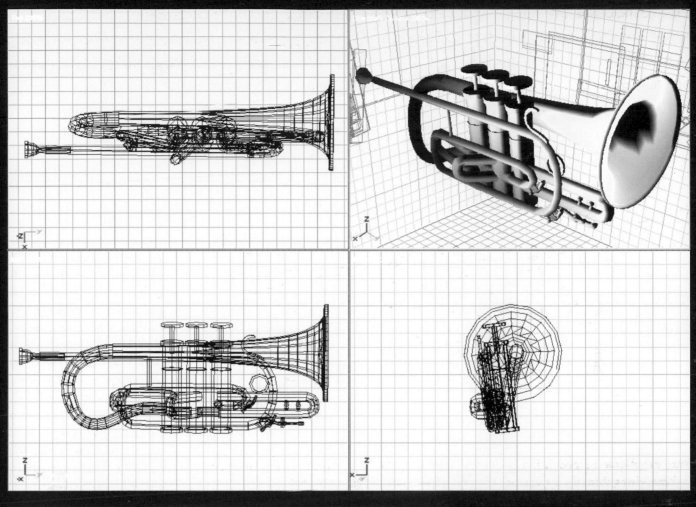

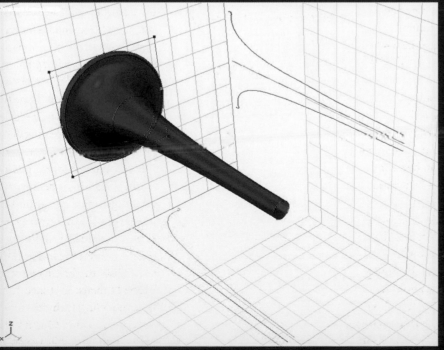

ANIMATION

ANIMATION Animators have always embraced a wide variety of media, and this continues in the digital domain. Using various types of application, any kind of artwork—whether bitmap, vector, or 3D—can be turned into frame-by-frame animations. Illustrators are increasingly called upon to add the dimension of time to their work, whether delivering a complete finished product, as with web advertising banners and short promotional spots, or contributing to a larger process, such as developing graphics for games, cartoons, or movies.

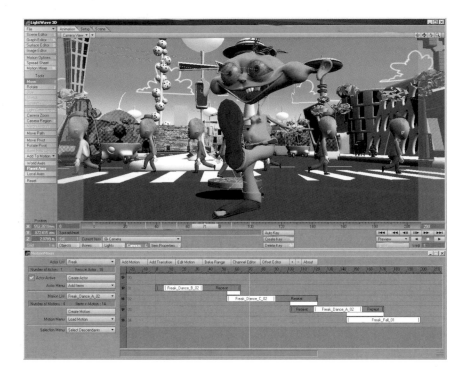

The most widely commissioned form of animation at present is probably Flash. The name refers both to an application used to create animations, and to a widely supported format for delivering them via the Internet; both are owned by the graphics software company Macromedia. Flash animations are vector-based, and use a simplified graphics language to store sequences in very small files. Bitmaps and video clips can be incorporated if necessary.

Because the format also offers interactivity, it's possible to build whole websites in Flash, with buttons and menus that respond to the user by changing the content that's displayed. More commonly, Flash is used for elements such as intro sequences and animated banners. Content will appear on users' screens only if they have a Flash plug in for their web browser software, but since the required download is available free of charge, this is very widely installed. There are plans to define a universal Internet standard for moving graphics, but

Full-blown 3D packages such as LightWave provide all the tools you need to model, animate, and render, and can be used for any task, up to and including the production of full-length TV shows. Developing all the necessary skills, however, is a longer and tougher process than coming to terms with drawing or painting software.
Picture: NewTek/MeniThings LLC

until that actually happens, Flash is likely to remain the accepted norm.

Flash owes some of its functionality to an earlier product, Macromedia Director, which revolutionized multimedia design in the mid-1990s. The advent of CD-ROMs made it possible to distribute moving graphics and video for playback on PCs, and Director provided the tools to build these into interactive products. Its key feature was a timeline on which events could be arranged, and this persists as the basis of Flash and other animation programs. Director is now used to create more advanced multimedia content in Macromedia's Shockwave format, typically for CD-based training materials.

A more traditional approach to cartoon animation is facilitated by Toon Boom's Toon Boom Studio, which provides tools to draw objects, place them in a pseudo-3D scene, then animate them by moving both the objects themselves and the imaginary camera through which the scene is viewed. The results can be output as Flash files. The same company's USAnimation covers more advanced projects.

Bitmap-based animation offers greater creative control, since there are no limits on what can be displayed. Images are imported into an application such as Adobe After Effects, where they can be arranged on a timeline and have adjustments, effects, and transitions applied. Extra features can be added via packages such as Pinnacle Commotion, which provides advanced frame painting and motion-tracking tools. Finished work is compressed into QuickTime or RealPlayer formats for use on the web, or exported to broadcast-quality digital video.

Right: Animators will often mix tools and media to create the overall effect they're looking for. This music video for the Robbie Williams track "Let Love Be Your Energy" was created mostly in LightWave, but rendered to simulate 2D painted animation. The final look and editing of an animated spot may owe as much to video postproduction software as to the package used to generate the original animated content.
Picture: Passion Pictures/EMI

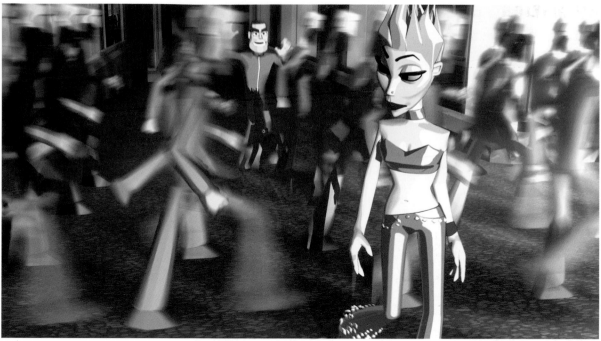

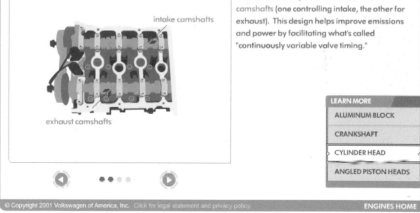

Basic 3D animation tools can add motion to artwork such as logos for use on websites. For more advanced work, animation is supported alongside modeling and rendering by the major 3D applications, including NewTek's LightWave and Alias/Wavefront's Maya. Here the construction and motion of virtual lights and cameras become as significant as that of objects and backgrounds. To produce a complete spot, specialized plug ins may be required to generate certain elements and effects, and the final result will usually be further enhanced in postproduction software. When it comes to 3D animation, patience is a virtue: it's a long, exacting process.

Serious bitmap and 3D animation place heavy demands on computers. Memory and hard disk requirements are large, and only the fastest processors and graphics cards will let you work with motion effects in real time. Nonetheless, an investment of less than $5,000 can equip a professional animation studio, and almost any personal computer can be used for Flash.

Above left: "Onion-skinning" is a technique that's been transferred from traditional cel-based animation to digital. The software shows ghosts of the frames before and/or after the one you're currently editing, so you can make gradual adjustments to build up a smoothly animated sequence.
Picture: Toon Boom Studio

Above: Flash can deliver animated graphics with interactivity in very small file sizes, making it ideal for Internet use. Here a complete presentation has been put together, with its own user interface to navigate between sections and link through to a glossary. Each section downloads only when it's called up, taking just a second or two.
Picture: Volkswagen of America, Inc

DIGITAL PAINTING

02

The premier application for bitmap (paint) illustration is Adobe Photoshop. Although, as the name implies, the program is designed for retouching and montaging photographic images, it can be used to generate illustration work from scratch; the painting tools have a natural feel, particularly when used with a pressure-sensitive graphics tablet, and can be used for freehand sketching and completed illustrations.

There are other photo-editing programs available, including Corel Photo-Paint and JASC Paintshop Pro, but Photoshop is the choice of the professional, offering a superb combination of power, reliability, and ease of use. This chapter will deal mainly with Photoshop, detailing its key strengths and capabilities.

Many illustrators use Photoshop for retouching and finishing off work begun in vector applications, adding texture and shading that would be too complex to create in a naturalistic manner in a vector environment. Artists working with 3D modeling applications frequently take their rendered output into Photoshop to correct modeling glitches, add backgrounds, and perform general compositing work. Although it would be possible—in theory, at least—to correct these factors directly in the 3D modeling environment, Photoshop avoids the sometimes lengthy rendering times by providing direct access to the image.

Photoshop 7 brings a new array of natural media brushes into play, which can be used to create work that looks as if it has been painted using traditional materials. Those artists wishing to specialize in this area may choose to work in Procreate Painter instead (see page 36), which is dedicated to simulating a wide range of paint and drawing materials.

PART 02. DIGITAL PAINTING

CHAPTER ONE

HOW DIGITAL PAINTING WORKS

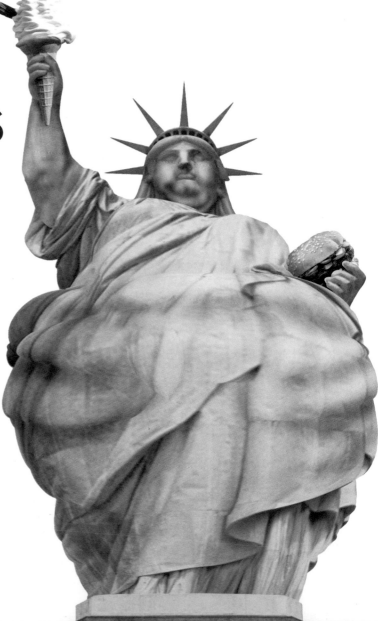

This illustration for a feature on overweight America was created in Photoshop, using a photograph of the Statue of Liberty as its starting point. Although few readers would be fooled into thinking this was a real photograph, it has a degree of realism that wouldn't be possible using illustration alone.

PHOTOGRAPHIC MANIPULATION Many of the features of bitmap applications, such as Photoshop, are designed for re-touching photographs. They mimic the processes that would traditionally be carried out in a darkroom or during the reproduction process, as well as those made possible only by digital manipulation. An understanding of photo manipulation techniques will help you prepare images obtained from scanned originals, digital photos, image libraries, and other sources.

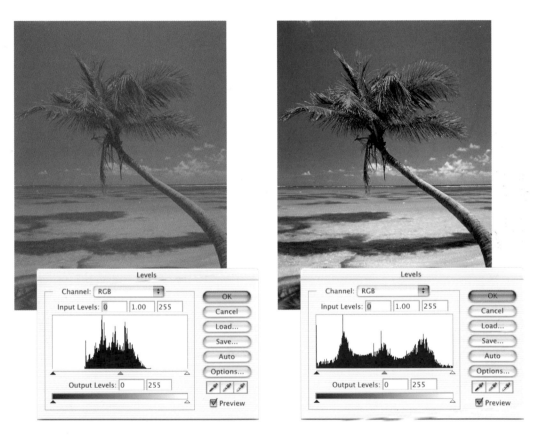

As well as maximizing the quality of your raw materials, you can also apply the same principles more creatively during the production of your artwork, whether for producing special effects, matching disparate images for montage, or simply ensuring that the final illustration is bright and crisp.

Endless mathematical operations can be carried out on the color values of pixels within your image. The most obviously useful are those corresponding to easily understood properties such as brightness, contrast, or hue. These are presented by the software in the form of sliders, with their effects on the image immediately visible as you drag the slider to increase or decrease the value. For more clever and effective adjustments, the pixel values across the image can first be plotted on a histogram (column chart). The axes can then be stretched or compressed to increase or limit the image's tonal range, or the midpoint shifted to change the balance of light and dark tones. This is performed using Photoshop's Levels control, which is typically used to correct images that look washed-out or "muddy," and offers an Auto option that can often provide instant improvements. Alternatively, the Curves control presents a graph on which average pixel values are represented by a diagonal line. You can then add points to this and move them, or redraw the line in any shape you choose, for subtle or dramatic tonal changes.

Filters offer even more complex adjustments. The most commonly used is Sharpening, where the software detects transitions between areas of different tone and

Above: **This image looks washed-out, and a glance at its histogram in Photoshop confirms that its tonal range is limited—no pixels reach the lightest (left) or darkest (right) possible values.**

Above right: **After applying Auto, the histogram is stretched, giving a much bolder result. Because Auto Levels can sometimes affect color balance, Auto Contrast and Auto Color are offered as alternatives.**

adjusts pixels to emphasise the difference. The effect is to clarify detail. Since the printing process has a blurring effect, artwork destined for print will usually benefit from extra sharpening. A function known as Unsharp Mask helps achieve optimum results on a particular image.

Blurring is also supported, again supplemented by a more controllable alternative, Gaussian Blur. Bear in mind, though, that Blurring and Sharpening are not strictly opposites, and Sharpening will not rescue a badly blurred image, or Blurring an over-sharpened one.

Other filters, often supplied as plug ins available either from the application's own manufacturer or from third parties,

This image (top left) may look satisfactory on-screen. However, when printed, the edges of the screw thread are softened and the metal texture is lost. Sharpening (top middle) recovers these details and gives a crisp appearance. Over-sharpening (top right) produces speckling and fringes of false color; check carefully for these after each sharpening operation.

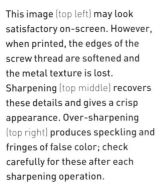

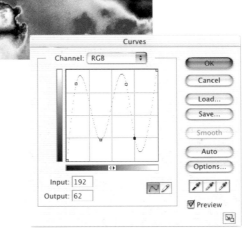

The Hue/Saturation/Lightness dialog box is a versatile tool, enabling global changes to be made directly to pixel values. Hue is what we would normally call the color spectrum. The scale is marked from 0° to 360°, and you should imagine it being bent around in a circle, so that the left-hand side touches the right. This point represents cyan, and (from left to right) values pass through blue and purple to red in the middle, then through yellow and green on the way back to cyan. Saturation represents strength of color, from pale to bold. Lightness is self-explanatory. We will demonstrate the effects of different adjustments on this brightly colored image.

can be used to stylize images, simulate lighting effects, or create patterns, such as clouds, from scratch. Filters that create a specific appearance, such as that of a bas-relief or oil painting, are often avoided by professional illustrators because these risk detracting from the originality of their work.

Exciting and innovative results can be generated by using filters in unexpected ways—for example, by applying extreme settings to distort an effect. Adjustments and filters are applied either to a whole image or to a selected area. An essential retouch tool that works rather differently is Cloning. You first click on a point within an image to pick up the surrounding pixels, and then paint elsewhere to apply them—the source point follows your brush, so an unlimited area can be duplicated. Cloning enables you to remove elements, such as deleting an irrelevant figure from a group photo, or duplicate them, turning a few figures into an army. The results can be seamless, but some skill and forethought are required.

The Curves dialog can reveal surprising hidden depths in the most innocuous of images. Here, several points have been manipulated to create multiple peaks and troughs, turning a bland blue sky into both a fantastic and sinister backdrop. Unnoticed graininess in the original photo has also become evident. However, this could be removed using a Blur or other filters.

Above: Dragging the Master Hue slider to +120 (one-third of the way around the color wheel) shifts all colors toward the blue part of the spectrum. The black-and-white pencils show no change.

Selecting Green instead of Master applies the adjustment only to certain hues (defined by the color sliders). Now only the green "2" changes color. This technique can be used for subtle re-coloring.

Shifting the Master Saturation to –50 washes out color across the board, leaving a range of grayish tones. Conversely, higher saturation will make for brighter, bolder images, though colors may start to look artificial.

Right: To remove the flower in the center of this image, parts of the wall were cloned over it. Since there was no single area of wall large enough, individual bricks and joints were cloned to build up a convincing replica. While the software makes this kind of retouching possible, the results are strongly dependent on the skills of the artist.

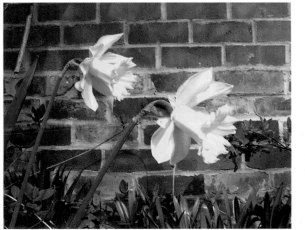

PHOTOMONTAGE Done well, photomontages can be indistinguishable from real photographs. Alternatively, they can achieve a more artistic effect, with a result that could only be an illustration. Photomontage is the process of assembling illustrations using a variety of different images. These may be scanned from photographic prints, captured using a digital camera, created using a 3D modeling application, or even drawn directly on the screen. In fact, photomontages do not necessarily have to include any photographs at all—it is the principle that counts.

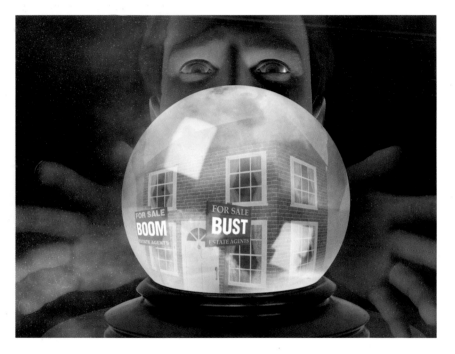

Each element in a photomontage is a separate layer, which can be manipulated independently of the others. Working this way means that it is possible to adjust the makeup of the montage as you go along. Elements can be moved, resized, re-colored, or removed entirely. It is only once you have completed the montage that you will need to "flatten" the layers into a single, composite image.

Unsurprisingly, Adobe Photoshop is the tool of choice for photomontage. Its selection, compositing, and layer-handling functions are powerful and highly sophisticated, enabling the user to manipulate images in just about any way imaginable. As the interface is quite intuitive, Photoshop is also relatively easy for the novice user to learn. Photoshop's own entry-level sibling, Photoshop Elements, has many of the same features at a much cheaper price, while rival applications such as Corel Photo-Paint and JASC Paint Shop Pro can also produce excellent results.

When making montages, you will rarely want to include whole images in the composition—for example, you

Above: **This illustration for Britain's** *Daily Telegraph* **newspaper was commissioned to accompany an article about realtors' difficulty in predicting the future of the housing market. The concept evolved through discussions with the section editor.**

Right: **It was decided that a "fake" house would look better than a real one. This house was created by distorting a photograph of a brick wall to make the front and side walls of the house; the same brick was darkened and distorted again to make the roof. Sections of the wall were further distorted and cropped to form the chimney stacks.**

Below: **Photographs of a door and window were distorted to match the perspective of the walls. The black inserts behind the window were created on a separate layer (see pages 40–41).**

Below: **A single drape was drawn in Photoshop, then textured, duplicated, and distorted to fit each window.**

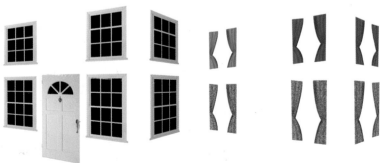

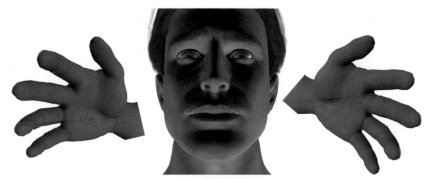

Left: The head and hands were modeled in Poser (see page 108). The slightly unreal quality of Poser models lent itself well to this kind of illustration.

will often need to cut the desired component from its background. Selecting a particular portion of an image is done using a variety of tools—from simple rectangular and elliptical selections to tracings, using the Lasso tool, through to paths drawn with a Pen tool.

Photoshop also enables you to make selected areas of an image disappear, either by selecting all areas of a similar color and deleting them or by using special controls to hide all the areas that are darker or lighter than the value you specify. But be aware that deleting areas from a layer is an irrevocable step: once they are erased, you cannot retrieve them later. An alternative approach is to use a technique known as masking, in which portions of a layer are hidden rather than deleted. See pages 42–43 for more on this useful technique.

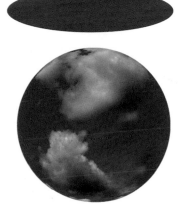

Left: The ball itself was formed from a circular section taken from a photograph of a vase; the base is taken from a photograph of an Oscar trophy. The table beneath is simply a circular selection taken from a scan of a piece of wood.

Below left: To add life to the crystal ball, this scan of a cloud was Spherized and then its layer mode changed (see page 41) so that only the brighter areas were visible.

Below: This image of a star field was placed in front of the head and hands layers, and its mode set so that only the dark background disappeared entirely.

Below: This is the finished house, with all the elements in their correct positions.

To make the house look as though it fitted inside the crystal ball, it was distorted using Photoshop's Spherize filter.

Done well a montage can look so realistic that it is difficult to discern from a single "real" photograph, or it can be more artistic, producing a finished result that is clearly an illustration. The example shown on these pages falls into the second category. Although most of the elements in it come from photographic sources, nobody would ever confuse it with a photograph.

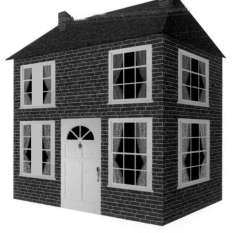

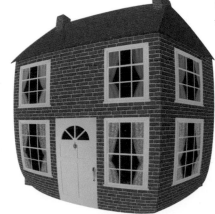

The two "For Sale" signs were created as separate elements, and then distorted slightly using the Spherize filter once again.

NATURAL MEDIA Computer applications that can mimic the effects of natural media, such as watercolor and oil, are only just beginning to come into their own. They have the added bonus that anything you don't like can be erased from your canvas completely, enabling you to start again. Although bitmap editors are sometimes referred to as paint programs, and provide tools with names like Brush and Pencil, their behavior has only recently begun to bear any notable resemblance to their real-world namesakes.

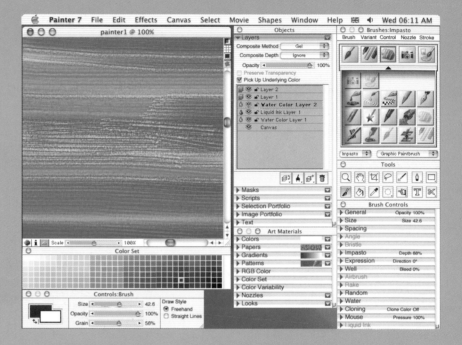

Accurate simulations of natural media such as inks and paints have proved difficult to program and are extremely demanding of computing power, leaving them low on the list of priorities when it comes to the development of mainstream software. For some users, however, particularly those converting traditional disciplines such as watercolor and pen and ink to digital illustration, these facilities are of paramount interest.

The leader in natural media for more than a decade has been Painter, a specialized application currently owned by Corel and marketed under the Procreate label. Painter includes some adjustments and filters reminiscent of Photoshop, and can also make use of Photoshop plug ins, but the majority of its features are dedicated to wet and dry brushes, pens, pencils, chalks, crayons, and other tools of the traditional artist. Particularly significant is the provision of wet watercolor layers, on which successive strokes can be left to run and bleed together as you paint. Not only is it possible to create highly realistic effects, but you can also carry out operations that would be impossible with real media, such as erasing a watercolor and starting again.

To get the best from Painter, it is almost essential to invest in a graphics tablet (see page 16). By linking stylus functions, such as pressure and tilt, to parameters such as the width and texture of brushstrokes, you can greatly increase the sense of physical interaction with the artwork. Drawing with the mouse is possible, but makes gestures unwieldy and relinquishes most of your real-time control over strokes. Many professional illustrators, who originally trained in media such as oils and airbrush, have successfully transferred their skills to Painter. The program is also widely used in the 2D departments of animation and movie studios, where it brings conventional visualization and rendering skills into the digital domain. Nonetheless, many users react to it with frustration. On screen, hundreds of controls are presented in a daunting and rather cumbersome list format.

When you start painting, different layers are created within your image depending on the kind of brush used, and each layer will then only respond to the application of

Painter's user interface is a little disorienting at first, with an unfamiliar structure and all too many options lurking within the list-based toolboxes. Once you start painting, however, you will gradually get a feel for the options you need and where to look for them.

appropriate brushes. The higher the resolution of your image, and the larger the brush you attempt to use, the slower the program will run. In practice, even modestly sized images will challenge the software to keep up with you. However, as Painter is developed further and computing power continues to climb, many of these issues are likely to be resolved in the future.

No other application goes as far in this context, but some general-purpose bitmap editors do offer brushes that can be used and edited creatively. In Photoshop, for example, brushes can each incorporate two different elements overlaid using any of the usual blending modes, with size, spacing, opacity, and color independently set to change randomly or in response to stylus functions. You will not get your strokes to blend and bleed together as you will with Painter, but impressive results can nevertheless still be obtained, particularly if creative experimentation is more important to you than mimicking specific real-world techniques.

The complex layering of color washes and fine brushstrokes in the leaf could only have been produced in Painter. At least two sets of veining detail have been drawn, one in fine, dark strokes and another in erased color, suggesting superimposed images.

Shading has been sketched onto the stalk using a very fine camel brush, effectively acting as a pen. The graphics tablet is ideal for fine detail such as this, and Painter's subtle blending and bleeding ensure the strokes are sufficiently integrated with the watercolor.

Created in Painter, this illustration demonstrates a number of techniques. Immediately obvious is the fact that it has been extensively worked and reworked. This is possible because the software lets successive strokes shift and distort what has already been painted.

A runny wash has been applied to this area using a dark color. The primary purpose of this is to add shadow, but it also blurs the underlying strokes, helping to give an impression of selective focus on the brighter part of the apple.

The edges here have been "burned" using a white eraser brush with a dark secondary color to catch the ocher paint, adding definition to this relatively light area. Further in, the ocher and green colors have been blended using a bleach brush.

A dry brush has been used to roughly scrape back the paint, adding textural interest. The increased contrast and definition make this area seem closer to the viewer's eye, and reinforce the perception that the object has three-dimensional depth.

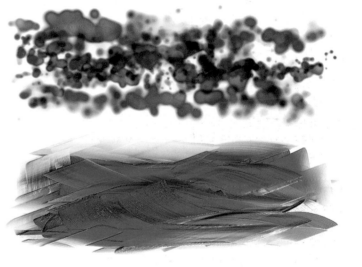

Right: Painter's Watercolor brushes closely simulate the running together of multiple strokes of wet paint (top). Note the distinct bristle pattern and the way this is blurred by the addition of yellow paint on top. An equivalent brush in Photoshop (bottom) produces a vaguely brushlike effect, but with far less definition and no attempt to blend successive strokes. On the other hand, the Photoshop example was much quicker to create.

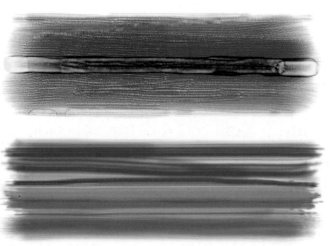

Above: Photoshop's brush technology has its strengths. This layered brush (top) gives an abstract effect that would be harder to achieve in Painter, and its extensive settings can all be found in one place for easy editing. But Painter excels when it comes to mimicking real media. Here (bottom) a notched palette knife is being used to smear thick impasto onto the paper, producing almost three-dimensional artwork.

PIXEL ART is a form of illustration that turns the conventional approach to bitmap editing on its head. Rather than using high resolutions and careful manipulation to prevent the "bitmapped" nature of the artwork becoming evident, pixel artists celebrate the digital medium by working at very low resolutions, using pixels as building blocks to construct often detailed, but always conspicuously bitmapped, images.

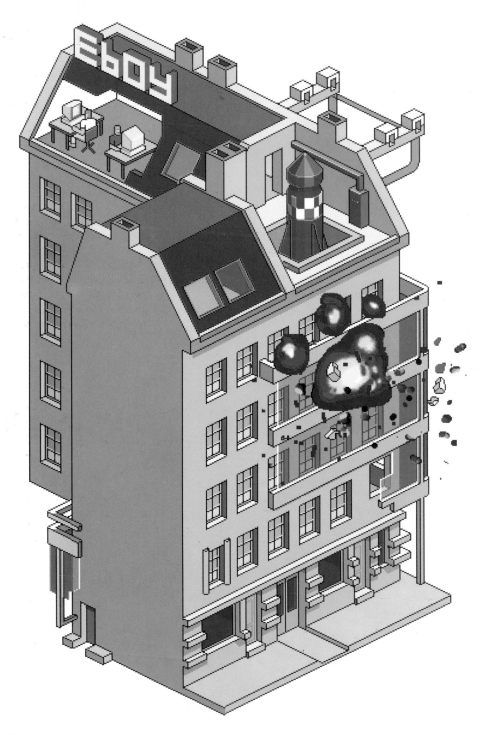

Since modern bitmap applications were not developed with this purpose in mind, they offer few relevant features. Selection and Fill tools can be used, provided that their anti-aliasing option is turned off, as it has the effect of disguising pixels rather than leaving them intact. Line drawing tools can be used for 90° and 45° lines, but their results are too unpredictable at other angles. Accordingly, the initial drawing process is generally little more sophisticated than placing individual pixels of different colors one at a time. Since this is extremely labor intensive, artists will duplicate elements (whether within the current artwork or from previous jobs) as often as they draw new ones. While working, elements can be set aside on separate layers or as alpha channels, ready for reuse.

Any subject can be tackled, but a popular sub-genre is isometrics, a form of perspective traditionally used in technical drawing. Based on 30° angles, this method simplifies the construction of 3D objects in 2D artwork, and its abstract, diagrammatic nature helps create a characteristic feel. Shading is added to heighten the semi-realistic effect, and the one-pixel black outlines with which elements are drawn are usually retained as part of the final artwork.

A restricted color palette is often used. This may be defined by the artist, or an existing palette may be applied, one choice being the so-called web-safe palette. This is a set of around 200 colors that are supposed to display correctly on almost any web-capable computer. However, as an increasing number of computers support millions of colors, and

Right: In this part of the illustration (opposite page), the artists play with pixel art conventions by enabling parts of the building to explode out of their isometric constraints. Even within the flames, however, a restricted color palette is used, and edges are not anti-aliased.

 Correct color shading lends a superficial impression of photorealism to pixel art objects. In highlights, the hues of the object and an imaginary light source must be combined; this can be done by eye or using a blending mode such as Overlay or Soft Light.

 Every pixel counts. Here, both figures are seated on chairs. Due to our angle of view, only the rear figure's chair is visible. Yet we still have the impression of a chair back behind the foreground figure. The visual cue is a single extra black pixel on his right shoulder.

 The challenge of bitmapping is especially intriguing in type design. Several Eboy font families are available through FontFont (www.fontfont.com); bitmap faces from other designers, including Emigré, variously mimic low resolution devices or stand as original creations.

 In isometric perspective objects can be repeated by copying and pasting with no need to change angles or shading. This makes it easy to build up highly complex illustrations, a temptation to which many pixel artists succumb.
Illustration: Eboy
www.eboy.com

web design trends demand the use of high-color photographic images that cannot be made web safe, the system is already close to obsolete. Despite that, it does still provide an esthetically interesting selection of shades.

When editing, re-purposing, or reproducing pixel art, take care not to compromise its bitmapped format. Re-sampling will normally involve interpolation, which breaks down the pixel structure. For this reason, the resolution of such illustrations must never be reduced. If resolution needs to be increased—for example, to increase the size of the pixels when displayed on a web site—this should always be done in whole multiples of 100% and with re-sampling disabled (in Photoshop, this can be done by selecting Nearest Neighbor, rather than Bicubic or Bilinear Interpolation).

A number of related genres exploit digital characteristics through various means. In ASCII art, for example, photos or even video clips are converted into grids of letters and numbers, using the relative "darkness" of different characters (a dash would be very light, an M very dark) in place of pixel values. Although this is an automated process, serious practitioners write their own software routines for the conversion, and in the process introduce an element of creativity. Other illustrators set arbitrary limits on their work, such as using only basic geometric shapes or working to a fixed grid, whether in bitmap or vector form.

Above: One tool that does save time and effort is the Paint Bucket; click anywhere within an area bounded by an unbroken line, and the area fills with the currently selected color (left). For this to work, it is vital that the outline has no missing pixels, or the color will leak out into surrounding areas (right). This is annoying, but it is a good way to check the integrity of your lines.

 FlipFlopFlyin's Minipops are an extreme example of bitmap art, using just a few pixels to construct miniscule portraits of musicians from Abba (below) to ZZ Top (left).

Above: Pixel art is typically based on a modified form of isometric drawing. A true isometric grid has lines at 30° angles on either side of the vertical. When these lines are bitmapped, the aliasing effect breaks them into an irregular sequence of one- and two-pixel segments. For a neater appearance, pixel artists draw lines at 22.5° angles. Just as a 45° line is formed from evenly stepped single pixels, a line at half this angle proceeds in two-pixel steps. The result is not a true isometric drawing, but looks similar, and the artist can compensate for any geometric discrepancies by eye.

Above: Unfortunately, standard bitmap drawing tools are of little help in constructing pixel art. Photoshop's Line tool is anti-aliased by default (left), and even when anti-aliasing is turned off, the results (middle) are unsatisfactory because pixels are not evenly distributed. Only a painstaking process of placing individual pixels with the Pencil tool will generate the perfectly clean effect required (right).

While the basics of paint applications such as Photoshop are fairly simple to grasp, it is once you delve into their more complex aspects—layers, masks, and effects filters— that you truly unlock their potential for illustration. By learning to work with layers you immediately open up a range of compositional possibilities. Add Layer Effects and the Lighting Effects filters to your repertoire and you can lend your work a new, three-dimensional edge. You can even combine your paper artwork with Photoshop to add color and shade the easy way, with the power and flexibility of digital techniques and the safety net of a single-click Undo. And should you reach the limits of your chosen application's capabilities, there is a host of third-party plug ins waiting to expand your options even further.

PART 02. DIGITAL PAINTING
CHAPTER TWO

PAINTING TECHNIQUES

When the Clouds layer is set to Hard Light mode (left), it lets the underlying artwork show through (right) and adds an overall texture to the illustration, unifying the disparate elements.

The Clouds layer (left) obscures the entire artwork when placed at the top of the composition (right).

The Spaceship layer (left) simply sits on top of the Earth layer in the composition (right).

The Earth layer is positioned off the "canvas" (left), but can still be retrieved if desired—in this composition (right), it is cropped by the canvas size.

The Stars layer sits at the very bottom of the stack to form the background.

WORKING WITH LAYERS Layers were a relatively late addition to the features of bitmap applications such as Photoshop, but are now central to the working methods of most illustrators. By maintaining elements of artwork as separate entities, while controlling how they combine to form the whole composite result, layers bring practical and creative advantages to digital painting.

A new document starts with just one layer, referred to as the Background, which is filled with white. When you add a layer, its pixels are transparent, so anything on the background shows through. Anything you add to the layer, whether by painting or pasting elements from other files, appears on top of the background. As you add more layers, each appears on top of the last. Each layer is listed on-screen in a palette, and any one of them can be visible or invisible. This means that you can work on a single layer at a time or check what the artwork would look like without it. One layer is the "active" layer at any time, and any operations you carry out apply only to it. This means that, when you make a selection, only pixels in the active layer are selected—moving or otherwise transforming the selection will not affect the layers on top or underneath. Copying and pasting the selection normally creates a new layer containing only the selected material. This can then be positioned independently.

Layers can be grouped into sets, which can then be repositioned together. Later, layers can be permanently merged with others, and ultimately the whole document can be flattened into a single composite image ready for reproduction. But although layers appear on top of each other, this is not a complete description of the way they combine. Each layer has an Opacity and a Blending mode, which together determine exactly how its pixels interact with those of underlying layers.

In Normal mode, pixels in a higher layer simply overwrite those underneath, to the degree dictated by the higher layer's opacity. However, in other modes, a mathematical formula is applied to determine color values.

When the sky image (above far left) is layered over the wire fence (second left), you can see the result obtained with the following blending modes: Darken, Lighten, Overlay, and Vivid Light.

Darken, for example, replaces only pixels that were lighter than the ones being overlaid, leaving darker pixels intact.

Multiply, meanwhile, creates a more subtle effect by multiplying the color values of the new and underlying pixels, giving a darkening effect. Screen does the opposite, multiplying the inverse of the color values for a lighter result, while Hard Light multiplies where the new pixels are dark and screens where they are light, creating an exaggerating effect similar to a spotlight. There are many more modes to choose from.

A further refinement of layers in Photoshop is incorporating adjustment layers. Most adjustments (such as Brightness and Contrast) that you might apply to an image can instead be applied to an adjustment layer. This layer does not contain any pixels, but instead carries information about the adjustment, which then affects pixels in all the layers below it. You can therefore apply effects without committing to them permanently—the adjustment layer's settings can be edited later—while the actual pixels in other layers remain intact throughout, with only the appearance of the composite artwork changing. This is great because it lets you experiment radically with illustrations in a completely reversible way.

LAYER MASKS let you hide and reveal different aspects of an image. But the best thing is that the technique is totally reversible. The easiest way to remove part of an unwanted layer in your image is to delete it. This is fine when you are sure you want to lose elements permanently, for example, when cutting an object from its background and being certain that you will not want to retrieve the background at a later point. However, deleting (making a selection and pressing the Delete key) and erasing (using the Eraser tool to paint out areas) are irrevocable steps, and should be used with caution.

A better solution is to create a mask for the layer, which hides parts of that layer without deleting them. The advantage is that you can selectively hide areas and, if necessary, bring them back later. This is the best way of keeping your options open, since you do not need to commit to a permanent deletion.

A layer mask is a grayscale image that affects the visibility of the layer to which it is attached. Any black areas on the mask will hide those parts of the layer, while white areas will enable the layer's other selections to remain visible. Gray areas render the layer semi-visible—the darker the gray, the more hidden those areas will be.

The easiest way to make a mask is to paint with the Brush—it is as easy as using the Eraser. Painting with a hard-edged brush will create a sharp cut-off between the visible and the hidden, whereas painting with a soft brush will make that part of the layer gradually fade away. Unlike using the Lasso tool, you do not need to trace a complete outline in one go, as masks can be painted in small sections to increasingly hide the layer with each brushstroke. Switching the foreground (painting) color from black to white will enable you to paint the layer back in again in exactly the same way. This makes it easy to perform complex cut-outs, since you do not need to worry about deleting areas that you want to retain —it is a simple matter to paint them back in again.

Masks can be created with any of the painting tools—not just the Brush. Use the Gradient tool to make a gradual fade in any direction, or the Smudge tool to tweak out strands of grass, hair, leaves, and so on. You can also make selections within the mask using the Lasso or Marquee tools, and fill them with black to hide large areas without having to laboriously paint them out.

Right: **This pipe is in front of the ring layer; the layer mask has been made on just the left side of the ring, obscuring that section of the pipe.**

Below: **This is the layer mask in isolation, showing how the ring portion is hidden on the pipe.**

Above right: **When the pipe is moved, the mask moves with it. This is because the layer is linked to its mask (right), which can be seen in the tiny chain symbol between the two in the top layer on the Layers palette.**

Below: **When the link is broken, the two components operate independently. Now, we can move the pipe wherever we like, and the mask will stay where it is.**

Far left: This box has been positioned on a beach background. As it stands, it does not look like as if it belongs there at all.

Left: We begin by making a layer mask and painting out the box layer using a hard-edged brush, which produces this crisp edge that hides the box.

Left: This is the layer mask itself— the black areas are those that have been hidden on the box.

Far left: Now we switch to a soft-edged brush, and paint out some more of the box layer where it meets the water. Already, it is starting to look more convincing.

Left: Switching the foreground color from black to white lets us paint the box back in again. By using a low opacity for the brush, we can partially reveal the hidden area so that the box is seen through the water.

Normally, the layer mask will be linked to the layer, and will move with it. But as the pipe and ring example on the opposite page shows, it is possible to separate the two so that they operate independently. In this way, it is possible to make the pipe appear to be both in front of and behind the ring layer simultaneously, as it appears to pass through it.

A counterpart to layer masks is QuickMask, a selection mode that works in exactly the same way. You enter QuickMask mode by pressing Q. You can then use any of the painting tools, just as if you were painting a mask. In this mode, the solid mask will be shown as a translucent red rather than black (so you can see what you are doing). When you exit QuickMask by pressing Q again, the area you painted will be turned into a selection.

Left: A special brush mode called "dissolve" paints rough, dotty edges. It has been put to good use here, to paint the box mask around the sand in a more convincing manner.

Left: Here is the finished mask seen alone, showing the dotted edges around the sand. The gray area on the right creates the semi-transparent edge of the box.

PHOTOMONTAGE The term "Photomontage" can cover a range of artistic styles, from the truly photographic to the entirely illustrative. In this example, we look at an image that falls halfway between the two: while photographic in treatment, it is clearly not a real photograph.

This image was commissioned for the cover of the "Review" section of Britain's *Independent* newspaper. When combining images from a variety of sources, the key to creating a successful montage lies in making all the elements blend together convincingly. The elements do not need to come from the same, or even a similar, source. Here, the fork was photographed with a digital camera, the map outline was a PostScript map with all the detail removed, and the steak came from a royalty-free photography collection.

If you are working on complex montages that contain many elements, it is possible to end up with dozens of separate layers. So, to avoid confusion, it is worth naming the layers as you create them—in this case, they might be called "steak," "fat mask," "fork prongs," and so on. It takes just a few seconds to name each layer, and it can avoid a mass of confusion later on.

Photoshop also enables layers to be grouped together in sets, without affecting their appearance, making navigation that much easier. In addition, entire sets can be turned on and off with a single click, making it possible to build multiple variations of a montage in a single file and flip between them instantly.

The finished illustration, with a new background, as printed in the newspaper.

1. To begin this image, a silhouette of a map of England, Scotland, and Wales is rotated to fit on top of a cutout photograph of a fork. This will form the basis for the steak shape.

2. This photograph of a piece of steak is positioned on top of the map. It doesn't quite cover it, but it's easy enough to clone areas to where they're wanted.

3. When the steak is "grouped" with the map layer, it shows up only where it overlaps the map. The steak now takes on the shape of the map perfectly.

1

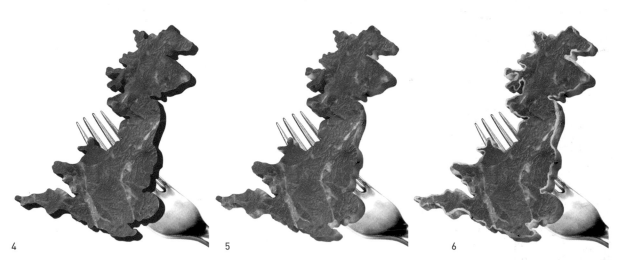

3

4. The map layer is duplicated, and offset to provide some thickness to the steak. This layer is then sent to the back, behind the original map.

5. Now a piece of the fat from the edge of the original steak is copied to a new layer, and grouped with the "thickness" layer. Elements of the fat are moved around so that they fill the layer completely.

6. A further layer of the fat is copied and grouped with a new mask, painted roughly around the edge of the whole map, so that the fat now runs all the way around the steak.

4

5

6

7. A new adjustment layer enables us to darken the steak. By painting irregular diagonal lines on the mask for this layer, we can give the impression of the steak being 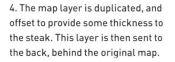 newly grilled.

8. A copy of the end of the fork is made on a new layer, and brought to the front. This is then masked so that the fork appears to be pressing through the steak. Shadows, both on the steak and on the fork, add to the realism.

Far right: **Photoshop's Layers** palette showing all the layers that comprise the main montage.

7

8

BEVELING AND EMBOSSING Autoshading and 3D shading can provide flat images with depth and dimension, and add contours and texture to objects. The process requires some trial and error, but the end results are always rewarding. Artists traditionally create the impression of 3D by painting highlights and shadows. Software packages provide various features to automate the process, which can be used very effectively to simulate two-and-a-half-dimensional or bas-relief materials and objects.

The most basic form of autoshading is beveling or embossing. This works by "offsetting" existing information in an image. Superimposing a lightened copy shifted up and left, or a darkened copy shifted in the opposite direction (down and right), gives the impression of light falling across an object from the top left corner. Scaling shaded copies of an image outward gives the effect of a flattened pyramid, reminiscent of a button—for example, a key on a computer keyboard. More complex profiles can be built up by varying the offsets, while a more softened result can be achieved by applying a "blur" to the image.

Bitmap programs and plug ins combine these processes into filters that are dedicated to producing certain types of bevel or contour. In Photoshop, for example, the most flexible beveling tools are found in the Layer Effects module, in which contours can be edited to govern the exact shape being represented (see page 50).

Although beveling has been over-used in contexts such as website navigation buttons, it remains a versatile technique with many useful applications. For example, soft bevels can add a subtle sense of depth to flat shapes within a composition, an effect now routinely seen in cartoons—where it is applied using specialized plugins—and mimicked in cartoon-like illustration and character-development work.

More advanced pseudo-3D shading can be achieved with tools such as Photoshop's Lighting Effects, which casts a glow over an image from one or more chosen directions. In itself, this is a 2D effect, but it can be applied through an "alpha" channel to create a complex contour. An alpha channel is a separate grayscale image, similar to a layer mask. Image pixels are shifted according to the value of each corresponding pixel in the alpha channel, with darker areas appearing higher in the contour. Pixel values are further adjusted according to the color and strength of the light at each point. Although this isn't a true 3D operation, it can be used to transform a few simple shapes into a highly realistic semi-3D object.

The Lighting Effects filter offers a large number of sliders, which need to be used carefully to produce the desired result. The position, intensity, and focus of the light must be balanced against the overall exposure and ambience to avoid the image being plunged into gloom or being "whited out." Two sliders control the surface properties of the object being rendered, varying from matte to shiny and from plastic (soft) to metallic (hard). These will also affect overall tonal range, and extreme values may create unwanted artifacts—patterns generated by the software—in the finished result.

More important still is the pre-processing of your alpha channel. Although you will usually create your object as a simple black-on-white shape, you will need to apply some Blur: this provides a transition from high to low in the contour, which would otherwise jump unrealistically from maximum to minimum.

Below left, top row: **Various techniques can be used to generate simple highlights and shadows. The simplest is to intersect offset copies of an object in opposite directions, then darken and lighten them. This process is automated by Photoshop's Emboss filter, with primitive results** (left to center) **that can be manipulated using Gaussian Blur to produce a fairly realistic effect** (right).

Bottom row: **Shading can be processed in various ways to change its appearance. Trial and error with Photoshop's Curves can give effects including shiny** (left) **and glassy** (center). **If photorealism is not required, tonal range can be reduced using Posterize** (right) **for low-tech or pop-art effects. Plug ins are available to create an endless range of predefined and customized results.**

part 02. digital painting

Further adjustment using Levels or Curves will dictate the exact shape of the contour.

Texture can also be added at this stage with a "texture" channel. The Noise filter randomizes the values of a certain proportion of pixels within an image, giving a speckled or grainy effect. A small amount of noise added to your alpha channel will produce a stippled surface when Lighting Effects is applied. More noise gives a rougher surface, while blurring the noise gives a beaten effect.

Some trial and error will be required to achieve good results with Lighting Effects, but the effort is usually rewarded. Having successfully completed a task, it is well worth saving the lighting setup and noting the amount of Blur, Noise, and other adjustments used.

Altering the pattern of light, dark, and blurring in the texture channel changes the profile of the virtual object rendered by Lighting Effects. An existing alpha channel can be adjusted using the Curves control. Here, different alpha channels created from a basic blurred disc create a simple rounded edge (left), a rounded edge with additional outer shading that avoids highlighted edges disappearing into the background (middle), and a simulated paint can lid (right).

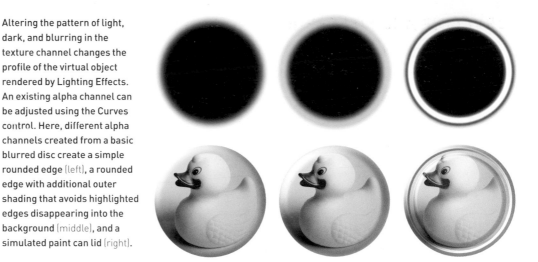

USING TEXTURE CHANNELS WITH LIGHTING EFFECTS

Photoshop's Lighting Effects filter can be used with a "texture" channel, also known as a bump map, to simulate different surfaces. Here a mottled bump map has been used to mimic the hammered metal of a traditional street sign.

Above: The text and outline are created in an alpha channel (see opposite page). The channel itself is loaded as a selection, and the smaller text is subtracted from this. The Noise filter is used to lightly speckle the text and outline, but not the background. A small Gaussian Blur is then applied to soften the noise to a mottled effect (inset). The smaller text is then treated with lesser amounts of noise and blur.

Above right: The alpha channel is then chosen as the texture channel for the Lighting Effects filter. This creates the illusion of a 3D object by offsetting light and dark pixels. The greater the contrast, the deeper the texture. Various sliders control the apparent depth of the object, as well as the color, direction, strength, and breadth of the light striking it. Several different lights can be used for more complex compositions.

Right: This generates the basic shading, with the smaller text appearing smoother and flatter than the street name and outline. Further work is needed to progress from an even, mid-gray image to the full-color sign. The alpha channel is used to separate the text and border from the background; the street name is darkened and the background lightened using Levels, then the smaller text is colored using Hue/Saturation.

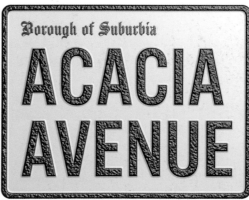

COLORING ARTWORK However much you may be used to your mouse or graphics tablet, there are times when only a pencil and real, old-fashioned paper are up to the job. Artists coming from a traditional illustration background will find drawing on paper more natural than trying to get smooth lines from a mouse. In cases like these, you'll need to scan your artwork and color it afterward.

Scanned line artwork will often appear with rather low contrast, with the lines a darkish gray against a pale gray background. This is particularly true of pencil sketches. Rather than attempting to get a better scan, it's easy to fix this in Photoshop: use the Brightness and Contrast controls, increasing them both until you end up with crisp black lines against a clean, white background.

There are two ways of selecting areas to be filled with color: Paint Bucket and the Magic Wand. Paint Bucket will "pour" color into any bordered area, and is the simplest method. However, because of the imperfect transition between the pure black of the outlines and the pure white of the interior, you'll usually find a faint white fringe remains inside all the black outlines. In addition, filling in this way will mean coloring directly onto the scanned outline layer. It's far better to keep the outline and color component as separate layers, to give you maximum flexibility later.

For these reasons, it's generally better to use the Magic Wand tool, which selects areas but doesn't fill them. Then simply expand the selection by a pixel or two (to make sure your color extends right into the outlines) and, switching to your "color" layer, fill with the color of your choice. Switch back to the "outline" layer to make further selections, and continue this process.

One problem with both the Paint Bucket and Magic Wand solutions is "leakage." Both tools will color or select areas that are wholly bounded by their outlines—that is, they select contiguous areas of the same color. But if your drawing style involves

Above: **Scanning line artwork, such as this simple pencil sketch, will often result in a washed-out image with a dirty gray background.**

Above right: **Increasing the brightness and contrast in Photoshop will help to salvage the image. You may need to paint out stray black dots as well.**

leaving gaps in these outlines, the selections will leak out through these gaps and fill or select the neighboring area as well—which may include the entire background.

The solution is to duplicate the outline layer once you've scanned it in, and use a small paintbrush to plug the gaps. This doesn't mean you need to change your drawing style: simply use this new layer for the purpose of making selections. After you've filled all the color areas, you can discard this new layer and return to the original. You'll find now, however, that because the selection areas were enlarged by that pixel or two, your outlines will be thinner than they were before. This is easily remedied: duplicate the original outline layer once more, and move the new layer to the top of the stack. As it stands, it will obscure all the coloring. But if you change its layer mode from Normal to Multiply, the white component (the background paper) will disappear entirely, enabling you to see the color elements underneath.

1. Here's our baseline artwork (right), typical of the sort of image that would be drawn on paper before being scanned in.

2. Because we're going to auto-select the areas, we need to plug any holds in the outlines. Here, we can see the gaps that would make selections hard to achieve.

3. Duplicate the original layer, and use the Brush tool to fill in the gaps in the outline. We can use this for making our selections, and revert to the original outline later.

4. Select areas to be filled with the Magic Wand tool, and enlarge the selection by a pixel or two. Then, on a new layer, fill with your chosen color.

5. The rest of the artwork can be colored in the same way. It can help to make multiple layers for each color element, to make it easier to adjust them later.

6. Now that the coloring is complete, hide the "patched" outline and bring the new one to the front. Set its mode to Multiply, and only the black lines will be visible.

7. You don't, of course, need to fill with flat colors. Here, we've used patterns and a scan of a piece of wood to make the artwork more interesting.

LAYER EFFECTS is a section of Photoshop designed to add beveling, glows, texture, and patterns to layers. Originally designed to speed up the creation of website elements such as banners, menus, and buttons, the capabilities of Layer Effects have been extended so that they can now be applied to general illustration as well.

Right: **This simple drawing uses two flat colors—brown for the thick outline, and a mid-orange for the fill. Using Layer Effects, we can turn this into a far more interesting illustration** (opposite).

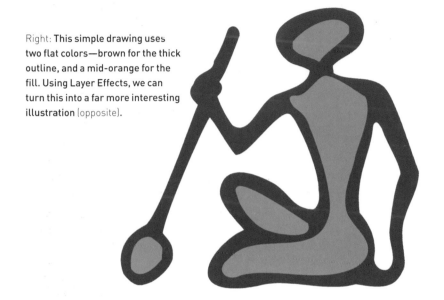

Above: **The Layer Effects dialog window, showing the Bevel and Emboss section; other functions are obtained by clicking on the list shown on the left-hand side.**

The range of possibilities is extensive. To take beveling as just one example, it's easy to add a bevel of any thickness, as an interior or exterior effect (in the latter case, the bevel is seen on the background behind the layer). Other alternatives include embossing and "pillow embossing," which adds a combination inner and outer bevel to make a layer look as if it was embossed out of the background. Varying the lighting position will make the bevel look as if it's lit from different directions, and choosing "up" or "down" as the overall direction will make the bevel look raised or incised. Changing the mode from Smooth to Chiseled will give a hard-edged appearance. Gloss contours can make the bevel look intricately carved; adding a pattern as a texture will give the appearance of surface texture. Unlike the Photoshop filters, Layer Effects don't change the pixels in a layer in any way; they are added on top of the layer, and affect the appearance without editing the layer itself. This means that if the layer is edited later—if new elements are painted on it, for example, or sections deleted— the existing Layer Effects will reshape themselves automatically to fit the new outline of the layer.

Best of all, nothing you do in Layer Effects is irrevocable. Any of the parameters can be removed, edited, or tweaked at any time; the effects are separate components, enabling the user to experiment endlessly with the huge range of possible options. Photoshop's Layers palette shows all the Layer Effects listed beneath the thumbnail icon for each layer, so it's possible to turn them on and off without having to reopen the dialog window.

Layer Effects can be simply dragged from one layer to another, to duplicate them on the new layer. All in all, they have the capability of making the dullest artwork look special. In the example on these pages, we'll begin with some flat artwork and add life and texture to them as we go along.

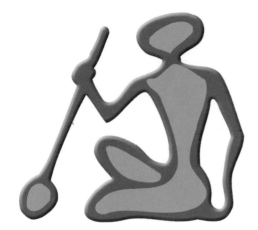

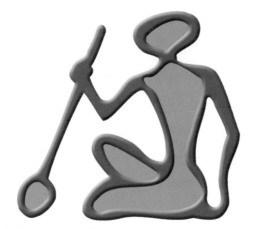

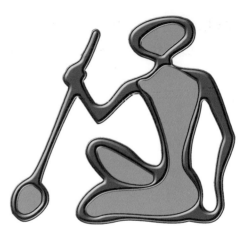

1. The Bevel effect adds a sense of thickness to the image. This thickness is fully user definable, as is the direction of the lighting.

2. When the orange fill is cut and made into a new layer, we can see how the Bevel effect on the brown layer is redrawn automatically to fit the new content of this layer.

3. It's possible to change the form of the bevel—in this case, by adding a contour to it, giving the effect of a more intricately carved surface. You can choose from any of the preset contours, or draw your own.

4. Here, we've added a texture to the bevel. These textures can be any pattern you've defined in Photoshop, and can be scaled as you wish; the apparent height of the carving is also definable.

5. Adding a drop shadow is the easiest way to make the object look 3D. The direction, size, distance, and spread of the shadow are all definable.

6. Because the orange interior is on a separate layer, we can apply a different range of Effects to it. To start, we've added a simple texture fill, which adds color but doesn't give a 3D effect.

7. An inner shadow added to the orange layer makes it look recessed, as if it's lying behind the outer layer. In fact, this layer is still positioned on top of the brown outer layer, as in the previous examples.

8. Layer Effects can be changed instantly. The brown layer gets a color overlay, the bevel becomes a gloss contour with chiseled edge, the orange layer loses its texture, and the inner shadow becomes an inner glow.

9. Layer Effects act on the layer as a whole, rather than just the pixels present when the effects are applied. So when the layer is redrawn, the effects apply to the new version automatically.

DIY POP ART Emulating the style of great artists is often easier on a computer than it is by any other means. While knocking out a quick Rembrandt or Caravaggio may be out of the reach of most illustrators, pop art lends itself well to digital techniques. Here, we look at how to create images in the style of Andy Warhol and Roy Lichtenstein.

To make this image, it's important to start with the right kind of photograph. You need to use one that's well contrasted, with strong shadows; a bland, front-lit photograph will prove much harder to work with. The technique we'll use here involves taking several copies of the image and applying different degrees of "thresholding" to them—a way of converting a scanned photograph to pure black and white—to make the different layers of shading in the image.

1. This is the original head for our "Warholesque" image. There are many sources of suitable images; this one is taken from a royalty-free photograph collection.

2. Begin by duplicating this layer (we'll need to use it later), and fill with a suitable flesh color. You can fill a selection with the foreground color in Photoshop by pressing Option+Delete (Alt+Delete).

3. Now duplicate the original layer again, and set its mode to Multiply. This causes the new layer to darken those beneath it: bright areas will not be affected, as we'll see later.

4. Use the Threshold dialog to turn the new layer into pure black and white. By moving the slider, we can control the cutoff point; here we're creating the deep shadows, so we want to see only the darkest regions. Note how the Multiply mode makes the white disappear.

5. Now duplicate the original layer again, then set its mode to Multiply and repeat the Threshold dialog, moving the slider so that more of the image is seen. When we colorize this layer, we make a second shadow layer that's not as dark as the first.

6. Paint the hair on a new layer. Set the mode of this layer to Color, and it will change the hue of the underlying layers without brightening them, so that the shading is still seen beneath.

7. The color for the pupils and the eyeshadow is applied in the same way. It's worth creating all these elements on separate layers, so that it's easier to edit them and change the colors later.

8. Using Color mode for the "lips" layer will produce a washed-out effect: we want the lips to be good and strong. Setting the layer mode to Multiply works much better in this instance.

9. While it would be possible to paint the white teeth and eyes on a new layer, it's easier to adjust them on the "base (fleshtone)" layer. Use the Dodge tool set to highlights to brighten up these areas. Finally, add a couple of dabs of red in the cheeks.

1. This is the starting point for our Lichtenstein-style image. It's a straight forward image of a plane, taken from a royalty-free clip art collection.

2. On a new Photoshop layer, paint in the shading on the plane. Set the new layer's mode to Multiply and you'll be able to see through it to the plane's detail below.

3. Now duplicate that layer, and use the Color Halftone filter to add the dots. The default screen angles in the resulting dialog will match those of halftone printing; set them all to 45° for this graphic effect.

4. Fill the background with blue, then make a new gray-filled layer and repeat the previous filter. The clouds are simply painted in white on a new layer.

5. To make the flame, first draw a path with the Pen tool. Hit Enter to make it into a selection, and fill with a fire color.

6. Now draw another, slightly smaller path inside the original flame. When you hit Enter, only the border will be selected. Fill this with black.

7. Add more layers of flame in exactly the same way, following the previous two steps.

8. Add the caption text, and draw a bubble behind it following the technique used for drawing the flames.

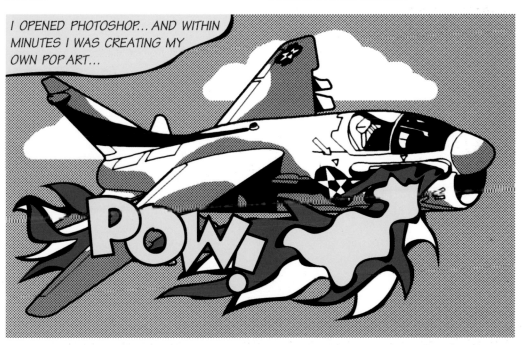

9. The large lettering needs to be "rasterized" (converted to a standard layer) so that the letters can be rearranged to overlap each other.

Comic-book paintings are easy to create, provided you have a suitable starting image. The key to making good pictures lies in choosing the right font for the lettering. Here, we've used Tekton for the caption, and Comics Cartoon for the large text. Tekton is now supplied with most computer operating systems, and is a useful stylized handwriting font; Comics Cartoon, or variations on it, is available as part of shareware collections.

MULTILAYER ILLUSTRATION In the late 1990s, a new genre of digital illustration emerged. Although associated with fast-rising agencies such as Attik, it seemed to spring from all quarters at once, including a generation of graphics students graduating from the new technology-oriented programs. Rich in detail, depth, and texture, stacking image upon image, and eschewing direct references to its subject matter, this fresh abstract style—known to some as "line action" for its typical embellishment with repeated rules, grids, and circles—was a controversial but exciting development only made possible by using digital methods.

In fact, what made it possible was the introduction of layers into Photoshop. Once users could keep elements separate from each other yet seamlessly combined, trial and error in compositing became immeasurably more productive and, potentially, creative. Along with rising computer power and new sources of raw material—including the Internet, royalty-free photo libraries, affordable scanners, and user-friendly 3D software—the arrival of layers rapidly triggered an explosion of experimentation.

Of course, not all experiments have desirable outcomes. When setting out to create this type of illustration, a good eye and sense of conceptual design are perhaps of even greater importance than with conventional artwork, since there are fewer barriers between the artist and a meaningless jumble. As with collage or photomontage, the starting point is usually not a blank canvas but a collection of raw material, probably centering on an image or form that has triggered the creative process in an illustrator who is searching for a concept.

The relationship between the artwork and the concept may be rather vague, however, and it is no coincidence that abstract digital pieces are often produced on spec and then sold to clients later, either as is or modified to fit a particular project. The illustration constructed on the opposite page, for example, is taken from a collection commissioned and marketed by a picture library—art directors buy the image as a

Photoshop PSD file with layers intact, and can edit or subtract elements, or combine layers from different files, to customize the artwork to their specifications.

Lacking the overt metaphors and visual puns characteristic of mainstream illustration, such images have to find new ways of engaging the viewer's interest. Striking visual forms, whether explosive patterns of light or evocative geometric or organic constructions, are often used to grab attention. These provide the foreground, often arranged in deliberate opposition to traditional ideas of composition, with large areas left blank. Behind, dense layers of additional material expand to the edges of the canvas and recede seemingly into infinity.

Here, some old-fashioned artists' tricks come into play: the illusion of depth is created by dimming, lightening, desaturating, or blurring elements, and the impression of movement by repeating objects at different scales, colors, and opacities. Frenzied "line action" can work in a way similar to the cartoonist's "whizz" lines, or in calmer examples may give a feeling of drifting motion, an effect more literally realized in related genres of animated web design.

Image from gform 1.26 by Bradley Grosh and Anders Schroeder, in the Infinity collection from Digital Vision
www.digitalvisiononline.co.uk

Right: Abstract illustrations make increasingly common use of 3D elements. Here, several have been combined to suggest both organic and technological forms. Objects such as these can be modeled in a 3D package and rendered out as bitmap files, or created within Photoshop using pseudo-3D tools such as beveling plug ins. A characteristic feature is that the shapes are wildly distorted, giving an impression of exaggerated perspective that draws the eye into the image.

Above: The main 2D elements are simple colored shapes, which can be drawn in Photoshop or imported from a drawing package. Blending modes such as Color Burn and Luminosity are used where shapes are required to show through each other. Although the 2D work is seen here in bitmap layers, it is also possible to use vector layers, enabling free scaling without loss of quality. Vector shapes can be rendered to pixels in the event that bitmap filters need to be applied.

Left: The number and diversity of layers in the palette may make this image look dauntingly complex, but they make it much simpler to work with. Since each layer can be turned on and off at will, and its content edited independently, changes to one element or aspect of the artwork can be made without affecting others, and without having to repeat tricky masking operations.

A sound understanding of the various layer types and modes is essential, and best developed through experience. Blending modes, such as Burn, Light, and Overlay, are particularly useful for building up dense imagery, as they preserve the contributions of underlying layers. Hard-edged foreground elements can be cut out using transparency or layer masks. Adjustment layers can change the color or brightness of certain elements—bound into clipping groups to limit their effect—or of the entire artwork, while leaving the imagery itself intact and all options open for later changes.

But there are still some limits imposed by the technology on all this unfettered creativity. While file sizes of single images are determined by their resolution, the amount of data in a layered document is unlimited. Photoshop's intelligent memory management ensures you will not be prevented from working with an image, but even on systems with a fast processor and a gigabyte of RAM, a heavily layered A4-plus file can slow performance. It is often useful to save a full copy of your artwork in its current state, then merge together any layers you are unlikely to want to change, leaving a less cumbersome document on which to continue working.

Top: This is how the initial composition looks. The 3D layers are higher up the stacking order. Normal mode is used to overwrite underlying pixels, but layer masks restrict each layer to the shape it contains, letting surrounding areas show through (layer masks are shown to the right of each layer's content in the Layers palette). The background layer is filled with a gradient traveling from light blue at the bottom to white at the top. This is modified by an adjustment layer (01) carrying a Levels function, which in turn is restricted by a layer mask containing a diagonal gradient. By graduating the adjustment at an angle to the fill, a subtler color wash is created.

Middle: Layer 29 is an adjustment layer set to Invert. Adjustment layers affect all underlying layers, so it turns the whole artwork to different extents into a negative image, changing its feel from bright to threatening. One of the benefits of adjustment layers is that you can experiment with dramatic changes such as this without committing to them. For now, the immediate problem is that key elements have become pink instead of blue. This will be corrected using Hue/Saturation with Colorize in an extra adjustment layer (33). Applying the same hue across the whole artwork helps make visual sense of the frenzied composition.

Below: Text is added (in this case, purely for decorative purposes) in a number of additional layers, using Normal mode with varying opacity. Type layers in Photoshop have the same choice of blending modes and opacity levels as ordinary layers, while text remains fully editable and re-sizeable. The artwork is completed by adding a half dozen extra layers containing subtle shading, blurred duplicates of some key elements, and a graph paper background; these are each added in layers arranged appropriately in the stacking order.

THIRD-PARTY PLUG INS
Although Photoshop includes a wide range of everyday and special-effect filters, third-party developers have produced dozens of additional effect modules, known as plug ins. These are generally available by direct download from the developer's web site, and appear in Photoshop's Filters menu after installation.

Third-party filters come from two main sources: software companies, which generally bundle a range of filters together and sell them as a set, and individual programmers, who tend to sell individual filters capable of performing a single task. The latter are usually sold as "shareware"—which means that you can try them out for a limited period or with limited features before buying the full version. Shareware filters are generally less expensive than commercial sets.

The effects produced by these filters vary considerably from set to set. Some add 3D beveling to flat artwork: filters in the EyeCandy 4000 and DreamSuite sets, as well as SuperBladePro, can make any artwork look like it's been cast in metal. Others can simulate molasses, concrete, water, or smoke. Some disregard the original image altogether: Flaming Pear Software, for example, produces filters that can simulate planets, suns, and star fields, which can be ideal for generating backgrounds for illustrations. Some filters are unique in their scope: 3Dluxe from Andromeda Software, for instance, is capable of wrapping images around primitive 3D shapes (such as a sphere, box, or cylinder), which can then be rotated, lit, and viewed from any angle.

Many sets of filters are now available for Photoshop, and will also work with most other leading paint applications, whether running on Mac or PC platforms. Shown here are examples of the best of them. At the time of writing, none of the filters shown had yet been rewritten to be compatible with Mac OS X. However, it's likely that most of them will be available by the time that you read this.

Since we have space to show only a single effect from each of the filter suites mentioned, it's worth visiting each developer's website, where you'll find examples of all the other filters in action. It's often the case that you'll buy a set of filters for a single effect, and then find others in the set that create interesting and often unique results.

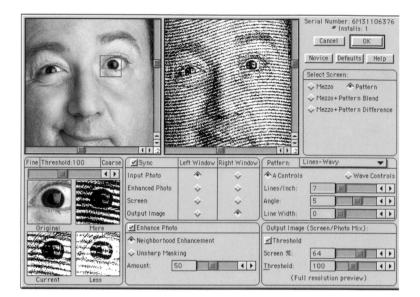

Above: **Alien Skin Splat** is a set of filters including effects that enable arrays of images to be wrapped around borders and within selected areas. Shown here is the Resurface filter, which adds a huge variety of custom textures to flat artwork (www.alienskin.com).

Top: **Andromeda Screens** is a one-shot filter for creating woodcut and mezzotint effects from photographs. By selecting areas of the image and varying the screen angles, it's possible to simulate a convincing engraving (www.andromeda.com).

DreamSuite: Three sets of filters make up the DreamSuite collection, which includes simulations of movie strips and jigsaw puzzles as well as metal and beveling effects—shown here is the Gel filter. The effects are impressive, but the interface is awkward and the rendering is slow. (www.alienskin.com)

EyeCandy4000: EyeCandy is a suite of filters that simulate real-world effects such as water and smoke. Here, the Fire effect is added on top of the Chrome effect. All the filters are fully customizable so you can achieve exactly the result you need. EyeCandy filters are quick and easy to use. (www.alienskin.com)

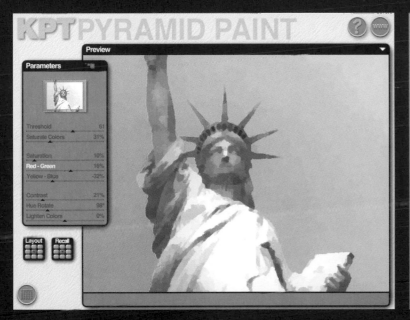

KPT Effects: The Kai's Power Tools Effects filters provide an array of effects, from abstraction to dazzling and coloring. Shown here is Pyramid Paint, which posterizes and blurs your image. The Pixel filters are useful, but the interface is often difficult to decipher. (www.corel.com)

SuperBladePro: one of the many filters from Flaming Pear Software. SuperBladePro adds beveling and depth to flat artwork and has a huge number of controls for adding lighting, corrosion, and other surface properties. (www.flamingpear.com)

02.03

PAINTING SHOWCASE

Right: The central figure in Derek Lea's immaculate montage was combined in Photoshop from three photographs of the original model; the figure in the upper right corner was created in Poser (see page 108). What really makes this image standout is the restrained use of color; it's painted almost entirely in a palette of browns, but the blue elements (all reflections of the sky) add highlight and interest.
Derek Lea
www.dereklea.com

Left and below: Montages such as this were traditionally compiled using Victorian woodcuts and engravings—the clip art of their day. But illustrator Jovan Djordjevic brings a new twist to his montages, which the Victorians could never have envisaged. The fish image, commissioned by Britain's *Financial Times*, started with scans of original engravings. The cannabis cigarette box, commissioned for an article in Britain's *Independent on Sunday* newspaper, was put together from digital photos, but Djordjevic has instilled a sense of the old-fashioned by using Photoshop's filters.
Jovan Djordjevic
www.jovandjordjevic.com

Left: **Laurence Whiteley** once worked in airbrush and gouache, but now uses Photoshop's Noise and Mezzotint filters to recreate the stippling effect seen in 1930s posters, as shown in this illustration for Personnel Publications. The airbrush tool in Photoshop is too clean compared with the real tool, so Whiteley overlays multiple textures to prevent the finished work from looking too digital.
Laurence Whitely
www.nbillustration.co.uk

Below: **Warren Manser** works mainly as a digital artist for movie companies. Here, though, he's used Painter to explore the Art Nouveau style. This image features organic motifs found in the art of the period, but some elements belong to the digital age, such as the glass ball effect on the clouds. A restrained color palette unifies the whole illustration.
Warren Manser
www.warrenmanser.com

Left: **Ruth Thomlevold also works in traditional media, but finds that Photoshop lets her try out different layouts and colors without having to stick to her first choice. Although the work looks hand-drawn, elements such as the curves of the car headlights are clearly digital in origin. Her skill is the ability to mix the two styles while maintaining uniformity of technique.**
Ruth Thomlevold
www.nbillustration.co.uk

Below: **Although it may look as if it was created in a vector application, Ben Kirchner's portraits are drawn in Photoshop. The ability to alter the opacity of layers makes Photoshop the right choice, although enhanced versions of vector programs mean Ben is now looking into using these.**
Ben Kirchner
www.heartagency.com

Left: **Louise Hilton takes photos with a digital camera, and uses the vector-tracing program Adobe Streamline to simplify the image. This is opened in Photoshop, where painting tools are used. The results, photographic in origin, have a textural quality that shows the artist's input.**
Louise Hilton
www.nbillustration.co.uk

Top: Caruso takes digital camera images, and draws over them in Photoshop. After overlaying paint strokes in Painter she returns to Photoshop to finalize the image.
Marina Caruso
www.marinacaruso.com

Above right: Daniel Mackie's work combines 3D modeling with the rawness of overlaid ink spattering the figure. This piece was created in Photoshop.
Daniel Mackie
www.danielmackie.co.uk

Above: Noel Ford's cartoon style is drawn in Painter using a pressure-sensitive tablet. Ford first roughs out the artwork on a separate layer, then inks in the black lines on the main canvas before deleting the rough.
Noel Ford
www.noelford.co.uk

Right: Painter is Simon Bosch's program of choice, although he uses the older version 5.5, having found the newer features of the program "stuffed up the layer mask method of beveling."
Simon Bosch
www.digital-illustration.com.au

SHOWCASE

Below left: **This illustration was created for a feature about guns concealed in mobile phones. An image of a phone was cut up and adjusted in Photoshop to turn it into the gun; all the extra elements were drawn directly in Photoshop using standard painting tools.**
Steve Caplin
www.stevecaplin.com

Below right: **Dan Davis' remarkable image of a chair is on the one hand photorealistic, yet at the same time shows a level of clarity and detail that could never be achieved with a camera. He uses Photoshop's Noise filter to prevent the final image from looking too clean—a complaint many artists have about digital illustration, but one that can successfully be corrected.**
Dan Davis, Vector Arts
vectorarts@usxchange.net

Left: **The anatomical accuracy of this illustration goes without saying. It's the overlaid textures that give this image its sense of realism; and the casual human pose adds to the sense of fun. A hand-drawn original was scanned, traced using vector tools, and then textured; a real-life specimen was set up in the studio for reference.**
Richard Tibbitts, AntBits
www.antbits.co.uk

Left: **Using a photo for reference, Dan Davis drew this tractor in Adobe Illustrator, then imported it into Photoshop. The painted effect was created by making selections from the line layer and adding color using Photoshop's Airbrush tool with various Layer–Blending modes. Painter was also used for some effects. By merging drawing and painting, a technical illustration becomes a lively work of art.**
Dan Davis, Vector Arts
vectorarts@usxchange.net

Below: **Francesco Franceschi's eye was drawn entirely in Painter, and combines the photorealism of the pupil with the more graphic quality of the lids and lashes. This shows Painter used as if the artist was working with traditional materials.**
Francesco Franceschi
ffranceschi@libero.it

Left: **Richard Osley's butterflies were created in Photoshop. He previously worked traditionally, and found Photoshop most closely echoed the tools he was used to. "No computer artist should overlook good basic drawing principles, such as perspective and the study of light and shade. The client is more interested in the end result than the means of achieving it."**
Richard Osley
www.nbillustration.co.uk

SHOWCASE

Below: **Derek Lea's** richly textured illustration, entitled Net Stalkers, shows in an innovative and compelling manner the forces that might prey on the unsuspecting web surfer. The raven's wings are from a blue jay, color adjusted; "I also scanned dripping India ink on white paper and used it as the basis for an alpha channel to create the dripping area underneath the wing."
Derek Lea
www.dereklea.com

part 02. digital painting

Left and below left: **Max Ellis'** stunning figure looks as if it was painstakingly modeled in a 3D application—but this image began life as a pencil sketch. Ellis uses the most unlikely objects in his montages: this woman was built entirely from digitally photographed sections of the rusty old sewing machine shown here. The irises of the eyes, seen through the keyholes, are made from a radially blurred image of a rocket engine.

Max Ellis

www.junkyard.co.uk

Above: **One problem with cutout images is knowing how to end elements that want to bleed off the bottom or sides. The problem is sidestepped here by placing a table beneath the iMac, which also serves as a cutoff for the PC stack; the reflections in the table bring interest to it, and prevent it from looking like flat plastic.**

Steve Caplin

www.stevecaplin.com

DIGITAL DRAWING

03.01

Drawing with a vector-based application requires a different approach to the bitmap-based packages we have discussed earlier. Vector drawings are built from simple elements, combined into objects, that together form finished drawings. We build the simplest element—the path—from Bézier curves. By applying strokes and fills we give that path shape, color, and form, producing an object from the outline. Through arranging, stacking, and layering objects it is possible to produce a drawn image, but with one crucial difference. Each object can be edited, transformed, and resized independently, giving us plentiful scope to experiment and rework.

This way of drawing takes time and practice before it can be mastered. Working with Bézier curves might prove tricky to those more used to the traditional ways of pen and ink. The approach can feel far less intuitive, and even clinical. However, you will soon discover quick ways of producing complex shapes, while more advanced strokes and fills bring a number of great creative possibilities within your reach. Gradient fills, transparency effects and blend modes can make your illustrations even more eye-catching, and every shading effect you can produce on paper has its equivalent in the digital realm. The same cannot be said the other way round.

That is not all. As objects can also be copied and used again and again, the vector approach can also be a major time saver. Why draw every window in a building when you can simply copy, transform, and rescale just a few?

DRAWING PRINCIPLES

Even the most basic vector drawing is based on a number of paths, themselves comprised of multiple Bézier curves. Producing such an object is a complex business, but once created this hand can be transformed or resized at will.

BÉZIER CURVES use complex mathematical models to help digital illustrators more easily draw curves, corners, circles, and arches. Practice is required, but they are not as daunting as they might first appear. All Vector drawing software is based on Bézier curves, which are each defined by four points: the start and end points, or nodes, and two control points, or handles. Behind the scenes, various different mathematical models are used to construct the curves, but the general principle is that curves tend toward their handles while never passing through them.

Continuous curves, or paths, are composed of multiple Bézier segments, each moving on from the last one's end point. Two control handles are arranged on a parallel line through this point, forming a tangent to the curve. This is referred to as a curve point, and the curve passes smoothly through it. If necessary, you can move one of the handles further away than the other, making an asymmetrical curve. Or you can adjust the handles independently, making the curve turn sharply, in which case the point becomes a corner point.

Using your software's pen tool, draw paths by clicking with the mouse wherever you want the next point. Clicking and letting go places a point with no handles; repeating this action forms a series of straight lines. To draw curves, you click to place a point, then drag away from it while still holding down the mouse button. This forms a curve by pulling out a handle, for the first point on the path, or two symmetrical handles, for all other points. If you click at the end of a curve without dragging, a point with no handles appears, and the next line or curve can continue at a sharp angle. So the basic rules are: click + click = straight line; drag + drag = smooth curve; drag + click = broken curve.

When you've finished your path, you can either click on the first point again to complete an enclosed shape, known as a closed path, or switch tools and click away from the path to leave it as an open line.

As the examples below demonstrate (seen here in Adobe Illustrator), this is all quite straightforward in practice. If Bézier curves seem a little mysterious at first, that's hardly surprising, they are quite mysterious mathematical beasts. There are no exact methods, for example, of drawing a circle using Bézier curves, or drawing concentric curves. But software developers have found sufficiently accurate approximations, and the way vector drawing tools work on screen is both comprehensible and efficient after a small amount of trial and error.

To provide a framework for accurate drawing, vector applications offer guides and grids. Grids are the digital version of graph paper, displayed either behind or in front of your artwork. You can set the grid units, such as every half inch (1 cm) or every 5 cm (2 inches), and the number of subdivisions within this. Guides are horizontal or vertical lines that can be placed anywhere across the page to help align objects; some programs will let you convert any path into a guide to make things easier.

Snapping options can make points snap to the grid, guides, or each other. As you move the mouse—whether getting ready to make a new point or dragging an existing point or object—the pointer will jump onto any snapping object it passes near. This makes it easier to ensure that shapes are precisely overlaid or butted up to each other. Some drawing programs go a step further, offering smart guides that pop up to let you know when lines are parallel with others or at a specified angle.

BÉZIER CURVES 1. CURVES AND CORNERS

In this example we'll draw a pair of arches, showing how to form simple curves and corners using the Bézier pen.

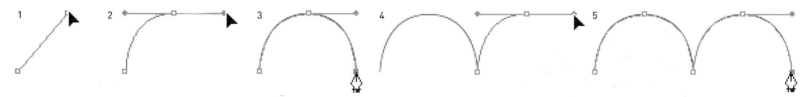

1. Having clicked once to make the first point, click where you want the second point, and keep the mouse button held down.

2. Drag the pointer to pull out a curve handle; the other handle follows it symmetrically on the opposite side of the point.

3. Let go, then click where you want the third point, forming a two-part curve, and let go immediately, to make a corner.

4. Click where you want the fourth point, and keep the mouse button held while you drag out a curve, as before.

5. Click and let go of the final point to complete the arches. In this example, we kept the handles aligned horizontally by holding down the Shift key.

BÉZIER CURVES 2. SHAPES AND SWITCHBACKS

Continuing a curve through the line formed by a pair of handles makes an S-shape. Doubling back from a corner makes a pointed shape.

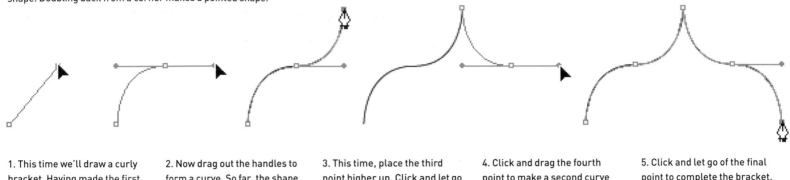

1. This time we'll draw a curly bracket. Having made the first point, click the second, and hold the mouse button.

2. Now drag out the handles to form a curve. So far, the shape is the same as in step 2 of the previous example.

3. This time, place the third point higher up. Click and let go to make a corner. The curve forms an S-shape.

4. Click and drag the fourth point to make a second curve symmetrical with the first.

5. Click and let go of the final point to complete the bracket. Using basic principles, we have made a more complex shape.

BÉZIER CURVES 3. BULGES AND FORCED CORNERS

This cloud shape relies on the basic Bézier principles: click for a corner, drag for a curve. But some extra tricks are required.

1. Having clicked to make the first point, click where you want the second and let go, forming a corner.

2. Click the third point and drag to make a bulge without an extra point (a parabola). Continuing the curve upward would make an S-shape...

3. ... but we want to double back. So, still holding the mouse button, press the Option key to move only one handle, and drag it back to the point.

4. This lets you make a corner. Click where you want the fourth point, and drag to make an ordinary curve.

5. After clicking to make the fifth point a corner, click back on the first point to complete the closed path and drag out a bulge.

BÉZIER CURVES 4. EDITING BÉZIER PATHS

Every point and handle doesn't have to be right first time. Various ways of editing paths are common to most drawing programs.

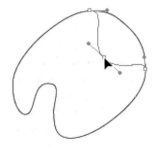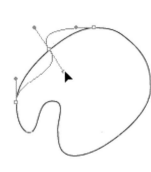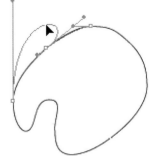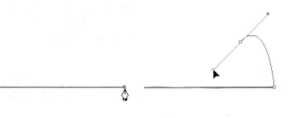

1. Points can be moved using a Selection tool. Holding the Shift key lets you select several points, which can then be moved all at once.

2. Using the same tool, you can move handles. One handle of a pair can be moved to a different distance, although always remaining parallel.

3. Clicking a point with a Convert tool retracts its handles, making it a corner. The same tool can drag handles in non-parallel directions.

4. Dragging from a point with the Convert tool replaces its handles with a new pair, in a symmetrical and parallel relationship.

5. In some programs, you can drag the curves themselves to reshape them; surrounding points' handles are automatically adjusted.

STROKE AND FILL Every vector path has a "stroke" and "fill," and changing these properties can transform simple lines into vibrant artwork. The stroke governs the appearance of the path itself; it may be invisible (no stroke), or may appear as a line of given thickness and color. When a path is closed, the space it encloses can also be filled with a chosen color or pattern.

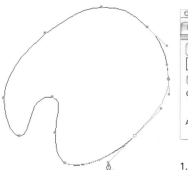

1. It is easiest to draw shapes with a fine stroke, such as 0.25 pt. Here, we are using Macromedia FreeHand.

2. Any desired thickness and color can be applied to strokes in the finished artwork.

3. Most programs offer a variety of dotted and dashed strokes, often customizable by the user.

4. Brush tools can be used to apply complex strokes or arrange small objects along a path.

STROKES

Basic strokes consist of a single line. The thickness of each—also known as the line weight—is usually measured in points, as with typeface size, although you can specify it in other units such as millimeters if you prefer. Colors can be selected from predefined libraries supplied with your software, picked from a color wheel, or specified using sliders based on CMYK, RGB, or other color models (see pages 172–173). You can also store colors as swatches for future use.

Various dotted or dashed strokes can be selected, and special line ends can be applied in shapes such as arrowheads. More complex strokes can be applied using brushes; this is explored in further detail on pages 82–83.

1. The Expand Stroke (or Outline Stroke) command lets you turn a path into an object in its own right.

2. A stroke can then be applied to the new object, creating a double outline. You can also add a fill.

3. Note that the central area is no longer contained within a path. Copy your shape first if you want to fill the middle.

4. Also useful is Inset Path, which makes concentric copies. Here, we have applied a different stroke color to each.

Below: **This complex illustration has been meticulously constructed using a wide range of fills and strokes, including plain and dashed strokes, simple fills, gradients, and complex fills created by blending between objects. The result is almost photorealistic, but with a precision and consistency that could only be achieved in vector drawing.**
Picture: Trevor Johnston for Macromedia

FILLS

Basic fills can be applied by choosing a color. Gradient fills blend smoothly from one color to another within an object, creating subtler shading. A linear gradient sweeps from side to side at a given angle, while a radial gradient progresses from one color at a center point to another at the edge. Almost all vector programs now support multipoint gradients, which can pass through any number of points between beginning and end; colors are added as points on a bar representing the whole gradient. Some packages offer additional types of gradients. Shapes can also be filled with patterns, which you can define yourself by creating smaller objects that are automatically tiled to fill the required space. Finally, any vector artwork, or an imported bitmap image, can be placed within a shape to fill it. This is known as a "clipping" mask.

However, almost all types of fill have the same limitation in common: although they are clipped by the edges of any objects that they are applied to, they do not distort to match its shape. A radial fill, for example, always progresses in concentric circles, whether or not the object it is filling is circular. One exception is Macromedia FreeHand's Contour fill, which radiates inward from a path, giving a soft beveled effect. Sadly, it is only satisfactory on simple, rounded shapes. Realistic shading can be created manually using the Blend command, which constructs intermediate stages between two or more shapes (see page 78).

FILLS

1. A basic fill consists of a single color. This covers the shape without overlapping the stroke.

3. For a richer effect, we have built up a custom gradient by adding colors to the gradient bar.

2. Here, we have applied a simple two-color linear gradient. Its angle is set by the dial on the right.

4. Here, we have turned a gradient-filled circle into a tile, which is automatically repeated to fill the shape.

ADVANCED FILLS

1. To make a hole in a shape, draw one path within another, and make them into a compound path (use the Join command in FreeHand).

3. To spread a single gradient across several objects, combine them using the Union command before applying the fill.

2. Here, we have applied the same radial gradient to several objects, then changed the colors contained in each.

4. Any shape can also clip a bitmap. In FreeHand, place the bitmap over the shape and cut it, then click the shape and Paste Inside.

STACKING AND LAYERS Although the concept of layered elements came late to bitmap software, it is fundamental to vector drawing. Every object you draw has a place in the stacking order—when shapes overlap, it is the stacking order that dictates which appear in front of the others. By default, each new object you draw is placed at the top of the stack, and appears in front of others.

You will often need to rearrange objects as you work, and this is made possible by the commands Send to Back, Send to Front, Send Backward, and Send Forward. The latter two options swap an object with the previous or next in the stacking order, and can be repeated as many times as necessary to get the order exactly right.

As an object moves down the stacking order, it can disappear completely behind others. If you know it is there, you may be able to select it using a special key command—in Macromedia FreeHand, for example, clicking while holding the Control key accesses the next object under the one currently selected. Alternatively, you can hide other objects temporarily to reveal the one you want, and then show it again after selecting and bringing it to the front.

If you arrange a number of objects so that they are grouped together and are moved and scaled as one, the group occupies a single place in the stacking order. The objects within the group maintain their stacking relationship with each other, but cannot be brought individually in front of or behind objects outside the group.

In a complex illustration, the number of objects and groups can be very large, and it can become very difficult to manage their stacking order. To organize things more efficiently, you can use "layers". As in bitmap programs, these work like transparent sheets on which you place elements, while those underneath show through in empty areas. Layers themselves can then be arranged in a stacking order, and moved forward or backward by clicking and dragging their names within a list. In some programs, objects and groups are also shown, giving a complete breakdown of the stacking order of the artwork, and letting objects be selected without having to find them and click on them directly.

An increasing number of vector applications let objects be "transparent". In this case, underlying objects show through to a specified extent. Stacking principles are preserved, however, and underlying objects or layers never modify those above them. Since output devices, including equipment used by commercial printers, may not support transparency functions, artwork can be exported with transparent elements by either being converted to intersected vector objects or to high-resolution bitmaps.

OTHER VECTOR APPLICATIONS

Top: **Macromedia FreeHand** supports transparency, but not "Blending" modes. You can combine objects using the Transparency command, which creates a new object representing the intersection of two others filled with an intermediate color. Or you can apply a Lens fill in Transparency mode, and then adjust its opacity. Strokes are always applied at 100% opacity. Objects stack within layers, but only layers can be viewed in a listing.

Above: **Deneba Canvas was among** the first vector programs to support transparency. You can choose to exempt an object's stroke from its "Blending" mode. Transparency can also be governed by gradient masks, which are easily created and edited within the Transparency palette. Like Illustrator, Canvas' transparency functions work with imported bitmaps as well as vector objects. It also enables a greater range of bitmap filters to be applied seamlessly to vector objects.

STACKING ORDER Some vector programs show a nested list of layers, groups, and objects, which clarifies the stacking order. Here, you can see how a series of objects is stacked in Adobe Illustrator.

1. A hand is drawn, and appears as the first object in the stacking order. We have given it a name, Hand, to make it easier to keep track of later.

2. Three stars are drawn and named. Since they'll want to remain together, we have grouped them; and this is shown in the list.

3. A banknote shape is drawn and named. Being the most recent object, it appears on top, covering the other elements.

4. The banknote is sent to the back. This places it lowest in the stacking order, behind the other objects and at the bottom of the list.

5. A shape is drawn on a new layer. Although it is at the top within this layer, it underlies the other elements, as its layer is lower than theirs.

TRANSPARENCY In Adobe Illustrator, the transparency of each object can be defined using the Transparency palette. Blending modes similar to Photoshop's (see page 40-41) are supported.

1. The Blending mode of the hand is changed from Normal to Multiply. Its color now combines with that of underlying objects.

2. The Blending mode of the banknote is changed from Normal to Color Burn. Only the background shape is affected; the others are on top.

3. The banknote is brought to the front. The colors of the hand and stars are now modified where the banknote intersects them.

4. If a white stroke is added to the banknote, it is governed by the Color Burn. Since white is neutral in this mode, the stroke isn't seen.

5. Instead, to make a visible outline, a copy of the banknote is pasted on top. This is given a white stroke, no fill, and then Blending mode is set at Normal.

EXPLODED DRAWING Vector illustrations commonly employ a variety of techniques. The illustration here uses several different ways of adding shading effects, as the pulled-out graphics demonstrate. The cone of the blue building is shaded by drawing a dark outline (the body of the cone) and a brighter highlight (the light streak running down the left-hand side). Blending these two elements together creates a smooth graduation between the dark and light.

The roof of the brown building in the center of the image has been created by filling flat elements with a graduated color. Although easier to handle than blends, gradient fills can only be either linear or circular, and so need to be used with care. Although the same gradient was applied to every element in this roof, the directions of the gradients were altered each time in order to give an impression of roundness.

The superhero figure was initially created filled with flat colors. Illustrator's Gradient Mesh feature (see page 92) lets spots of other colors be placed by simply choosing the color and clicking at an appropriate point; the two colors are blended together automatically, producing a pleasing airbrush effect.

Because this image uses isometric projection rather than true perspective (see page 86), drawing the buildings themselves was a simple matter. In each case, a single window was drawn, matching the perspective of the building. The window was then duplicated horizontally as many times as required, and the group of windows was duplicated vertically until they filled the face of the building. One building was duplicated and re-colored to make several others; windows were re-colored at random to give the impression of lights behind them. The windows on the circular building are a special case (see the opporiste page to find out how this was done).

This illustration gives an idea of the processes involved in building a complex piece of artwork. The tear-away beneath the main, shaded illustration shows the individual paths alone, without any fill. Beneath that, the tear-away shows the type of scanned rough drawing frequently used as a template. The digital illustration can be drawn on top of this.

Right: The dome of this building comprises just five separate elements. When overlaid on top of each other and filled with a simple gradient, they create a convincing illusion of 3D.

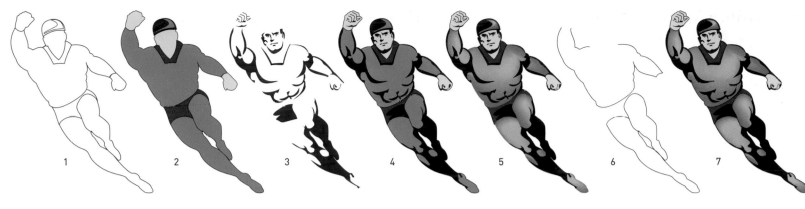

1. The basic outline of the superhero figure is drawn over a scanned template.
2. Each element of the outline is filled with solid colors as appropriate.

3. Black, stylized shadows are drawn straight onto the figure. Here they have been separated to show them in isolation.
4. The color figure, together with its shadows.

5. A paler version of the main costume color is placed as a Gradient Mesh into the solid color, creating a soft blend effect.
6. Because Illustrator objects do not support both the Gradient Mesh

feature and stroke on a single object, a new unfilled stroke has to be prepared to provide an outline for the figure.
7. The completed figure, with Gradient Mesh and stroke.

1. The dome of the tower is made of three elements: the front and side of the dome itself, and the spike on top.

2. Smaller versions of the spike and front are filled with a paler color and positioned to create a blend focus.

Ten steps are created between the beginning and end of the main blend; here they are spread out so we can see each one. The spike

uses just three intermediate steps. The completed dome, with all the blend stages in their correct position.

1. The elements of the tower are drawn as individual objects. A single blue ring is drawn and then scaled toward the apex of the tower; this operation was duplicated to make the rest of the rings.
2. A dark triangle forms the basis of the cone, while a smaller, lighter colored triangle is used for the

highlight. The two are then blended together to create the final shading effect seen here.
3. The vapor trail from the rocket is drawn and filled with a solid color, then placed on top of the tower. The opacity of this vapor trail is reduced to 80% to let the tower underneath show through.

1. The basic outline is created by drawing an arc, duplicating it, then joining the endpoints and filling with a gradient.
2. A shorter version of the resulting shape is filled with solid yellow for the window band.
3. Vertical bars are drawn on top of

this single window to mark the dividing sections of the windows.
4. Illustrator's Pathfinder palette allows us to subtract the vertical bars from the band, turning it into a ring of individual windows.
5. By repeating steps 2–4, more windows can be created with ease.

So far we have covered the most fundamental aspects of vector drawing, and the results are impressive already. But we have only just scratched the surface. The two main applications on the market—Adobe Illustrator and Macromedia Freehand—now come with a range of features that give you additional artistic scope. You can give an outline a rough-sketched look with one click, then an artistic watercolor style with another. Calligraphic, Pattern, and Scatter brushes enable you to turn basic paths into something quite spectacular, and as these brushes adhere to the vector path beneath, changing the length, angle, or style of a stroke can be done with ease. You can also use the Gradient Mesh tool to simulate realistic 3D shading, or use a "mesh" to distort simple objects into strange and wonderful new shapes. It is even possible to convert a bitmap image, such as a photograph, into the paths, strokes, and fills of a vector graphic, creating almost instant drawings.

The strengths of the object-centered approach also make vector-based applications a natural choice for those tasks that can make up the bulk of a working illustrator's job. Isometric and technical drawings are straightforward, maps can be made with a minimum of worry, while the ability to copy and re-purpose objects can save huge amounts of time. An architect or engineer would use more specialized software to design an office building or complex mechanism, but vector-based packages use similar techniques and can give your image the same clean, scientific look. See the Showcase (page 94) at the end of this section for some great examples.

PART 03. DIGITAL DRAWING

CHAPTER TWO

DRAWING TECHNIQUES

Illustrator's Art Brushes are drawings of typical brushstrokes that can be wrapped around the stroke lines of artwork. They have the ability to make the simplest line drawings look like complex creations, and have the added advantage that the underlying artwork can be edited as easily as if the Art Brushes hadn't been applied to them. Brushes can be resized, re-colored, and tweaked endlessly to suit the job in hand, either globally or individually for each group or stroke.

When an Art Brush is applied to base artwork, it acts on top of the underlying structure without altering it. This makes it easy to try out a variety of different strokes to see which one best suits the illustration. You commit yourself irrevocably to the effect only if you specifically choose to do so, at which point the strokes are turned into regular Illustrator outlines, ready to be adjusted just

Dozens of useful custom Art Brushes are available for you to browse through. You can also create your own.

like any other artwork. This system offers tremendous flexibility and scope for experimentation, without creating over-complex artwork that would be hard to edit.

Art Brush strokes are stretched to fit the entire length of a selected path. In practice, this can make the stroke look artificial and unwieldy, but there is a way around this. As our example on the opposite page shows, breaking that path into several smaller paths forces the Art Brush stroke to redraw itself for each path segment, resulting in a more flowing and natural appearance.

Custom brushes can do far more than simulating natural media. Any object drawn in Illustrator can be defined as a brush. Along with Art Brushes, which follow a drawn stroke, there are also Scatter Brushes (which place multiple instances of the artwork along the stroke), Calligraphic Brushes (which place an angled line along the stroke), and Pattern Brushes (useful for creating custom borders). Each comes with its own range of variations—so that Scatter Brushes, for example, can be set to vary in size, spacing, rotation, and scattering from the drawn path.

1. This simple outline drawing is the basis for our brush stroke. The drawing is unfilled, and the stroke lines are kept relatively short.

2. The Charcoal brush adds roughness and complexity to the outline, with a suitably scratchy appearance.

3. The Fountain Pen brush is smoother in feel, but it is still a distinctly leaky pen.

4. The Watercolor brush uses multiple shades of gray to create a soft, almost transparent look.

5. The Watercolor brush again, this time colored in shades of red and yellow—the stroke size has been increased for a less-controlled look.

6. The same Watercolor brush, but now with a copy of the artwork placed on top using the Fountain Pen brush at an opacity of 75%.

The two elements used in this image—a blade of grass and a bubble—are defined as two custom brushes: the grass as an Art brush, the bubble as a Scatter brush.

Below left: Several strokes are drawn, using the Grass brush. By changing the color of each stroke, we can vary the appearance.

Below center: Another layer of brushstrokes has its opacity lowered to make it recede into the distance.

Below right: By setting random scaling, spacing, and scatter, we can make the bubbles follow a few drawn paths in a natural manner.

1. This simple outline of a hand will provide the basis for our Art Brush application.

2. When the Art Brush is applied to the hand, the single brush stroke follows the outline from beginning to end.

3. We can divide this single path into several smaller ones by cutting it at the points shown.

4. Now, each application of the Art Brush fits just that segment of the outline, resulting in a more natural look.

MAP MAKING Sooner or later, every digital artist is asked to create a map. The quality of the end result depends on your artistic inspiration, but by bearing some basic rules in mind you can take much of the tedium out of the process.

Mountain High Maps is one of the world's leading suppliers of highly detailed customizable mapmaking resources. By combining multi-layer Illustrator and Freehand images with bitmap reliefs for the landscape, these complex maps offer the designer a huge number of possible variations, any of which may be modified further to suit the needs of the project in hand (www.digiwis.com).

The basic technique is simple. Begin by drawing a network of roads, either freehand or by tracing over a sketch. While it is possible to use an existing map as a template, this approach should be used with extreme caution: copyright in maps is heavily protected by their owners, and you can get into serious trouble by using someone else's design.

Roads should be drawn using a thick black stroke (the width of the line) with no fill. The thickness of the line can depend on the importance of each road, if you wish—but it is important to draw each road as a separate path to make editing easier later. Once all the roads are drawn, there's a useful trick for creating the outlines. First, duplicate the road layer, to create an identical copy. Then lock the original layer so that it will not be accidentally altered later. Now change the color of the stroke on the duplicated layer to a light color (white or yellow work well), and reduce the width of the stroke. This lets the underlying road layer show through beneath, and creates a perfect outline. The smaller the size of the new stroke, the thicker the outlines will be—so if the original roads use, say, a 9-pt stroke, and the copy uses a 7-pt stroke, the new roads will be 2-pt smaller, resulting in a 1-pt stroke on both edges. Try varying this to separate major and minor roads.

There are several ways of creating other "line" elements, such as rivers and railway lines. To draw a river of uniform thickness, a custom brush made up of parallel blue lines on a pale blue background can be created. When applied to a stroke, this will produce a stylized river similar to those drawn on underground maps. For a more realistic approach, you will have to draw the river varying in thickness and simply fill it with a pale blue.

You can create custom brushes to draw railway lines, but there's an easier method. First, draw your rail using a thin black stroke with no fill. Then duplicate this path, and apply a dashed stroke to it: this alternates solid with empty spaces along the path. By increasing the width of the stroke, and inserting large spaces as the gaps between the dashes, it is easy to simulate a railway line.

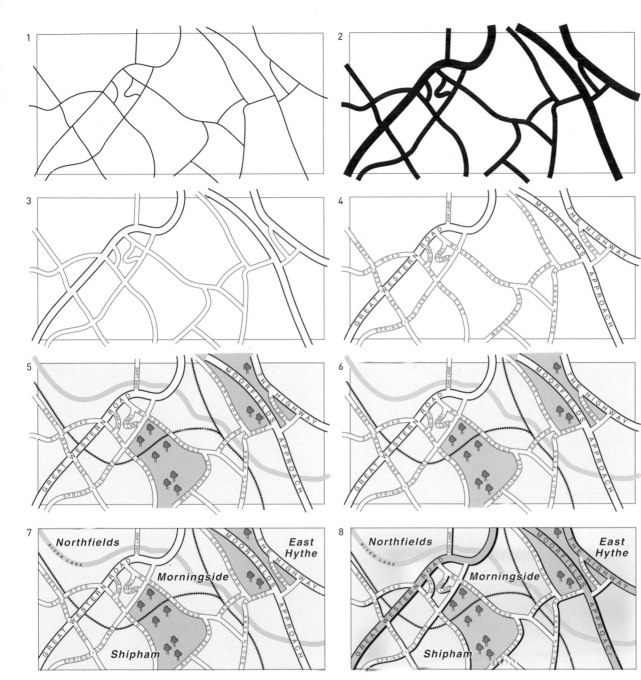

1. Begin by drawing the roads that define your map. Set your roads to have a black stroke, but no fill. Draw each road as a separate path.

2. Now increase the stroke for your roads as appropriate. The minor roads here have been given a 9-pt stroke, while the major roads have a thicker 15-pt stroke.

3. Now duplicate the road layer to make an exact copy of it, and change the stroke on the new layer to a contrasting color. By reducing the stroke width, we make outlines for each road: a 7-pt yellow stroke provides a 1-pt outline for the minor roads, and an 11-pt stroke makes a 2-pt outline for the major roads.

4. Duplicate the road layer again, and cut the path into segments where each name will appear; the Text on a Path feature will let the names run along the roads perfectly.

5. The parkland is drawn on a new layer behind the road layers. It isn't necessary to follow the original road lines

exactly, as the roads themselves will cover any discrepancies. This is also a good time to choose a background color. Pick one that contrast strongly with the map data.

6. The river and railways are drawn using different kinds of stroke—an Art Brush for the river, and a simple dashed stroke for the rails.

7. After the place names have been added (on their own layer), duplicate the layer and add a white stroke to make them stand out.

8. With the data in place, it is time to start tinkering. Adding a drop shadow by duplicating a road layer makes them stand out: coloring the major roads differently is simply a matter of changing their stroke color. Finally, we can add variations in the background tone by using a Gradient Mesh, although this can be hard to control —a white mask as the top covers the ragged edges.

ISOMETRIC DRAWING is a form of perspective whereby horizontal lines are converted to 30° angles, in both directions. Unlike real perspective illustrations, there's no vanishing point, so objects do not diminish with distance. It is a style favored by technical illustrators for its combination of ease of drawing and clarity of appearance.

Exploded diagrams of computer innards, engine parts, and electrical components generally use isometric drawings in order to show clearly and precisely how the various elements fit together. A number of non-technical illustrators have also adopted the form in order to create arresting, heavily stylized images—a very good example can be seen on page 99.

Isometric projection is also a favorite with game designers (although they generally work in a bitmap rather than vector environment). Games such as Sim City, which need to display a large number of buildings, roads, and natural features, incorporate this drawing method because the lack of true perspective simplifies the visual style and enables the game to run more smoothly.

Creating an isometric grid is one way to draw using this projection: snapping each pen point to a grid line will ensure that, with a little thought, you follow the correct angles. This is the way a traditional illustrator would work, and this method has its application here as well. But in the digital arena, we have more powerful tools at our disposal: specifically, the ability to shear artwork (skewing it along a single axis) by a precise 30°, as well as the ability to scale artwork by 86.6%. This is the cosine of 30°, and is the angle required to make "side" faces appear in the correct proportions. The example on the opposite page shows how to create an isometric view from existing artwork using these two techniques.

Top: If you are creating drawings from scratch, it can help to make an isometric grid such as this one. Begin with an array of vertical lines, then group and skew them 60° to make one dimension axis—copy and flip the result horizontally to make the other axis.

Above: In isometric drawings, each dimension retains its natural size. So although the sides of this cube appear to be going back in perspective, the length of each side still measures the same.

Right: Isometric drawing is often used in construction diagrams, such as this building brick example. The similarities are striking: after drawing the original brick (left), the virtual model is constructed by piling bricks on top of each other—exactly in the way the real model would be built.

Above: Illustrator's Smart Guides feature enables pen paths and movements to snap to 30° alignments with existing points in the artwork, making it an ideal tool for creating isometric drawings.

Left: As well as drawing isometric projections from scratch, it is also possible to turn existing artwork into an isometric view. Here, we'll begin with this head-on view of an old radio.

1 (above). The first step is to scale the artwork horizontally by 86.6% (the cosine of 30°), and then shear it vertically 30°. This makes the first isometric plane.

2 (right). The side and top are added by duplicating the back layer, cutting the path, then offsetting a duplicate of the cut path and joining the endpoints together. Filled with just the standard brown, it looks rather dull.

3 (above). A Gradient fill, set to the same 30°, is designed to provide a dark side with a highlight on the rounded corner. The knobs are given depth by simply duplicating them, the aerial is made from a copy of the knob, and a bevel on the inside of the speaker grille adds a sense of depth.

TECHNICAL DRAWING is not a field every illustrator would wish to stray into, but it is an important category in its own right. Technical illustrations generally use an isometric projection of the type described on the previous pages, which provides a clear view of how different components fit together.

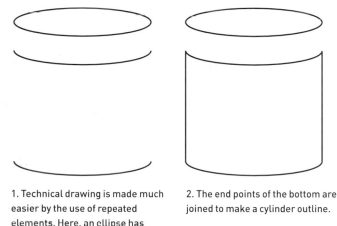

1. Technical drawing is made much easier by the use of repeated elements. Here, an ellipse has been duplicated and the top half deleted—this bottom half is duplicated again.

2. The end points of the bottom are joined to make a cylinder outline.

3. This cylinder, together with the original ellipse, is filled with a black–white gradient.

4. If the original ellipse is placed on top of the cylinder with the gradient reversed, it becomes an open end.

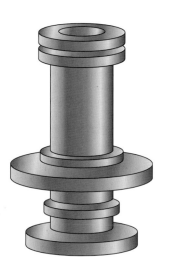

Above left: **Multiple copies of the cylinder can be scaled, stretched, and combined to form a wide variety of shapes.**

Above right: **When the simple gradient is changed to a more complex one, the cylinder stack begins to look far more metallic.**

The trick in drawing diagrams of this kind is to re-purpose picture elements wherever possible. Since vector programs enable artwork to be scaled, rotated, and manipulated with no loss of quality whatsoever, the individual parts can be drawn to any size and then scaled as required.

The examples on these pages use a gradient fill to add texture to the illustrations; by applying a common gradient to all the elements of the illustration, a homogeneous appearance can be achieved. It is then possible to change the gradient globally at a later date, or even remove it entirely—a lot of technical drawing relies on white fills with simple black outlines for clarity.

Crosshatching—drawing an array of parallel lines to simulate shading—is a useful technique for adding depth to line artwork. Illustrator has a complex crosshatching engine that can apply a variety of styles of hatching with a high level of user control. On the opposite page, we will look at how to apply this crosshatching feature to a photograph to produce an automatic line drawing.

1. To create a 3D cogwheel, begin by drawing a circle.

2. The first tooth is drawn by radiating two lines from the center of the circle, then joining them together at the ends.

3. This tooth is rotated 30°, and the operation is duplicated to make the rest of the teeth.

4. All the elements are merged into one, and a central, smaller circle is knocked out from the whole assembly.

5. The flat cog is compressed horizontally, and duplicated to make the thickness of the cog.

6. Each face of each tooth is drawn as a new element to add solidity to the wheel.

7. With a simple gradient shading applied, the wheel looks more 3D.

1. To make a cable or pipeline, begin by drawing the path you want it to follow.

2. Apply a thick, dark stroke to the line, then duplicate it and apply a thin, light stroke to the new version.

3. We need to be able to access two endpoints, so they must be offset. The bottom right points have been nudged up on the light version, and down on the dark version.

4. The blend tool is now used to create a smooth blend between these two paths, by clicking on the endpoints of both.

5. When the endpoints are returned to their original position, the pipe is complete.

6. By offsetting the lighter path, we achieve asymmetrical shading that looks more realistic.

1. This photograph of a hand is an ideal candidate for Illustrator's autocrosshatch feature, as it offers a good degree of contrast combined with definable edges.

2. With one degree of hatch (a single shading), the darker parts of the image are shaded and the lighter areas left blank.

3 An outline is needed to make this illustration work. Common practice is to combine a thick outer edge with thinner internal strokes.

4. Adding a second degree of crosshatching provides more realistic shading; the new lines are at a different angle to the first set.

5. A third level of crosshatching shows more detail, but is perhaps one level too far. The illustration is now starting to look muddy.

TRACING AND AUTOTRACING Given the existence of both bitmap and vector applications and images, it is inevitable that artwork will need to be converted between the two. There are a number of ways of performing this task, each with its own advantages and disadvantages. While there are circumstances where it is best to do things the manual way, most drawing packages have an easier, automatic tracing option.

One solution is quite straightforward: each pixel can simply be replaced by a geometric square filled with the same color. In practice, however, this would be both pointless and massively inefficient. The challenge is to transform bitmap imagery into something representing the same subject, but with the distinctive economy (both aesthetic and technical) of vector art.

At the academic end of the software development industry, many different methods of applying vectors to bitmap artwork have been explored and incorporated into specialized programs. Within the everyday tools available to the illustrator, however, options are rather limited. Converting a bitmap into vector shapes is known as autotracing—one of the leading packages aimed specifically at this task is Adobe Streamline. This offers comprehensive control over the process and can produce excellent results, whether you want a clean reproduction of a piece of line art, or a detailed facsimile of a photo. Many artists prefer to draw initial sketches on paper, and Streamline enables them to scan these in and convert them to vectors to form the basis of a resolution-independent illustration.

Unless you habitually work this way, however, the investment in Streamline—both financially and in the time it takes to learn to use it effectively—may not be worth the reward. Fortunately, most professional drawing packages provide built-in autotracing. As you might expect, one of the most primitive tools is found in Adobe Illustrator, leaving the clever stuff to Streamline. A more effective implementation can be found in Macromedia FreeHand, which traces images remarkably quickly and effectively.

What none of these tools will do, however, is interpret a photographic image aesthetically, and create a drawing of it in the same way as an artist, or even a child. Although the software can use edge-finding techniques to try to follow the outlines of objects in a scene, it doesn't understand the visual content of the image, and cannot interpret it intelligently.

Below: **Illustrator's Auto Trace tool looks for one shape at a time. The method is to click near the edge of an object to make the software trace around it. Repeat the process to complete enough objects to make up an image. After considerable trial and error, the end result tends to look something like this. Fills have been added manually, since colors in the image are ignored. This highly stylized drawing could most kindly be described as reminiscent of the original.**

Above: **Because its subject is clichéd, this image has the visual quality of a pictogram. Technically, however, it is a bitmap containing millions of differently colored pixels. How can we convert it into vector objects?**

Right: The Auto Trace tool's job can be assisted by pre-processing the image in Photoshop. Here, we have reduced the number of color levels using the Posterize adjustment, then removed noise using the Median filter. Tracing these areas of flat color would be easier, but the quality is, of course, limited before you start. Only limited control is offered over the tool's operation, so results are difficult to improve or customize.

Right: Manual tracing is generally a better option for producing useful vector artwork. Having placed the image in a lower layer, draw around the key elements using Bézier curves. Follow the traditional maxim "draw what you see," but start with an idea of the level of detail you are aiming for and limit the number of points you create. Ignore fills and the stacking order for now, but where items will ultimately lie under others, do not waste time drawing the invisible portions correctly.

Above: Adobe does offer professional tracing tools, but in a separate product called, Streamline. Adobe Illustrator's rival, Macromedia FreeHand, comes with pretty good tracing included in the program. The Trace tool lets you drag a marquee around an entire image, and in a fraction of a second produces a complete trace. Colors as well as shapes are recognized and applied to the paths created.

Above: The exact result is governed by a number of controls. Since it would be pointless to mimic the millions of pixel colors, you can choose the number of colors, and define a wand tolerance (as with Photoshop's Magic Wand; see page 48) to set the level of color change that will be detected. The Conformity level dictates how closely the image detail is followed in the paths created, while Noise Tolerance lets insignificant speckles be ignored.

This is where manual tracing takes over. Trace art has become a genre of digital illustration in its own right, and, contrary to the popular impression that it is somehow computer-generated, it is usually produced without any automation. Instead, after obtaining one or more suitable source images—often by arranging objects or friends into the desired scene, or by taking a digital camera picture—the illustrator loads them into a vector program and draws Bézier curves over the top, finally deleting the bitmaps. Any of the usual stroke-and-fill options can be exploited to create a particular look and feel. Styles can range from highly abstract, with just a few lines judiciously used to suggest forms in a 3D space, to detailed and painterly, with complex shading sketched in.

Left: Here, having constructed all our paths, we have filled them using multipoint gradients. Radial fills give the paint blobs a 3D feel. Linear gradients work similarly on the brush, and produce a simple sweep of light across the palette. The palette shape has been duplicated, sent behind, moved slightly, and darkened to give it thickness. Shadow objects have been set to Multiply mode to darken underlying colors.

MESHES AND DISTORTION Bézier curves are infinitely editable, but moving points and handles to transform a whole object can be difficult and time consuming. Instead, meshes and distortion controls can create unique effects, pulling graphics and text into unusual shapes and colors. A standard feature of vector software is the ability to scale, rotate, and skew objects, and this can be done either by entering numeric values or by reshaping an enclosing rectangle, known as a bounding box.

More recently, envelope distortion has been added, which lets objects be fitted to an irregular shape. Imagine an envelope as a flat elastic sheet with the object printed on it. By grabbing any part of the sheet and pulling it in any direction, you distort the surface and the object along with it. The uses of envelope distortion are almost limitless: you can squeeze type into shapes for logos, fit labels onto drawings of 3D containers, or just pull objects around for unique, abstract effects.

Within the software, envelopes are constructed from crisscrossing Bézier curves to form a flexible grid or mesh. Some programs prefer not to present this directly to the user, and instead offer a range of envelopes in predefined shapes that cannot be significantly altered. Others, such as Macromedia FreeHand, present the mesh as an editable outline, with middle points calculated automatically. Adobe Illustrator gives direct control over all points in a mesh.

Illustrator alone can also use meshes to distort color rather than shape. A gradient mesh takes exactly the same form as a distortion envelope, but lets colors be applied to its points, smoothly blending neighboring colors across the grid. The effect is unique, and extremely subtle shading can be built up much more quickly and flexibly than by the conventional method of constructing many separate blends, with end results similar to traditional airbrush illustration. Alternatively, more dramatic color shifts can be introduced for wild effects.

On the downside, no tools have yet been developed that assist in placing and coloring mesh points in such a way as to create particular effects, such as contoured edges. Instead, it is up to the user to build up the desired effect by adding, moving, and coloring points. However, since these are treated as ordinary Bézier points, many of the usual editing tools can provide assistance here. For example, you can press Shift+Click to select several points at once, and then move them all together, scale to push shading outward or inward, or rotate for a twirling effect.

ENVELOPE DISTORTIONS
Most vector programs offer some form of envelope distortion. Adobe Illustrator provides three options.

Above: **A Warp Distortion** applies a predefined shape to the selected object. The shape can then be altered manually if necessary.

Above: **A Mesh Distortion** applies a grid that is constructed in exactly the same way as a gradient mesh fill, and is similarly editable.

When it comes to output, gradient meshes raise even greater problems than transparency, as they are not supported by any current version of PostScript (the graphics language invented by Adobe which is used by most equipment throughout the pre-press chain). In most cases, the most straightforward and satisfactory way to exchange and print illustrations that use such advanced effects is to export the whole file as a large bitmap, enabling the application to rasterize its own vector code rather than ask other products to do so. To preserve the quality of the vector artwork, however, it is vital to set a high resolution and use anti-aliasing.

Envelope distortions usually remain live after being applied to an object, so you can edit the envelope later or remove it to leave the object intact. Some operations cannot be performed on objects governed by envelopes, the most obvious being applying another envelope for further distortion to give you the option of applying an envelope permanently to an object's geometry. Once this is done, the object consists of ordinary paths that form the distorted shape, and can be edited without restriction. However, it cannot easily be returned to its original form.

1 2 3

GRADIENT MESH

Adobe Illustrator's Gradient Mesh tool provides a unique way to blend any number of colors within an object.

1. Used on any shape, the Create Gradient Mesh command adds a grid of color points. A lighter tint can automatically be applied to certain points to make a highlight at the center or edge of the shape.
2. A gradient mesh is formed from Bézier curves, and its points and handles can be moved like any others. Here, the points nearest the edges have been selected together and scaled by 120%.
3. An alternative way to build up a gradient mesh is by clicking, using the Mesh tool, to place individual color points. Whichever way the mesh is created, color applied to any point is blended with those around it.

Gradient meshes can be used to build up complex realistic shading, as seen in this illustration. Each petal, leaf, and stem consists of a single mesh containing several dozen color points.

Picture: © 2001 Adobe Systems Incorporated

USING MULTIPLE ENVELOPES

1. Sometimes more than one envelope operation is needed. Here, we want to reshape the logo to make it more dynamic, and then apply it to the cup.
2. The logo is shaped using a warp envelope called Rise, applying a positive value to make the text swirl upward. The object is then expanded.
3. This warps the object permanently. We can now apply a second warp, an Arch with vertical distortion, to fit the text to the cup shape.

1 2 3

03.03
DRAWING
SHOWCASE

Below: **This image is taken from the gform 1.26 collection commissioned by image library Digital Vision. Artists Bradley Grosh and Anders Schroeder work mainly in Photoshop, but vector artwork plays the leading role here. Large numbers of outlined 3D forms are arranged into a complex architectural composition; tiny elements are scattered for a sense of vast scale. Lines and planes are extended right to left to give a feeling of high-speed motion reminiscent of long-exposure photography.**
Digital Vision
www.digitalvisiononline.com

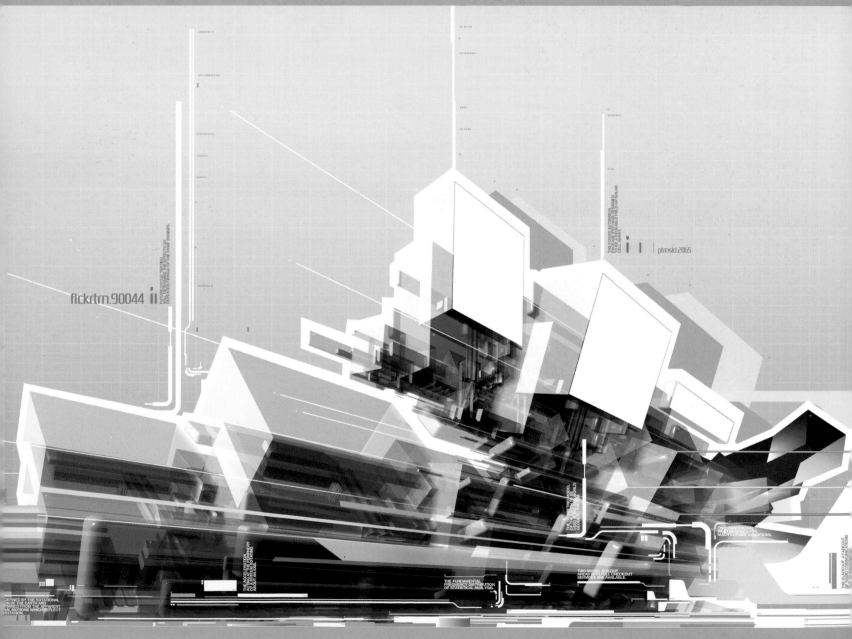

Below: **This CD cover is one of several created for drum'n'bass label Metalheadz by designer Jon Black. At first glance, the image seems detailed, complex, and almost random in arrangement. In fact, it's made up from very simple cuboid forms, stacked together and rotated in three dimensions, and the composition is carefully judged to draw the eye and give an impression of motion and depth. Layers are used to superimpose elements with varying transparency.**
Jon Black
www.magnetstudio.net

Right and bottom: Graffiti artists 123klan have turned to Adobe Illustrator to develop a style that's anarchic yet controlled. Despite the rather technical nature of vector drawing, partners Scien and Klor say it's still possible to create spontaneously: "We use the mouse like a spray can—you click and something comes out. "The robot illustration is from a drum'n'bass party flyer; the T-shirt design was commissioned for the IdN international graphics conference.
123klan
www.123klan.com

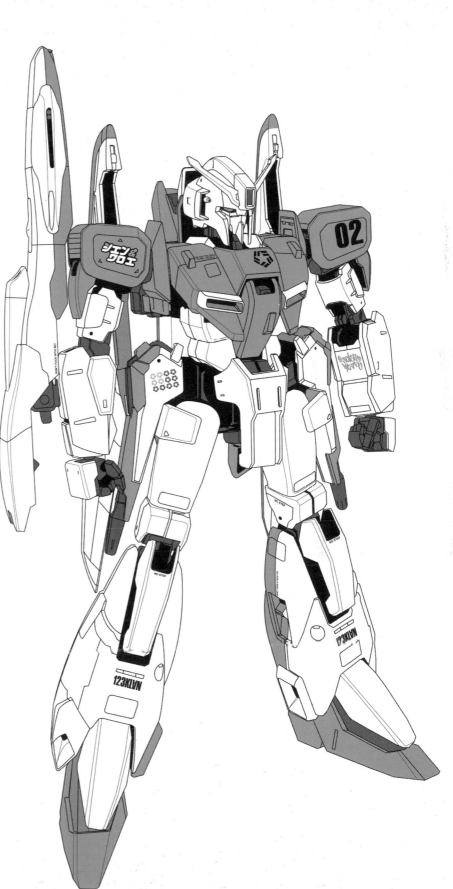

Below: This astonishing view of Chartres Cathedral was produced by Richard Tibbitts of partnership AntBits, in collaboration with Martin Woodward, for a commission for Hutchinson's Encyclopedia. A detailed pencil sketch was created from photographic reference, then line work was drawn in Illustrator. Finally, shading was added in Photoshop. "A nightmare job. It started off as a simple exterior view of the cathedral, then turned into a cutaway. Heaps more work, but as usual not heaps more money," recalls Tibbitts.

Richard Tibbitts, AntBits
www.antbits.co.uk

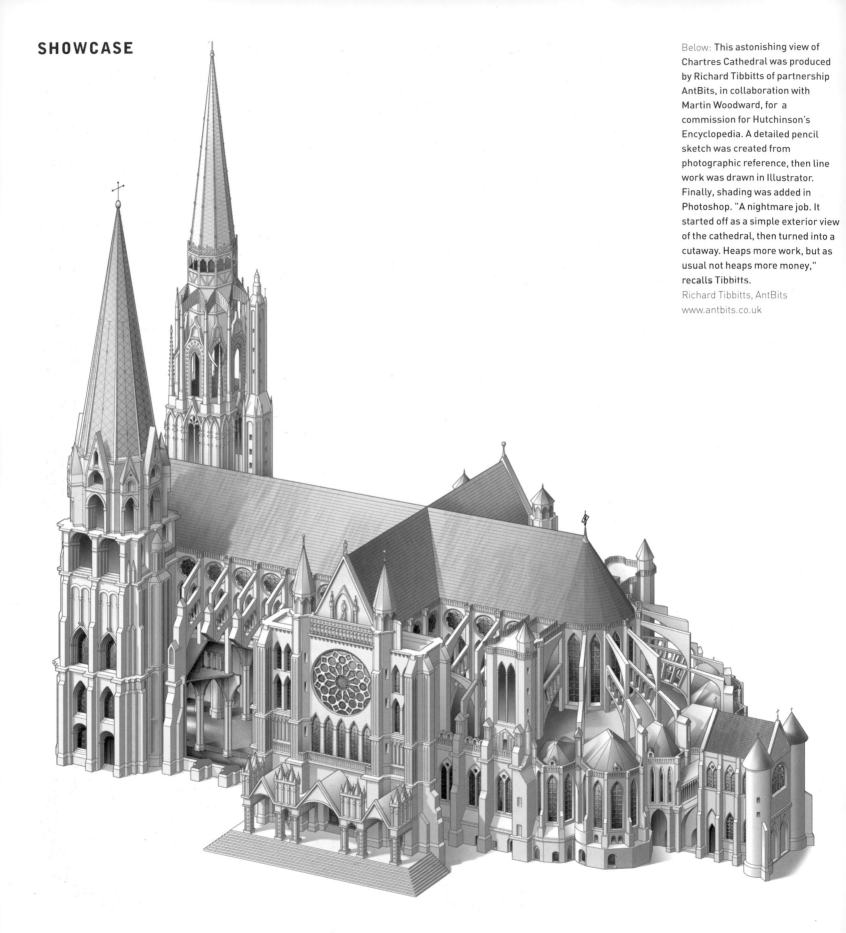

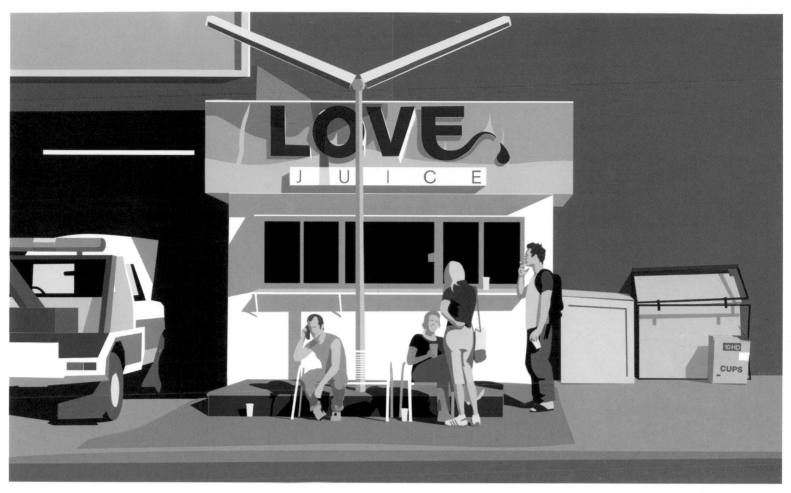

Above: **Love Juice** is one of a series of Adobe Illustrator drawings inspired by a trip to New York. Illustrator Gary Andrew Newman combines freehand drawing and tracing from scanned photographs. The skill lies in knowing what to leave out: detail is there where it's needed, but omitted where it would distract the eye.

Gary Andrew Newman
www.gazdesign.com

Below: Woodcock's photorealistic illustrations are so perfect it's hard to believe they're not photographs. But photographs would never capture the detail of these images; every nut and bolt on this motorbike has been drawn, and the reflection in the side of the computer shows a mastery of the form.

John Woodcock
john.woodcock2@virgin.net

SHOWCASE

Below: "Led Pants' style combines Hieronymus Bosch with the Atari 2600 into a post-modern mixture that is colorful, enthusiastic, wacky, and uninhibited," says the artist, whose style was inspired by experiences as an illustrator for software companies, including Microsoft. This image could only be digital, exploiting the potential to push the boundaries of contemporary illustration.
Mr Led Pants
www.ledpants.com
kaw@scotthull.com

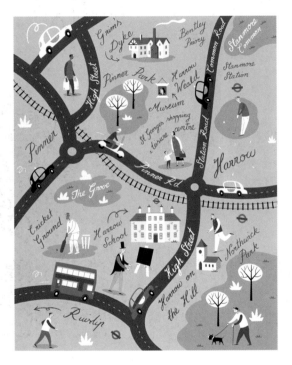

Above: Every illustrator is asked to draw maps at some point, but few do so with the style and verve of David Hitch. The humor of the illustrative style is complemented by the handwritten-style text, and the variations in text size contribute to the hand-lettered feel. The restraint of the color palette also helps to unify the map.
David Hitch
www.davidhitch.com,
www.arenaworks.com

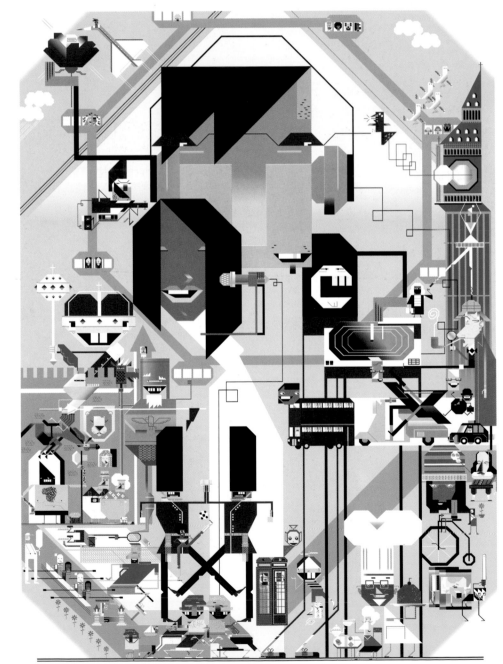

Above: **Identical twins Adam and Nick Hayes, best known for their typefaces, drew this in FreeHand 9. It's compiled from a series of repeated images; subtle changes to hair and clothing differentiate the people, and the isometric projection means no perspective distortion is required.**
Identikal Corporation
www.identikal.com

Left: **Paul Wootton has created a similar scene, but has introduced true perspective. He begins by constructing 3D models of his scenes using Cinema 4D and Poser, then draws the elements in Illustrator, distorting and adapting each object to fit the new view correctly.**
Paul Wootton Associates
www.graphicnet.co.uk

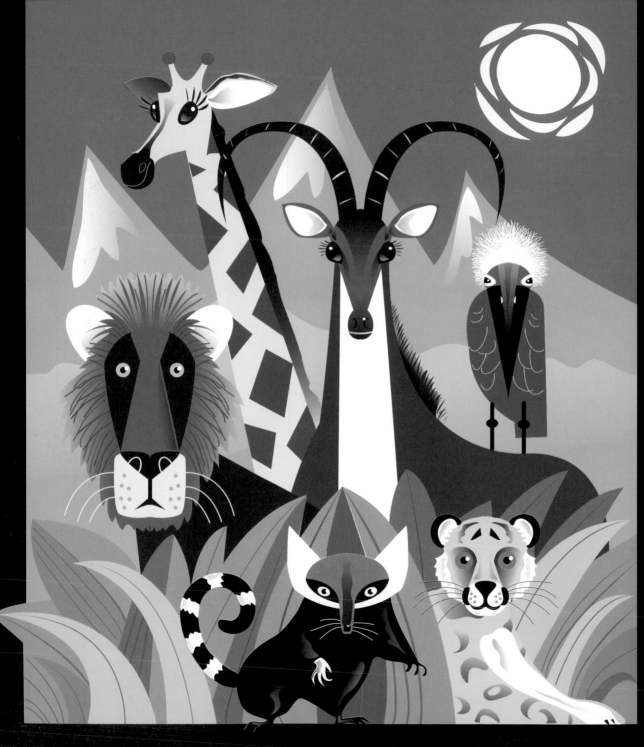

Left: **It's hard to believe that this playful, appealing collection of creatures was created by the same person who drew the photorealistic objects on page 97. The stylization of the form is immaculate, from the polygonal markings on the giraffe's neck to geometric rays around the sun. And yet John Woodcock is not shy of complexity where it's needed—for example, in the hairlike fringe around the bird's head.**
John Woodcock
john.woodcock2@virgin.net

Right: Andy Martin is in high demand for his unique graphic style, combining flat drawn shapes with line art scans. The apparent simplicity of this image of swimming sperm belies the artistry needed to make the image work; what could have been simply a mess of shapes has instead become a dynamic illustration.
Andy Martin
www.andymartin.uk.com

Left: Drawing in true perspective is a painstaking process. But when all the elements radiate from a single vanishing point, as in this example, the arrangement of the objects can come last.
Steve Caplin
www.stevecaplin.com

Below: Applied in projects from corporate identity to government initiatives, Mark Bown's style of vector drawing is fresh and fun. This illustration for a TV network shows the wide range of expressions that can be created using the bare minimum of facial features.
Mark Bown
www.honkshoo.com

SHOWCASE

Right: As deputy art editor at computing and digital arts magazine *MacUser*, Aston Leach is regularly called upon to produce striking illustrations for articles on technical subjects. Here, manual vector tracing of a photo gives a simple piece of line work, which is transformed into an arresting double-page spread by the use of color and composition. The horizon line and shadows tell us the partially seen figure is jumping for joy.
Aston Leach
www.macuser.co.uk

Right: Internationally known as an illustrator and typographer, Rian Hughes is the supreme stylist, taking great liberties with form to create highly illustrative artwork. This kind of image could only be produced digitally; objects such as the chain-of-dots strings holding the kinetic sculpture would have been almost impossible to draw conventionally. Hughes uses wholly unrealistic image elements, like the silhouetted plant in the foreground, combined with realistic shading where needed.
Rian Hughes
www.rianhughes.com

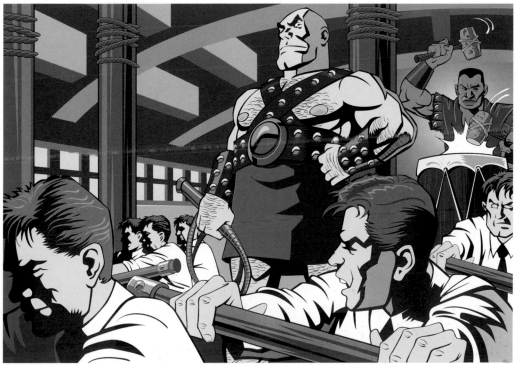

Above: The tight lines and flat shading in Lee Woodgate's work mark it out as digital illustration; only occasionally, as on the fish and bread, are gradient fills used. Economy of line is what makes his illustrations work. This piece was created for British Airways' *Business Life* magazine.
Lee Woodgate
www.leewoodgate.com

Left: Cartoonist Kev Hopgood began his career in science fiction. He uses Illustrator with a graphics tablet. Jobs with complex line work are traced with the Pen tool in Painter, enabling more calligraphic effects, then vectorized using Streamline for coloring in Illustrator. This image, for an article on management, has little to betray its digital origins except the purity of the lines.
Kev Hopgood
www.kevhopgood.co.uk

3D ILLUSTRATION

04

04.01

Where both bitmap and vector-based applications have clear analogs in traditional paper-based art, 3D applications are something altogether different. In a 3D application you are building fully 3D models and arranging them within a virtual world. By adding complex textures and lighting effects you can create something that looks uncannily realistic. In fact, in the early days of 3D imaging, realism was the main concern. However, it was not too long before artists realized that 3D applications could also create stunning fantasy and science-fiction images, not to mention more stylized and exaggerated cartoon effects. The processes can seem complicated to traditional illustrators, but, as with vector-based drawing applications, the object-based approach makes it easy to copy, transform, and reuse elements at will, while the photorealistic results speak for themselves.

Finished images can be rendered to any size—and the larger they are, the more detail visible.

PART 04. 3D ILLUSTRATION

CHAPTER ONE

3D APPLICATIONS

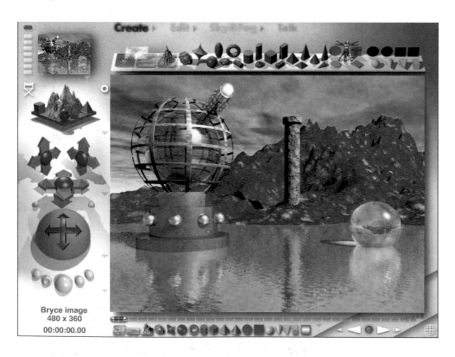

Bryce image
480 x 360
00:00:00.00

There have been several attempts at landscape modelers, but few programs have had the instant appeal of Bryce. Both relatively easy to use and sophisticated in its end result, Bryce can create any landscape you can imagine—and many that you cannot.

Beginning with a blank perspective plane, add water, mountain ranges, individual rocks, and cloud layers to build up the scene. A huge range of naturalistic textures can be applied to any object, with dozens of seas, rock formations, and terrain types to choose from. You can even draw your own landscapes using a "height map," where white areas are raised and black areas depressed. A built-in tree lab lets you design and build your own trees and shrubs, which can be positioned and scaled as you wish. A separate sky lab enables you to tweak, adjust, and modify cloud formations, sun and moon positions, and general weather conditions.

There are no 3D modeling tools as such, but by combining the primitive objects you are using as building blocks—spheres, cubes, cylinders, and so on—it is possible to populate your landscape with buildings, fantasy scientific artifacts, and alien spaceships. The interface is strongly

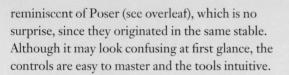

reminiscent of Poser (see overleaf), which is no surprise, since they originated in the same stable. Although it may look confusing at first glance, the controls are easy to master and the tools intuitive.

When working in Bryce, objects (including terrains) appear as wireframe models. By viewing these from different angles, it is possible to arrange them precisely to align with one another. The tiny Preview pane at the top left of the screen shows a full textured view of the scene at postage stamp size, making it easy to see at a glance how effects such as sky and lighting will change the image.

Rendering the final image, however, is a long process that can take several hours for large file sizes. This is due to the complexity of the rendering rather than any software shortfalls—when complex transparent and mirrored objects are themselves reflected in shimmering water, it takes its toll on the rendering engine.

Bryce is used largely for creating backgrounds for illustrations, and works well when combined with objects from Poser or other 3D applications. The ability to add animation to scenes means that you can design a camera to fly through your artificial landscape, producing movies of sometimes astonishing sophistication. However, with a rendering time of several hours per frame, you do need either a network of computers or plenty of time on your hands to get the most out of it.

Right: **The wireframe working arena means you can see where all your objects lie—but complex scenes can quickly look like a jumble of lines.**

Middle right: **Changing viewpoint—in this case, to an overhead view—can greatly help in the accurate positioning of elements within the scene.**

Opposite page: **The rendered view shows all the objects with texture applied. Even a low-resolution rendering such as this can take 20 minutes or more to create.**

Below right: **If you really want to get under the hood, the Materials Lab enables you to control the surface of each object with the utmost level of precision.**

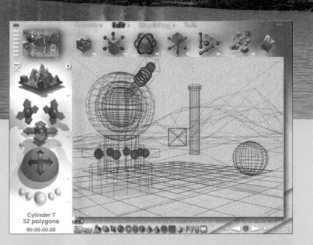

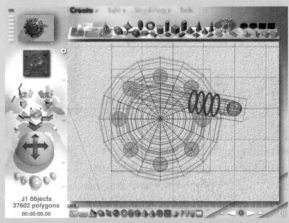

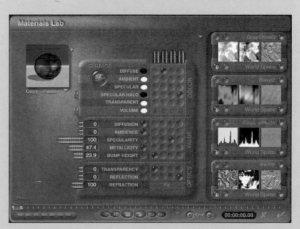

POSER is a human figure modeler that's capable of producing photorealistic images of people to a quality that can be hard to discern from the real thing. Models can be positioned in any pose, and the links between body parts conform to real limbs as they are moved; stretching an arm out, for example, will make the body lurch forward to follow its motion.

As well as posing bodies, Poser provides a huge range of parameters to control every aspect of a figure's physiognomy. While the models that come with the program are fairly basic, third-party developers—most notably Daz3D, which created the original models—sell a wide range of additional figures that add realism and flexibility. Body weights can vary from emaciated to overweight, from weedy to superheroic, and individual limbs can be tweaked to suit any purpose.

As you might expect, the head steals most of the attention. It is possible to create virtually any expression imaginable, by changing the position of the eyes, mouth, nose, eyebrows, and so on. It is also possible to design any type of head you want—from

Poser's interface shows all the controls needed to pose and animate figures. By choosing from a variety of cameras, you can zoom in on faces and hands to adjust expressions, or pose your own camera as desired.

ultra-realistic to alien—by adjusting the dozens of separate controls that determine the size, position, and shape of every facial element. Daz3D's Michael 2 model, for example, includes 230 head controls (including 15 eye shapes, 8 eyebrow modifiers, and 12 teeth modifiers), and nearly 350 individual controls for adjusting the shape of the body.

Poser models can be viewed as wireframe models, blocky 3D models, or "skinned" people. When the desired pose and body morph have been achieved, a final rendering of the image will use a combination of texture, reflection, transparency, and bump maps to add realistic skin tones to figures that can be created at any size.

Poser figures can be composited with backgrounds or other elements in a bitmap-editing program such as Photoshop. It is also possible to create finished artwork directly in Poser, either by placing backgrounds behind the figures or by populating your scene with props, landscapes, and room settings.

One of Poser's strengths is its ability to generate animations. A custom Walk Designer makes the figures walk in any manner you choose along a path you draw. Mouths can then be posed to synchronize with recorded speech by dropping in one of the range of phoneme mouth shapes at the relevant points. By adding occasional eye blinks and making the chest expand and contract over time to simulate breathing, it is possible to create convincing character animations that you can then output as finished movies, or composite with other elements in a video-editing application such as Adobe Premiere or Apple's Final Cut Pro.

However, figures rendered in Poser are rarely perfect, and most of the artwork generated with it will need tidying up in Photoshop afterward to smooth out sharp edges on body outlines, and to fix any glitches that may have crept into the joints, for instance. The examples on the opposite page (the woman sitting on a piano stool) show a rendered image before it has been cleaned up, so you can see the kinds of errors that may creep in.

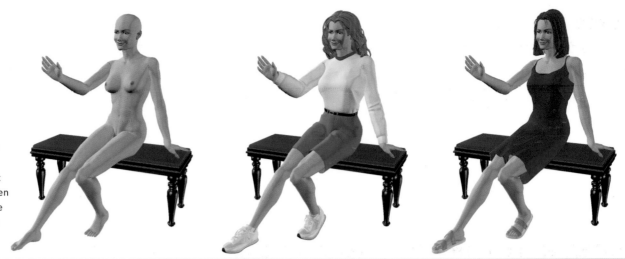

Right: Begin by positioning your figure as you want it to appear, taking care not to over-bend any limbs because this would cause distortion. Props can be added at the same time. The figure can then be given hair, and you can choose from a range of clothing types to complete the model.

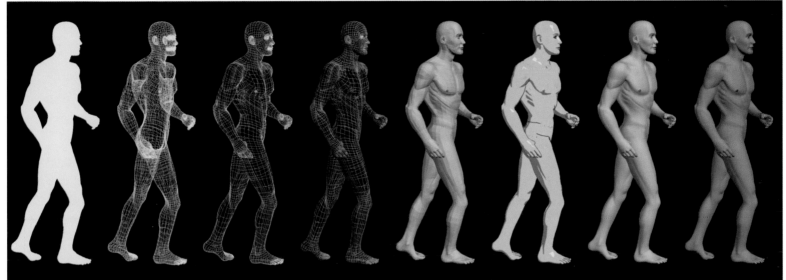

Left: A wide variety of figures can be created by varying the face and body parameters. Here, two versions of the same basic figure have been composited in Photoshop, where the other elements were added.

Above: Poser can generate figures in a variety of modeling styles. Shown here, from left to right— Outline, Wireframe, Hidden Line Wireframe, Shaded Wireframe, Block Shaded, Sketch, Texture Preview, and Fully Rendered.

AMORPHIUM is a 3D modeling tool that helps to construct complex animations with relative ease, and can produce some spectacular results. Amorphium is unique in the 3D modeling world in that it works not with lathe or extrusion profiles, but with "virtual clay." Starting with a primitive object—a sphere, cube, cylinder, and so on—the user models the surface with a brush that can pull, pinch, smear, and distort the object through a variety of tip shapes and characteristics.

By applying symmetry to the actions, it is possible to distort both sides of the object at once. A set of filters adds spikes, twists, and waves to the surface, as well as a range of other distortions—sides can be flattened to turn a sphere into a hemisphere, for example, and "noise" can be added to give surfaces a rough or hammered look.

Once modeled, the surface can be painted—either by painting directly onto the object, or by wrapping an image around it. Special effects such as clouds, marble, and veins can be applied in any color—by painting "masks" on selected areas, it is also possible to prevent any action from affecting those objects as remaining areas are adjusted. Meanwhile, specular controls enable shininess, transparency, etc. to be applied to the model as desired.

A special section of the Amorphium modeling environment concerns "biospheres." These are individual spheres that, when placed in proximity to each other, merge together to form a single shape. Biospheres can be combined to make objects such as hands, with each distorted sphere forming a single finger joint.

Only one object can be worked upon at a time, but any number may be combined in the Composer section. Here, objects can be scaled, rotated, and arranged to compose the scene. As with all 3D applications, the finished model can be rendered at any size.

Scenes may be animated using a standard keyframe palette—the coloring and shape of each object, as well as its position relative to other objects, can vary with time. This makes it possible to construct complex-looking animations with relative ease.

Amorphium excels as an organic modeler, producing the sort of natural forms that would be very much harder to produce by conventional means. It is also able to generate animations by morphing between different states of an object; the coloring, position, shading, and form of the object can be changed to any degree, and the program will produce a smooth merge from one to the other. Such animations may take awhile to render, but the results can be amazing.

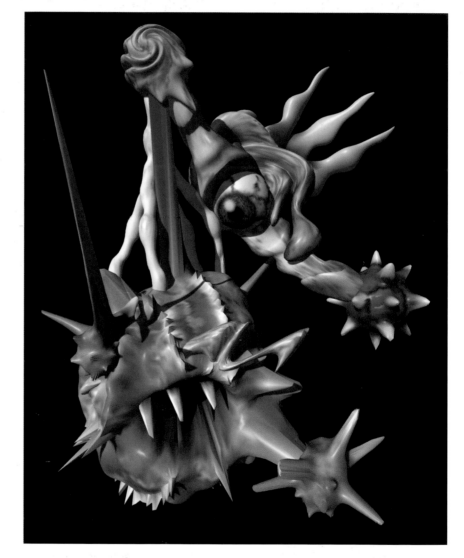

Above: **It is possible to construct complex, organic forms with Amorphium far more easily than with standard 3D modeling applications.**

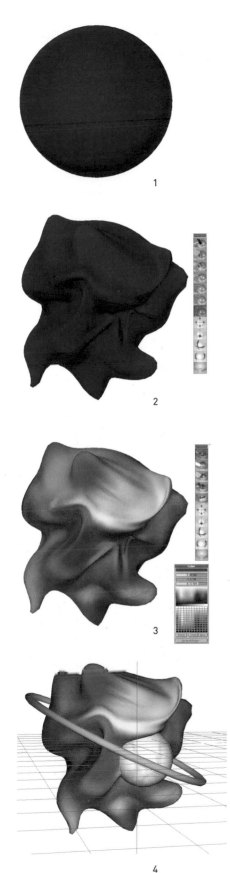

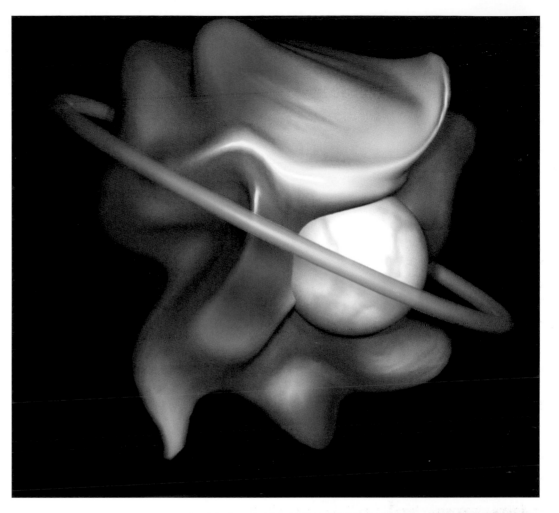

1. New models begin life as 3D primitive objects, such as this ball.

2. Using the various deformation tools it is possible to squeeze, bend, and pluck the ball into any shape.

3. Coloring is achieved using the painting tools—the model can be rotated as you paint so that you can see it from all angles.

4. The finished model is opened in the Composer section, where it can be combined with other objects— here, a torus (ring) and sphere have been added.

Top right: The finished composition can be rendered at any size. Note how the final model is smoother than the working previews.

Above: Amorphium's interface is somewhat quirky, and consists of a number of tool sets, each of which opens a separate range of palettes for working on your models.

ADOBE DIMENSIONS is a basic 3D program that uses two modeling techniques, Revolve and Extrude, to create its models. Although the program is now showing its age—it has not been updated since 1997—it offers the unique capability of being able to generate PostScript artwork. Where other, more powerful 3D applications render a bitmap image, with the render time escalating as larger images are drawn, PostScript artwork—the basis of all vector (drawing) applications—can be scaled to any size without loss of quality.

Revolve involves drawing a profile that spins around a central axis, similar in technique to turning wood on a lathe. Hitting the Apply button will show the model rendered instantly as draft artwork; it is then easy to keep adjusting the lathe profile, performing frequent draft renders, to see how the changes affect the finished model.

Extrude begins with a Bézier curve path, which may be drawn directly in Dimensions or imported from existing PostScript artwork. This makes it ideal for turning company logos and symbols into 3D shapes. The flat shape is given depth via a simple numeric measurement, and turns into a 3D object. Adding custom bevels to the extrusion varies the profile to create curves, rims, or other designs.

The two modeling methods can create image elements that may then be combined to form a larger, more complex object. Once constructed, the resulting model can be colored and shaded, and viewed from any angle before being output as a PostScript file—images can also be rendered as raster (bitmap) files. Although the texturing component is weak—images can be wrapped around models, but the results are somewhat crude—Dimensions lets you draw your own mapped artwork, which can be fitted to any object surface you

select. This is useful for placing labels on bottles, for example. You can even import existing artwork (in PostScript format) to be wrapped around 3D surfaces.

Dimensions may not have the texturing and rendering sophistication of high-end modelers, but it is the ideal tool for knocking out quick models that can be viewed from any angle, exported as PostScript artwork, and then imported into Photoshop to add texture. Models that have been rendered in seconds or minutes, rather than hours, can be used as large as you want as the basis for illustrations.

Sometimes drawing a model can be easier than trying to find an object to photograph. The roulette wheel shown here was modeled in just a few steps, and then imported into Photoshop for completion. But you do not need to create complex models to get the best out of Dimensions; sometimes, even modeling a simple box can be easier than trying to draw the perspectives from scratch.

Below, left to right
1. The profile of one of the arms of the spinner is drawn in the Revolve window.
2. This is turned into a basic 3D model automatically—the outline can then be refined.
3. By adding extra lights and changing the gloss value of the surface, we are able to make it far more shiny.
4. A simple ball is added to the top of the object.
5. The ball and stick composite is duplicated and arranged around a central pinion—itself an adaptation of the original spinner arm.

1 2 3 4 5

part 04. 3D illustration

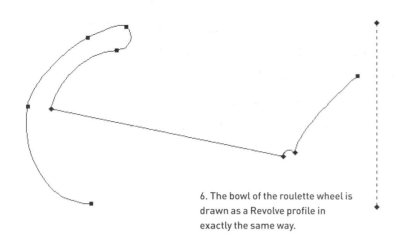

6. The bowl of the roulette wheel is drawn as a Revolve profile in exactly the same way.

7. The inner surface of the wheel is selected, and alternating black and red squares drawn on it as mapped artwork.

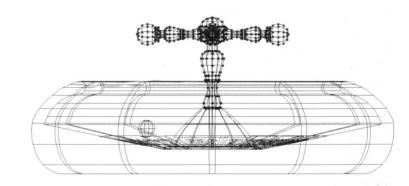

8. The completed bowl now shows the numbers correctly mapped onto the interior.

9. To align the spinner with the bowl, it helps to switch to Wireframe mode and view the entire assembly from the side.

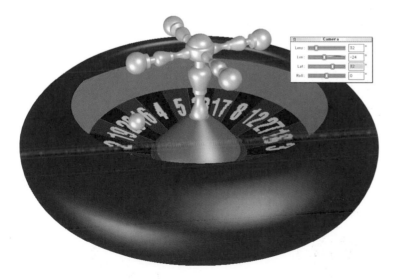

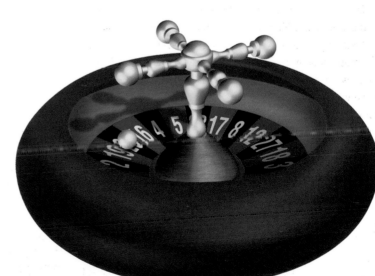

10. With the wheel now complete, we can adjust the viewing angle to add perspective to the scene.

11. The final wheel was exported as two separate pieces of artwork—one for the spinner, and one for the bowl. This made the two elements easier to work with in Photoshop, where texture and shading were added to complete the scene.

chapter 01. 3D applications

For work that is beyond the scope of the task-based applications already mentioned, you will need a full-blown 3D package. Many are now available for standard Macs and PCs, and standards are rising while prices fall—you will now typically pay only twice as much as for a professional 2D application, rather than ten times, as in the past.

Digital illustrators have no need to invest in a top-of-the-range 3D solution. Such programs are designed around advanced animation and effects, and are unnecessarily complex for stills artists. Having installed an affordable general-purpose package, you can always add tools to provide any extra features you need. Most programs can interchange 3D data, and combining a number of applications and plug ins is often more productive than trying to achieve everything within a single package, however advanced it may be.

On the other hand, it is important to ensure your choice is not a dead end. Check that the manufacturer releases regular updates, and will let you upgrade to an improved version when it becomes available. Look for evidence of a sizable and enthusiastic base of users, who will exchange tips and fixes as well as encourage effective development of the product. Plug ins are of benefit only if plenty are available in a compatible format—a healthy number of plug ins from third parties, including smaller companies and amateurs, is a good indicator of the success of a package.

The three basic areas of functionality are modeling, rendering, and animation, each of which we consider in more detail on the following pages. It is preferable for a program to offer more than one kind of geometry for modeling. Ideally, polygons, NURBS, and subdivision surfaces (see page 116) should all be present, but support for two of these is acceptable. Most professional 3D packages support animation, but if this is something you are likely to explore, avoid those with limited animation features.

PART 04. 3D ILLUSTRATION

CHAPTER TWO

3D MODELING AND RENDERING

3D applications tend to have complex and cluttered user interfaces, making a large screen—or more than one monitor—almost essential for a comfortable working environment. You will often want multiple windows to show objects, lights, and cameras within a scene from different angles and at various zoom factors. Extensive toolbars and palettes are needed to accommodate the hundreds of commands and options available, although many can be hidden when not in use. Modeling and animation may be handled separately from rendering, or all three may be combined into a single interface, as in Maxon Cinema 4D XL. Seen here on the Mac, this application will also run on Windows PCs.

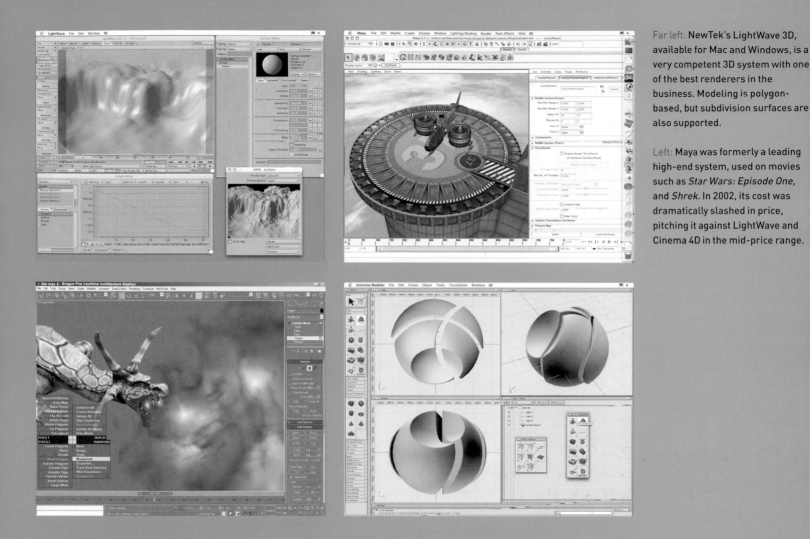

Rendering capabilities vary widely, as do speeds, and you should bear in mind that waiting time can be measured in hours. Some of the more advanced programs enable you to use separate third-party renderers: 3ds Max—a very capable package in itself—has at least four plug in renderers supporting functions such as global illumination and radiosity, and sub-surface scattering.

Professional packages with all the features you are likely to need include Newtek LightWave 3D, Maxon Cinema 4D XL, Softimage/3D, Electric Image Universe, form•Z from auto•des•sys, and Alias/Wavefront's Maya Complete. All of these cost under £2,000, but at lower prices there are capable programs such as Strata 3D, Pixels3D, Caligari trueSpace, and Eovia's Carrara and Amapi 3D. Among the more expensive options are Maya Unlimited, Softimage/XSI, and Discreet's 3ds max.

Above left: 3ds max, from Discreet, is a popular high-end 3D solution running on Windows PCs. It is particularly suited to games development, and has been very successful in this booming area of the 3D graphics market.

Above right: Electric Image Universe, available for Macs and PCs, has a unique modeler and the fastest renderer of any commercial system (as long as you do not turn on raytracing), as well as great output quality.

LightWave 3D and Cinema 4D XL are ideal choices for the illustrator. Both offer excellent modeling capabilities, and very fast, high-quality rendering. LightWave can be problematic when rendering very large images, but has a huge community of dedicated users, and a vast library of free and shareware plug-ins. It also supports HDRI rendering (see page 121), and has an ingenious user interface. Cinema 4D XL has a very flexible interface and is becoming increasingly popular. Well suited to rendering very large images, it is stable and has a very fast development schedule. It is also available in a cut-down edition aimed specifically at graphic artists, Cinema 4D Art.

While 3D applications are extremely demanding, almost any current Mac or PCs above bargain-basement level will be more than capable of handling them. Memory is certainly vital—256MB of RAM is a bare minimum and 512MB would be better—and a large hard disk is a necessity. Otherwise the most significant component is the graphics card, which must be OpenGL accelerated. Again, specifications change quickly, so it is wise to check with magazines and Web sites before buying, and choose a well-regarded graphics card toward the top end of the current range.

3D MODELING is the process of building the object that you will later render to produce a finished image. All 3D programs have a world coordinate system, starting at 0,0,0—the "world center"—and extending away from that point in all directions. The three perpendicular axes are named x, y, and z, and by using these you can define any location, or point, in space.

Everything else in 3D modeling is built on this basis. Connect three points to form a triangle, and you have a polygon, or face. Join a number of faces together, and you can create any object. In practice, you no longer have to build objects point by point or face by face, as there are sophisticated tools that let you work much more efficiently.

The face, or "poly," is one type of geometry in 3D, but there are others. Curves can be created, as in 2D drawing programs, and used as the starting point for more complex objects. To create a pipe in the shape of an S, for example, first draw a path by placing points in the familiar way. Then draw the cross-section, in this case a simple circle. Finally, extend the profile along the path to create a 3D pipe. This process is called sweeping. The surface created might be polygonal, or (depending on the 3D software you are using) formed from Béziers or Non Uniform Rational B-Splines (NURBS).

Béziers and NURBS are special types of geometry whose surface is defined by mathematical equations. The former are familiar from 2D illustration software. Objects created using these geometries still have points, but unlike polygon objects they do not have faces. Surfaces are therefore continuous rather than faceted, making them particularly useful for organic objects, where tight curves need to remain smooth and flowing. When it comes to rendering a surface, however, the 3D software must freeze the object into a polygon mesh so that it can be shaded. The benefit is that the density of the mesh generated—that is, the number of

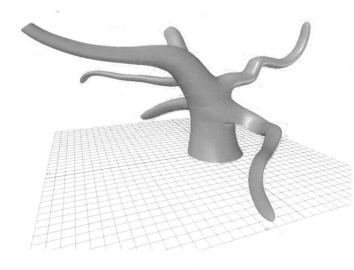

polygons required to construct it—can be precisely controlled, so that at any distance from the object it always appears smooth, unlike a conventional polygonal model. NURBS and Béziers are therefore said to be resolution independent.

3D programs also come with a stock of primitives. These are ready-made 3D objects that you can add to your scene and assemble into more complex forms. For example, to make a table you first create five cubes. Four are stretched along the y-axis to make legs, and the fifth is stretched along the x- and z-axes to form the top.

Procedurals are a special class of primitive object. In effect, these are small programs that generate 3D objects. Procedural objects often have controls that can be accessed to change parameters such as radius, the rounding of edges, or polygonal resolution.

A final common geometry type is the subdivision surface. This combines the hands-on nature of polygons with the resolution independence of NURBS. You can use most of the standard polygon tools, but do not have to worry about your objects appearing faceted. Subdivision surfaces can be used to create any kind of object, but they tend to be well suited to organic objects such as characters.

Left: Subdivision surfaces combine polygons with independent surfaces of NURBS-like resolution and are ideal for creating organic forms. The outer "cage," which has few points and faces, controls the inner smooth surface beneath. Because there are fewer points on the cage, it is easy to edit to change the shape of the surface beneath.

Right: Polygon modeling, as used in games, can generate extremely detailed and realistic objects, limited mainly by the processing power of the computers available to run the software. In the four years between the launch of Epic Games' *Unreal* and *Unreal II*, from which this image is taken, the number of polygons per character has increased tenfold.
Picture: Legend Entertainment/ Epic Games/Infogrames

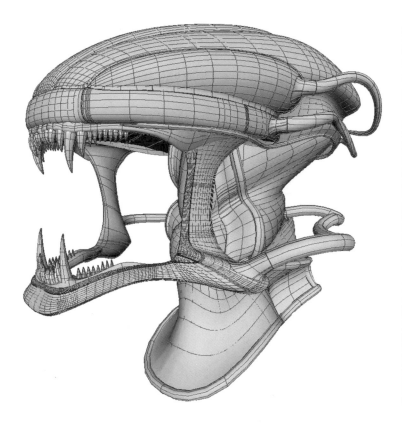

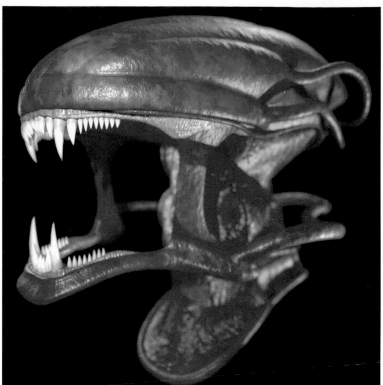

Above: **NURBS** surfaces are well suited to organic modeling and characters. Models such as this alien head can be created by stitching together various NURBS surfaces. Unlike other kinds of 3D geometry, you can create blends and fillets between NURBS surfaces to make smooth, seamless joins. The model (left) is displayed with an isoparm wireframe overlay, enabling you to see its structure. NURBS are resolution independent, so when rendered (right) there are no visible faceted edges, even when viewed close up, as would inevitably be the case with polygon objects.

chapter 02. 3D modeling and rendering

LIGHTING in 3D is just like lighting for film or photography—more or less. However, a computer enables you to manipulate any form of light, such as sunlight, in any way you choose. As in real life, an unlit scene would be invisible when rendered. Within your scene, you can place four main types of light: spotlights, point lights, distant (or parallel) lights, and ambient light.

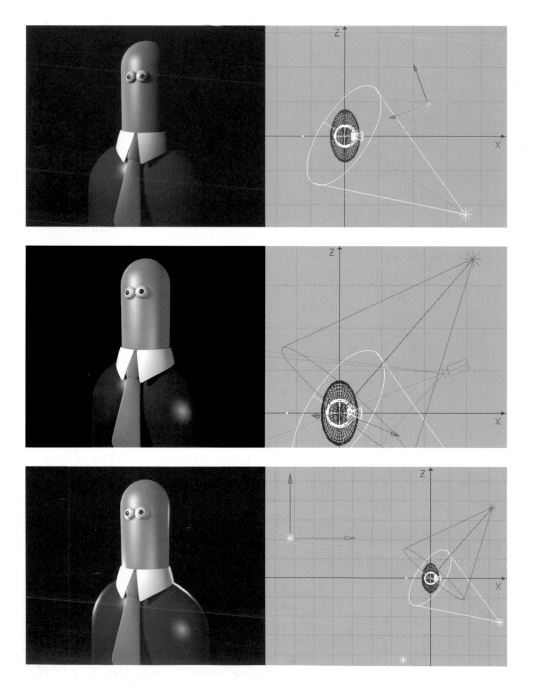

To cast a cone of light onto a subject, as on a stage, you use a spotlight. Spotlights are very practical, since their illumination can be focused on one particular area. Point lights are good for simulating a lightbulb, camp-fire, or any other type of light that is cast from one location and dispersed in every direction .

For an exterior, however, you may want the effect of natural sunlight, and for this a distant light is most suitable, because it acts like a light source infinitely far away from the subject. Ambient light does not have a location or direction, but

STUDIO LIGHTING SETUP

1. A simple three-point lighting setup is easy to achieve, and mimics similar setups used in photography. Our scene is a simple 3D character that needs to be clearly lit. Begin by adding a single spot (shown as a white cone in the wireframe), which is the key light. Notice that much of one side of the object is still in darkness.

2. A fill light is added (shown as a black cone here) to fill in the area in shadow. Importantly, it is not as bright as the key light, but about 40% of its brightness. The fill is positioned on the opposite side of the camera to the key. There's still a problem: the black body does not stand out from the background.

3. To fix this, the third light comes into play. Two bright kicker lights—also known as backlights or rim lights—are added behind the object (marked in white, left and bottom) and positioned so that, from the camera view (marked in green), they catch highlights on the character, making it pop out from the background.

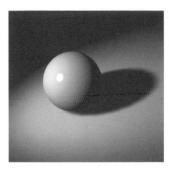

illuminates all parts of a 3D scene equally. You would use ambient light to decrease the contrast of hard black shadow areas in a scene, for example. Many 3D artists prefer not to use it, and instead fake ambient lighting using one or more of the other light types.

There is another form of light called an area light. This is similar to a point light, except that its source of illumination is spread over an area, normally a square or disc. You can use area lights to simulate a photographer's light diffuser, or an open window.

Aside from the way they illuminate objects, the various types of light also cast shadows in their own specific ways. Distant lights and spotlights will cast very different-looking shadows, because their rays travel in different ways (radially in the case of a point light; in parallel in the case of a distant light). These two light types also use a process called raytracing (see page 122) to enable their shadows to take into account the transparency of surfaces. Raytraced shadows are usually hard edged, and can look unrealistic. Soft-edged raytraced shadows, such as those cast by area lights, can be rendered, but are computationally expensive, which in practical terms means rendering can take a very long time.

Spotlights can raytrace, too, but they can also use depth maps. These render quickly, as long as sufficient memory is available in the computer. Depth map shadows' edges can be variably blurred to create realistic soft shadows—not as realistic as area shadows, but usually convincing. On the other hand, depth map shadows do not usually take into account surface transparency, although Cinema 4D XL can pull this off.

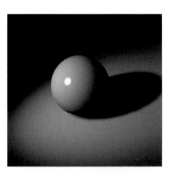

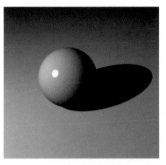

A good place to start when lighting in 3D is to use the traditional photographer's two-point light setup. A spotlight is used as the main light, or key, while a second, dimmer spot or point light fills in the shadows. This is called the fill, and is usually placed on the opposite side from the key light. So if the key light is above and to the right, the fill will be on the left, level with the object or slightly below. The fill is often moved backward away from the key.

A three-point lighting rig adds a third backlight, sometimes called a rim or kicker light. This is positioned behind the object and either above, below, or to the side, so that it just catches its edge. Rim lighting is useful for pulling an object out against a dark background.

Although your basic lighting setup may resemble a real-world rig, it would be unusual to rely entirely on a simulation of physical lighting to render a scene. A useful trick of virtual lighting is that lights can be set to a negative value. This removes illumination from a scene wherever they "shine." Negative lights are good for mopping up light spillage and for darkening areas of a scene that look over-illuminated.

TEXTURING

Applying textures is a vital technique for making models appear more natural, and more like the objects they are intended to represent. For newcomers, it is also one of the more confusing aspects of 3D illustration.

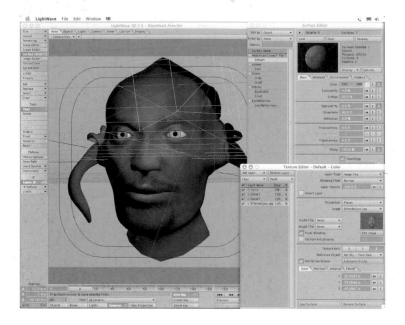

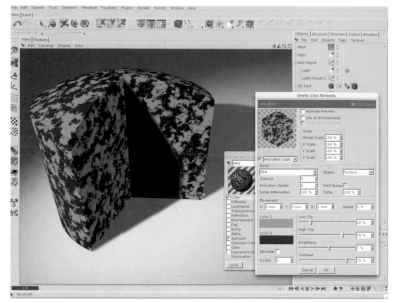

3D programs enable you to use a bitmap—whether a photo or an image painted from scratch—to create surface detail on objects. The bitmap is wrapped around the object using a projection. This can be thought of as curving the flat image in space, enveloping the object, then shining light inward through it onto the object's surface. Where light strikes the object, the texture will appear. This is called projection mapping, or just mapping, and can be used with movie files or sequences as well as still images.

The shape of the projection can vary. For example, to map a flat plane you can use a planar projection parallel to the object surface. To map a sphere, a spherical projection is used. The shape of the projection, however, is independent of the shape of the object.

The obvious use for a texture map is to provide color and pattern, but maps can also control other properties of the surface, such as its shininess, transparency, or bumpiness. Here, the texture is created in grayscale—whiter parts let the surface's original property show through, while blacker parts mask it out. For example, to add a label to a bottle, you first create an image map of a black square on a white background, and apply it using a cylindrical projection to the transparency property of the bottle. Where the texture map is white, the glass will be transparent, where it is black, it will be opaque, forming the label. A separate RGB image could then be applied to the label to add its printed message.

Above left: Advanced mapping can be performed by breaking a complex model up into many different surfaces, and then mapping these separately using suitable projections. This raises further difficulties, because you also need to make sure the edges of each section blend well with their neighbors.

Above right: As an alternative to image maps, 3D shaders can be used. These are procedural textures whose patterns exist in three dimensions, so they don't require projections, but rather permeate the entire object. In essence, the texture you see on the object is where the surface intersects the volume. The benefit is that there is no stretching or smearing of the texture.

To help keep these maps together, 3D programs use the concept of a material, which contains all the surface property settings and maps for a particular kind of surface. The material is usually independent from the object it is applied to as well as the projection used, so it can easily be applied to any object in your scene.

When creating a 3D object, the trick is to know where to stop modeling and begin texturing. It is surprising how little detail is often needed in the geometry, and how much can be supplied by textures.

Bump maps are used to take over where geometry leaves off. A bump map is a grayscale image map whose brightness values create virtual perturbations on the surfaces of an object. (A similar effect can be used in 2D software—see page 47.) White in the map causes a bump, black a dip. These surface bumps only change the shading of the object; they do not change its geometry, so lights will

MODELING WITH DISPLACEMENT MAPS

1. It is possible to create an entire model by displacement, and thus avoid time-consuming geometry. Here is an image we want to turn into a 3D model. The background is 50% gray, indicating no displacement. The image is white, so it will rise above the surface, and is slightly blurred to round the edges.

2. In the 3D program (Maya in this case), a NURBS plane is created. A material is assigned to the object and the image is loaded, and applied as a displacement map. Test rendering shows the displacement is occurring, but the resolution of the NURBS object is insufficient to create the fine detail required.

3. The tesselation on the NURBS surface is increased, so that it is subdivided many times into tiny triangles before the surface is displaced. The result is that the bitmap is accurately represented in the displaced geometry. Note that, because it is a real displacement of the geometry, it casts shadows.

4. In Maya, you can go one step further and convert what will be rendered into a polygonal object. The displacement is now seen as geometry, and you can continue to model the resulting object as normal. In this way you could build up a finished, realistic object without ever doing any modeling as such.

1

2

3

4

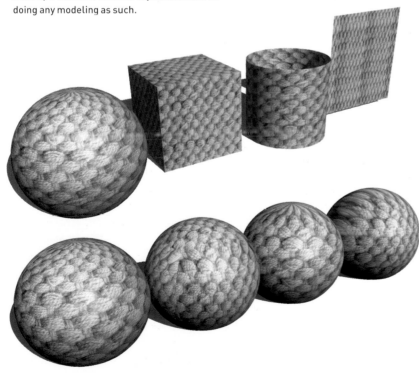

not create additional highlights on their peaks or shadows in their troughs. But the details in a bump map can be infinitely finer than the geometry of the model. The only limit is how big the map resolution is and how close the camera can get to the surface.

A typical use of a bump map is the rendering of human skin. There is no need to model each tiny fold, crease, or pore, because all this detail can be created using bump maps.

Displacement maps are similar to bump maps, but they really do move the geometry to which they are applied. As such, displacements are dependent on the geometry of the object being fine enough to recreate the detail present in the map. While this is a tricky proposition for polygon models, it is ideal for NURBS, since the surface can be created during rendering with any resolution you like. A particularly clever technique is to use animations or movie files as displacement maps to produce effects such as undulating water.

Top left: **Mapping textures to objects** involves using projections. Here are some standard projections used in 3D, applied to objects of similar shape. Left to right—spherical, cubic, cylindrical, and planar. In practice, of course, you will rarely be mapping such simple objects.

Bottom left: **Choosing the right** projection for an object is usually a compromise. To illustrate, a sphere has been mapped using each of the four projections. Some look a lot better than others—notice how the planar texture is smearing around the edges of the sphere.

RENDERING is the process of creating a 2D image or animation from the 3D data you have created. Whether it is a simple sphere or an entire city, a human character, or an assemblage of abstract forms makes no difference. The software uses a process called shading to fill in the surfaces with color, taking into account the scene lighting and textures you have applied.

To do this, the software must have a point of view from which to render the scene. This is provided by a camera, which you place, like a light, within your scene, adjusting its field of view (zoom) as required. The camera is not used only for rendering, but also to view the 3D scene during modeling and scene setup. There are other kinds of views to help as well, notably the three orthographic or parallel views that look down the three world axes. You can place multiple cameras in a scene and switch between them. When it comes to rendering, cameras as well as characters can be moved through time to build up a movie.

Because high-quality rendering takes time, various display rendering options are used while working on your scene. Display rendering is usually accelerated using OpenGL, a standardized set of graphics commands that are understood by both 3D software and graphics cards, enabling the latter to process the display very efficiently.

HDRI images store floating-point brightness values that can be much greater than traditional 24-bit color files. When such an image is used in a 3D program as a source of illumination with radiosity rendering, the results are highly realistic, since the scene lighting mimics the lighting at the time the HDRI image was captured. A "light probe" image of a forest (left) has been used in LightWave 3D as a spherical environment background for the rendering seen here (right).

Objects can be viewed fully shaded, with textures and scene lighting taken into account. Even special effects such as reflections, fog, depth of field, and motion blur can be displayed very quickly. Nonetheless, OpenGL is not a final-quality rendering process.

Assuming all other aspects, such as lighting and texturing, have been correctly set up, the final image quality is dependent on the rendering. If you render the scene pixel-for-pixel at the size required, you will get aliasing, or jagged edges (see page 20–21). To smooth this out, the software uses anti-aliasing during the rendering process, which adds to the rendering time but produces far superior images. Most 3D programs offer adaptive anti-aliasing, which smooths only pixels that need it, based on a threshold set by you, and speeds up rendering considerably. Some programs, such as 3D Studio Max and Cinema 4D XL, also give a choice of anti-aliasing algorithms that create different image qualities.

Raytracing is a special rendering technique that can be combined with standard shading to create effects such as reflections, refractions and transparent shadows. The software shines imaginary light rays onto the scene, tracing their paths as they strike objects.

part 04. 3D illustration

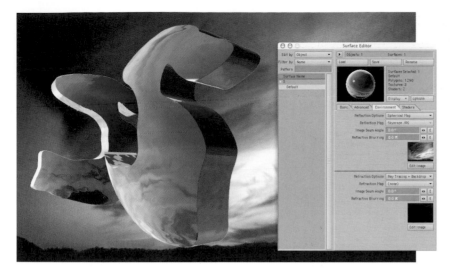

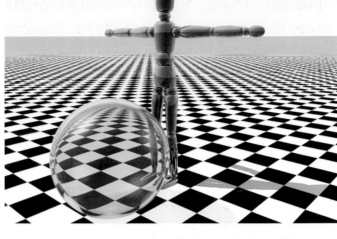

Above: **Rather than raytracing, many 3D artists prefer to fake effects, such as reflections, to save time. Using environment reflection maps, you can make objects appear reflective without raytracing. The effect is not strictly accurate, but in most cases it provides the appearance of reflectivity well enough to fool the eye.**

Above right: **Raytracing takes longer than normal shading methods, but can simulate natural effects such as reflection and refraction. By plotting the paths of millions of light rays through the scene, a renderer can accurately recreate these phenomena, which would otherwise be impossible to represent accurately.**

Right: **Depth of field (DOF) rendering simulates the shallow depth of field obtainable with real large-aperture lens and camera systems. Some portions of the image are blurred and others in focus, depending on the object's distance. You have complete control over the degree of the effect, and results can be very photographic.**

Thanks to advances in software techniques and computer power, there has been a recent increase in the use of special rendering techniques that take into account the effects of lighting in a scene—more specifically, the way light is bounced between objects. Global illumination and radiosity rendering produce very realistic images that have a natural warmth and ambience to them.

By taking global illumination further, you can do away with scene lighting altogether and use an image to light your scene. A special HDRI (high dynamic range imagery) bitmap encircles the scene, and its brighter portions act like light sources, casting the original illumination and its color onto objects. Using this method, you can recreate with breathtaking realism the lighting of any real-world location. Creating HDRI images remains quite an involved process, but many ready-made examples are freely available via the Internet. LightWave 3D is currently the only 3D application that directly supports HDRI rendering, while most others offer radiosity and global illumination.

Global illumination, or GI for short, is a rendering method that takes into account the effect of light bounced between objects. Here a scene has been rendered with GI (left) and without . Notice the effect of color bleeding from one object to the next, and the warmer, less sterile look of the image.

3D INTO 2D Combining a 2D image-editing program such as Photoshop with a 3D package enables you to get the best of both worlds. Individual renders can be brought into Photoshop for final tweaks to overall levels and color balance in the scene, or to smooth over minor rendering glitches. Or, having rendered a number of 3D objects separately, you might composite them all into an illustration.

WORKING WITH MULTIPASS RENDERINGS

1. By rendering a multi-pass file, you give yourself the option of making changes easily in Photoshop. In this multipass rendering, the scene has four spotlights. Each light has its own layer folder in the Photoshop PSD file containing shadow, specular, and diffuse layers.

2. Working entirely within Photoshop, you can deactivate any of the layer folders to turn off that light completely. Here, the red light layers have been turned off. In the image, all the components of the red light vanish, including its shadows.

3. The white light has now also been turned off, leaving just the blue and green lights to illuminate the scene. We can compensate for the reduction in brightness by first adding a Levels adjustment layer above the blue light's layer folder, then increasing the gamma and decreasing the white point.

4. Finally, we have duplicated the specular layer of the green light (which is applied in Screen mode) and used Levels to brighten it, increasing the highlights. To brighten up the image overall, we reactivate the diffuse layer of the white light and adjust its opacity to reach the desired level.

It is important to plan this type of work before you render, and make sure you also render out an alpha channel (see page 46) so that each 3D element can be separated from its background. Most 3D programs can save images in standard bitmap formats, such as TIFF, with an embedded alpha channel. Alternatively, the alpha can be saved in a separate file and re-applied in Photoshop.

If there is more than one object in the scene, the 3D software will need to know what to include in the alpha channel. For example, if you rendered a sphere resting on an infinite floor plane, viewed from above, you might expect the alpha channel to show a disc surrounding the sphere, but in fact it would be completely white. An obvious solution would be to delete the floor before rendering. However, in many cases you may want to include background objects in a rendering, though not in the alpha channel, and it would be needlessly time consuming to render each on its own. To get around this, many 3D programs let you set whether each object will appear in the alpha channel or not. Making full use of workflow enhancements such as this is an essential aspect of advanced 3D work, since render time plays such a large part in your efficiency.

Experienced 3D artists know only too well how much quicker it is to change something in 2D than in 3D. If the client decides the color of a logo in a scene needs changing from blue to red, you could make the alteration in 3D and re-render. But why bother? It is far quicker to do it in Photoshop using the previously rendered image. Of course, if the client wanted a sequence of

USING ALPHA CHANNELS

Above: This 3D object has been rendered and saved as a TIFF file. We now have two layers, each with a layer mask that we have created from the relevant alpha channel generated by the 3D program. The star's layer mask matches its own alpha channel, so anything outside itself will show through. The circle has the reverse of the star's alpha channel, so only those parts of it that do not overlap the star are seen.

illustrations showing the scene from different angles, and you had not yet rendered the others, it might well be quicker to make the change in 3D than to re-color all the logos in Photoshop. More often, though, if you can change something after the rendering, it will be quicker. Recognizing this, many 3D programs now make post-processing of renderings even easier by offering multipass rendering.

With multipass rendering, the different components of an image are saved as individual files, or, better still, as layers within a Photoshop PSD file. What we mean by components is not separate objects, but different material and illumination information. So highlights alone will be on one layer, color on another, diffuse shading on a third, shadows on yet another, and so on. The great thing about multipass rendering is that it does not take significantly longer, since internally the 3D software calculates all these "buffers" separately anyway.

Armed with a multilayered version of a rendering, you can select just the highlights in Photoshop and use Levels to brighten them, or duplicate the layer and blur it for specular blooming effects. You have similar control over any other property, including reflections, luminance, and sometimes even radiosity, enabling you to adjust its contribution to the overall lighting. In Cinema 4D XL you can also save out each light's diffuse, specular, and shadow contributions as separate layers (handily arranged in layer folders in the Photoshop file), enabling you to adjust all of the lighting in a scene even after the final rendering.

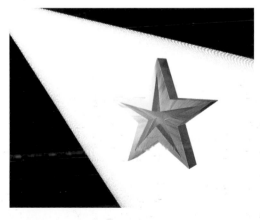

Top left: If you place a masked element over a color that's different from the background on which it was rendered, you will see a dark or light halo around the 3D object. This is because the anti-aliasing applied to the edge of the object during rendering combines the colors of the object and background pixels. When compositing over a single-color background, this can be avoided simply by setting the background to the same color in your 3D program.

Left: Where this cannot be done—for example, because the object overlaps different elements in the composition—start by rendering the object over a black or white background. In Photoshop, having applied the alpha as a layer mask, remove the mask, opting to apply rather than discard it. This leaves your object on a transparent background (represented as a checkerboard). The halo can now be removed using the Remove Black Matte or Remove White Matte command.

Left and below left: When compositing volumetric effects, such as light shining through dust or smoke, a good choice is the Straight Alpha option. Rather than applying these effects to the background itself during rendering, the software then places only the transparency information, which creates the effect, in the alpha channel. When compositing in Photoshop, you can use this to apply the volumetric effect over any background.

Below: **Advertising photographer Benedict Campbell brings well-honed lighting techniques to 3D scene building. Created at vast resolution for exhibition display, this image was conceived as a re-working of Pre-Raphaelite religious paintings. Within the sparse composition, details tell all: moonlight; an elevated location; awe; and mystery (the white glow in the rear window represents the angel Gabriel).**
Benedict Campbell
www.debutart.com

Right below: **Sean Rodwell** starts with abstract forms in Cinema 4D, tweaking and adding elements in 3D before rendering out bitmaps that are colored, composited, and retouched in Photoshop. This image was created for Digital Vision's Infinity series (www.digitalvisiononline.com).
Sean Rodwell
www.aeriform.co.uk

Right: **Although** Bryce was designed as a landscape creation tool, its ability to create and render both geometric shapes and metallic surfaces made it the ideal tool for creating this simple spider, constructed entirely from basic Bryce objects.
Steve Caplin
www.stevecaplin.com

SHOWCASE

Right: Illustrator Eddie Bowen has been working in 3D longer than most. This image—influenced by African exhibits in the New York Metropolitan Museum of Art—was created in Cinema 4D, with textures prepared in Photoshop. The shiny, toy-like style was achieved by using uniform specular highlights and reflection.
Eddie Bowen
cosmo7.com

Opposite page: Daniel Mackie's style recalls Ralph Steadman and Francis Bacon. It's surprising to see such a visceral approach explored in 3D modeling, but the combination of shiny surfaces with exaggerated cartoon features and wild motion blur helps this image to pack a punch.
Daniel Mackie
www.danielmackie.co.uk

Above: This image of a digital video camera is done in a style that falls somewhere between the descriptive rigor of technical drawing and the shiny simplicity of a cartoon. Illustrator Paul Wootton works in Cinema 4D and Photoshop.
Paul Wootton Associates
www.graphicnet.co.uk

Above: This picture was created in Cinema 4D for a commission from advertising agency McCann-Erickson. Two versions of the sky—sunny and stormy—were modeled separately, then rendered out and merged in Photoshop. Rather than applying the ark's wooden surface as a bitmapped texture, Nicholson modeled each plank individually to give greater depth. The campaign was for home flood insurance.
Philip Nicholson
philip@illustrations.netq.se

Above: This image, titled *The Visit*, was created by François Rimasson using Maya. The face was based on a standard head model, heavily edited, with additional items created using Nurbs. Lit with six area lights, the result is an astonishing homage to Vermeer, whose *The Milkmaid* inspired the piece. The artist, who works as a 3D modeler and character designer for games and films, also cites surrealist HR Giger and *Toy Story* director John Lasseter among his influences.
François Rimasson
rimasson.francois@wanadoo.fr

Right: Illustrator Martin Macrae previously worked in watercolor and gouache, but finds the computer quicker, cleaner, and conducive to a broader range of possibilities. New digital tools are also quicker to learn than painting techniques, he says. This scene was modeled in TrueSpace, then finished in Photoshop.
Martin Macrae
www.nbillustration.co.uk

Below: Doug Stern is Graphics and Illustrations Director at US News & World Report. His cutaway of the Russian submarine Kursk, for *Men's Journal*, illustrates a theory accounting for the vessel's sinking.
Doug Stern
Washington, DC

SHOWCASE

Below: **Created by Arcana Digital for beverage company Baileys, this image of liqueur splashing into an ice-filled box depicts a squeaky-clean version of reality.**
Arcana Digital
www.arcanadigital.com

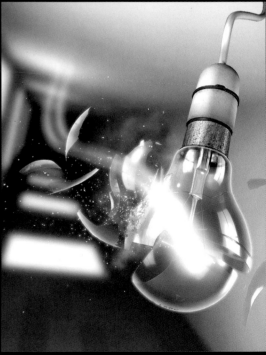

Above: **Faiyaz Jafri's award-winning graphics betray little of the darker side of his work. This image for Amsterdam's _MAN Magazine_ makes use of untextured models in naturalistic poses. The artist refers to his process as "virtual sculpture."**
Faiyaz Jafri
www.bam-b.com

Above: **In this photorealistic image, Simon Danaher imagines a lightbulb swinging on its cord to smash against the glass through which the viewer sees the image. The effect is of a photograph capturing a moment in time with perfect clarity.**
Simon Danaher
simon.danaher@ntlworld.com

Below: Gilles Tran works in POV-Ray a powerful but daunting freeware program from Persistence of Vision (www.povray.org), in which objects are constructed using programming language. This illustration, *The Classroom*, reconstructs a photo taken by Tran, with the addition of a human figure (modeled in Poser). Why take such pains to recreate what already exists? Even in mimicking reality, believes Tran, the artist can "represent the complexity of what he/she experiences." The result is intriguing because "we like to have our senses tricked and deceived. And what is reality anyway, if not a trick of the senses?"
Gilles Tran
www.oyonale.com

SHOWCASE

Left: Richard Tibbitts produced this anatomical image for *FHM* magazine using Cinema 4D. A simple cutaway model was constructed, and detail added using specially drawn textures. Multiple renderings were exported and combined in Photoshop—"This saves time messing around to get the lighting exactly right."
Richard Tibbitts, AntBits
www.antbits.co.uk

Below left: In this picture by Simon Danaher, there's a very short physical distance between the tongue in the foreground and the face behind, yet the tongue needs to be the clear focus of attention. As well as exaggerating the perspective, Danaher used negative lights to accentuate the tongue and prevent the lights on it from over-illuminating the face.
Simon Danaher
simon.danaher@ntlworld.com

Below: You might feel better about having staphylococci in your nasal epithelium if they looked this good. Gary Carlson's image for a medical journal was based on models created using form•Z's Metaformz and Metaballz; the bumpy textures were added using a plug in, and the final rendering retouched in Photoshop.
Gary Carlson
www.artcoreps.com

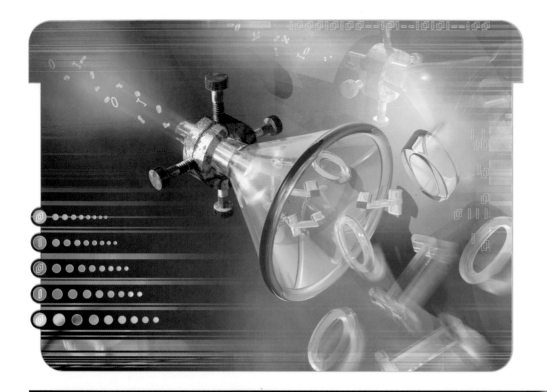

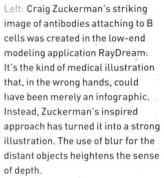

Left: This conceptual illustration for an article about data compression started as a series of profile shapes in Adobe Illustrator. These were imported into a 3D package, where they were lathed and extruded to construct the glass funnel and numerals. Artist Derek Lea reveals the secret behind the final image: "What really brings it to life is a few carefully placed lights and a "mirror" to reflect light back."
Derek Lea
www.dereklea.com

Left: Craig Zuckerman's striking image of antibodies attaching to B cells was created in the low-end modeling application RayDream. It's the kind of medical illustration that, in the wrong hands, could have been merely an infographic. Instead, Zuckerman's inspired approach has turned it into a strong illustration. The use of blur for the distant objects heightens the sense of depth.
Craig Zuckerman
www.craigzuckerman.net

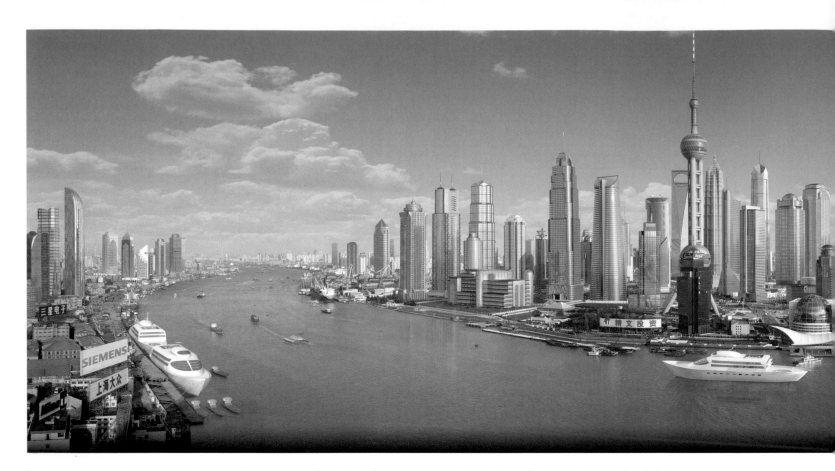

Left: When a car company approached Benedict Campbell to produce this image for a large-format brochure, they expected him to have a physical model manufactured and shipped to his studio for photography. He pointed out that it would be far more cost effective to build the scene digitally. The curve of the river was drawn in Illustrator, then extruded in Cinema 4D. The lighting setup was crucial to the final result, and far more complex than might be expected.
Benedict Campbell
www.benedict1.com,
www.debutart.com

Left: This image was commissioned for the Shanghai Expo to illustrate the planned regeneration of the Pudong area. A series of photos was combined in Photoshop to form the background; the buildings were then modeled from scratch in 3ds max, based on architects' sketches. To get the detail and accuracy required, around 80% of the finished result was achieved with geometry, and only 20% with texturing. The finished artwork was rendered out for display at a length of 50 meters (164 ft). Studio Liddell
www.studioliddell.com

Right: This advertising image for the Sony PlayStation 2 game *Wipeout Fusion*, developed by SCEE, was created by agency Arcana Digital. 3D modeled and photographic elements have been combined so seamlessly that the result is a completely convincing depiction of the game designers' fantasy of London as a racetrack.
Arcana Digital
www.arcanadigital.com

ANIMATION

05

Where animation has traditionally been a painfully slow process—moving each element frame by frame a tiny amount—the digital solution removes much of the drudgery, and lets the animator concentrate on the more creative aspects.

Although the mind-numbing process of frame-by-frame motion is largely automated by software, digital animation still requires painstaking attention to detail. The software takes care of the more repetitive tasks, but the artist needs to keep track of the dozens of individual objects or layers that combine to make up a scene.

All computer animation programs use a timeline system—a chart showing either individual frames or timings (in seconds) along the horizontal axis, with a list of the animation elements down the vertical axis. In many cases, a component will have several attributes such as size, rotation, and color, each of which can be set individually.

Elements of the animation—whether 3D objects, photomontages, or drawn images—are positioned at user-specified keyframes along the timeline. The programs use a system known as "tweening" to generate the positions of each object for every frame between two keyframes: if a human figure has its arm by its side in frame one, and raised above its head in frame 30, the computer works out the position of the arm for each intermediate frame. Sophisticated effects, such as motion blur, provide a better impression of movement by preventing the motion from looking stilted.

Animations for movies and television are usually generated at 24 or 25 frames per second, but those for websites usually use a far lower frame rate—each frame in an animation is a separate image, and for Internet delivery the higher rate would result in files that are far too large to be

PART 05. ANIMATION

CHAPTER ONE

INTRODUCING DIGITAL ANIMATION

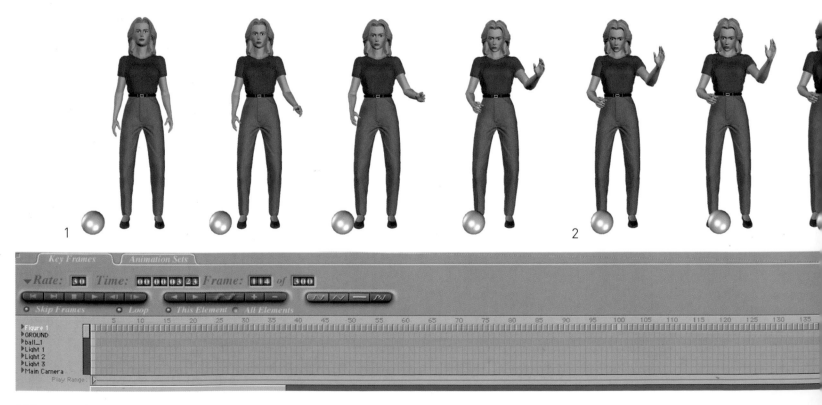

downloaded smoothly. Since most websites that feature animations use a "streaming" process, whereby movies begin playing before they have completely downloaded, it is important to ensure that the download is always ahead of the play position of the movie to avoid stops and starts.

Although you need to specify a frame rate before beginning an animation project, you do not have to adhere to it for the output. Performing a test render of a movie at half the normal frame rate, or even less, will result in a far quicker rendering that will still show how the animation works—even if it is a little jerky in this preview state. Turning off such extras as motion blur, anti-aliasing, and other special effects can also greatly speed up the test render process.

The illustration at the bottom of this page shows a simple animation running over 300 frames, with a keyframe for the female figure at the 100, 200, and 300 marks. Only four discrete positions were created for the figure; all the intermediate steps were generated by Poser (see page 108). The ball, which simply moves from left to right, has only two keyframes—one right at the beginning, the other at the end.

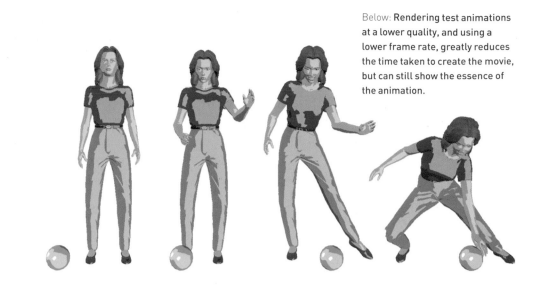

Below: **Rendering test animations at a lower quality, and using a lower frame rate, greatly reduces the time taken to create the movie, but can still show the essence of the animation.**

Below: **This simple animation lasts for 300 frames, and consists of two elements—the woman and the ball. The ball has just two states: on the left in frame 1, and at the far right in frame 300. All the intermediate stages between the two states are automatically interpolated by the software.**

1. At frame 1, the woman stands motionless in a resting position. This frame is, by default, the first keyframe.

2. The second keyframe comes at frame 100: her head has tilted down to see the ball, and her hands are raised in the air.

3. At frame 200, the third keyframe marks the completion of her change in facial expression from neutral to a full smile. Her left foot has also slid to the side in preparation for the final stoop.

4. Frame 300 completes the animation, as the woman stoops to catch the ball. The coordination of the two elements was simple: the ball's final position was aligned with the catching hand in the last keyframe.

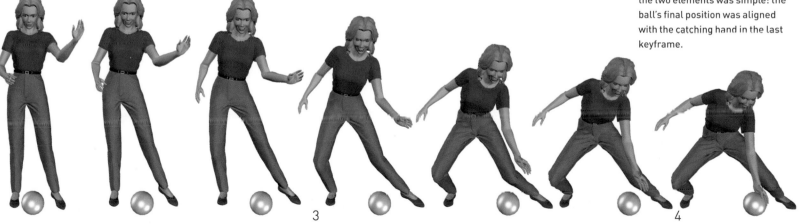

3

4

MACROMEDIA FLASH is the main application of choice for illustrators looking to create a broad range of animated content. The popularity of the Flash format and the widespread availability of its browser plug ins have made Flash animation a standard feature on ambitious websites. The package itself is actually three applications in one: an animation tool and sequencer; an interactive multimedia authoring environment; and a vector-drawing program.

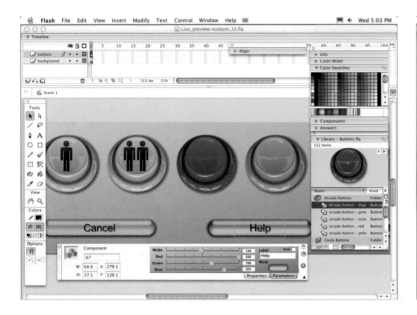

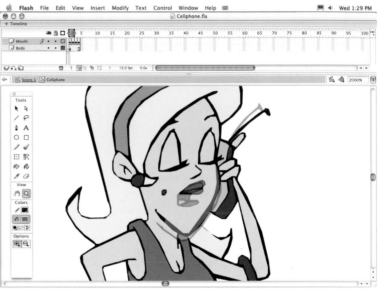

Thanks to these hybrid features, it is capable of creating a broad range of animated and/or interactive content, from website intros, banner adverts, and navigation bars to broadcast-quality cartoons. Added to this, Flash includes its own highly robust programming language, ActionScript–based on JavaScript, which, since the late 1990s has become one of the world's most popular programming languages. ActionScript enables Flash content to work with other Web-based systems and resources, such as databases, so it can be integrated with the most advanced delivery systems.

We are mainly concerned here with the vector animation capabilities of Flash, which are both powerful and suitable for

Above left: **The Flash user interface matches that of other Macromedia products, such as Fireworks and FreeHand. A series of dockable and collapsible panels contains all the main controls and features, while the animation timeline is always available at the top of the screen.**

Above right: **Flash, like other animation tools, offers "onion skinning" as an aid to the animation process. The current frame's artwork is overlaid semi-transparently with the illustrations in the prior and subsequent frames, so you can make adjustments taking these into account.**

many types of work. Although Flash is capable of animating bitmaps and even handling full-motion video content, its native file format is vector based, and this is where its core strengths lie. Unlike Director, Flash relies on its low-bandwidth vector format to transmit the final animation via the web. Most Internet users will have encountered Flash content on hundreds of websites, whether as overt graphical content or in enhanced navigation features.

Flash movies are very compact, and download fairly rapidly even on modem-based connections. However, standard web browsers, such as Microsoft Internet Explorer and Netscape Communicator, need a Macromedia Flash Player plug in before they can display Flash content. Although over 20 million users have already installed this free download, most site owners still recognize the need to provide parallel, non-Flash content to ensure material is universally accessible.

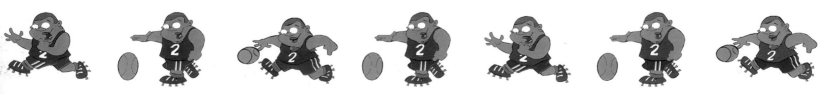

Flash provides a wide variety of vector drawing tools with which to create characters and backgrounds, and you can also add imported vector graphics, bitmaps or video clips to your movies. For video playback, Flash uses Sorensen Spark encoding and playback technology, which enables very high quality video to be streamed at low connection speeds over the Internet.

Central to Flash is a powerful animation sequencer. The organization of sequences, or movies, is achieved using a variety of methods. Each Flash movie can contain any number of scenes, which can be arranged in any playing order. ActionScript commands can be applied to individual objects within a scene or to the whole scene. Each scene can contain an unlimited number of layers, which are viewed from front to back in the scene, as in an ordinary vector drawing. The stacking order of layers is arranged inside a familiar timeline: the top layer in the timeline appears at the front of the scene, and the bottom layer at the back. There is also a stacking order within each layer, and at the top of this—called the overlay level—are special types of object, such as bitmaps, text, grouped items, and symbol instances. Symbol instances, as in vector drawing programs, are references to an object stored once for all in a Flash library file.

A series of frames within a sequence of scenes is thus built up to make a movie. Within each frame of the movie you can have elements that change size, position, and color from the previous frame. Using scenes, you can organize sequences of frames within a movie, and link multiple scenes and movies together to complete a longer animation. You can also create traditional frame-by-frame animation using a separate image for each frame, and tweening is offered to automate the creation of intermediate frames between start and end images.

Top left: **Once you have built all the separate animated elements for your scene, the most economical way to build an animation is to convert each element into an animated symbol. Symbols can be animated, static, or interactive (like web navigation buttons). Here, we have converted all of our animated objects into Flash symbols, and we are now ready to start building a complete animated scene.**

Left: **Flash has some useful features that let you organize a scene to make it easier and more productive to animate. Once all your symbols have been created, the next step is to create a series of hierarchical layers in the timeline, where they can reside. Here, we have set all the elements in their own layers and positioned them for the first keyframe of the scene.**

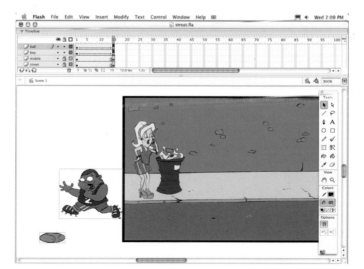

Bottom left: **Flash's frame tweening feature is simple but powerful. From the timeline, you set the first keyframe. Next, you decide which animated elements are to move and over how many frames. We have set the animated boy and his basketball to move across the scene in 15 frames. A keyframe is selected for frame 15, and, using the tweening controls, we move the animated boy and ball to a position off-screen at that frame. Flash creates all the in-between frames to form the animated sequence** (below).

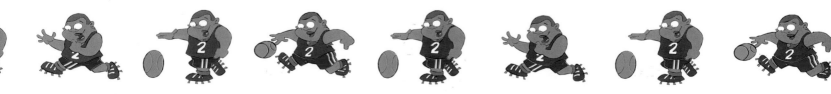

AFTER EFFECTS Adobe After Effects is a powerful animation program that combines still images with movies and sound. Designed to work in conjunction with Photoshop, it can open files from that application directly—each layer in Photoshop will be retained as a separate object in After Effects. This means that it is possible to construct an entire animation, element by element, within Photoshop; opening the file in After Effects lets all the elements be animated.

The range of animation techniques employed by the program is extensive. Simple effects include rotation, scaling, and movement of objects over time—the most basic animation controls. Motion events can be triggered automatically by movies or sound files; for example, the size of a split in a figure's mouth can be determined by the volume of an audio file, making the figure's lips move in time with recorded speech to give a reasonable impression of talking.

Many more sophisticated effects are also available, such as the ability to vary the color, opacity, and sharpening of a layer. Several Photoshop plug in filters, such as Ripple, Spherize and Lens Flare, can also be animated over time. In addition, After Effects includes a unique 3D engine, whereby flat images are arranged in a virtual 3D space; they can then be rotated and viewed from any angle, made to cast shadows, and so on.

Like most animation applications, motion in After Effects is controlled by a timeline. Colored bars show the length of time for which an object is visible, while controls for each object indicate the angle of rotation, scaling, or degree of special effect at each point. Tweening, the process whereby intermediary steps are calculated between keyframes, applies to all the parameters of a chosen object, so a Lens Flare filter, for example, may be set to start from nothing and gradually build to full strength by setting the opacity at 0% and 100% at two keyframes. By adding a third keyframe marking its focal point in a different position an object can then be made to move across the image area.

Drawing a curved path between the second and third keyframes will make the flare follow that path rather than moving in a straight line. The final result will be that of a spotlight fading into view and then panning smoothly across the scene.

After Effects is designed for creating animations for TV and movie display, as well as for multimedia and web projects. The output quality is easily good enough for television; since the source material consists of high-resolution still images, there need be no concerns about the broadcast quality of video footage. Many professional television title sequences are created using After Effects, as the results can be output to a range of standard movie formats.

Above left: It is frequently necessary to break down objects into their constituent parts so that each can be animated independently. Here, the head of John F. Kennedy is a single element; the eyeballs are placed on a separate layer behind it, and the pupils on another layer between the two. In this way it is possible to move the pupils within the eye sockets. Another layer containing eyelids lets him blink.

Left: All the images and sounds used in a project are referenced through a single palette. This indicates the size, type, and location of the original files, and lets each be previewed in isolation.

Left: The animation is previewed in its own window, which may be set to a variety of sizes. The rectangles inside the image area show the Action Safe and Title Safe areas for film and TV use.

Below: Time controls let the animation be played at a set frame rate, or stepped through frame by frame forward or backward.

Above: The timeline shows the length of each picture and sound element; for each image the length of its "bat" indicates the time for which it will be visible in the finished animation.

TOON BOOM STUDIO is a complete 2D animation application that is ideal for creating web graphics and other multimedia applications. Even novice digital illustrators may find that it suits their purposes better than Macromedia Flash. While most new media animators have settled on Macromedia Director or Flash as their main program, neither is very attractive to traditional animators who want to work in a digital environment. Toon Boom Studio is aimed at the professional animator who needs a tool for the single purpose of emulating traditional animation techniques.

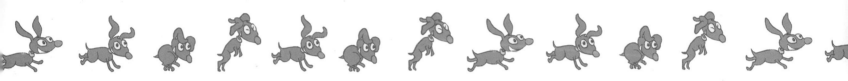

This program is based on US Animation, a high-end package for broadcast and film production. It uses Macromedia's Flash graphics and animation technology, omitting the interactive capabilities. The entire program is based on tried and tested animation production techniques, and as a result it is exceptionally efficient. Work of an impressive quality can be created with relative ease, and even newcomers to the field may find Toon Boom suits their purposes better than Flash.

Toon Boom Studio has two modes of working: Drawing and Scene Planning. All the graphic elements of an

Below: Toon Boom Studio offers two interfaces—one for drawing and one for scene planning. Here in Drawing mode, you have access to a traditional animator's field chart and a series of basic vector drawing tools. The exposure sheet is similar to a traditional animator's column-based spreadsheet for the management of each frame and cel.

animation are created, manipulated, and inked in Drawing mode. Scene Planning brings all these elements into a scene layout window and timeline, where you can manipulate the position and behavior of every object, both in space and time.

The Drawing mode offers graphic tools that are similar to those in Flash but arguably easier to handle. The brush tools, for instance, are pressure sensitive, which makes it easy for users with conventional drawing skills and a graphics tablet to create expressive illustrations that resemble traditional inked cels. Ink fills can be applied separately using a Paint tool, and you can use Custom Shapes to close any open paths you have created. Text is not supported, but it can be imported from another drawing program via the most popular vector formats.

In the Scene Planning mode, you can arrange your drawings using a form of 3D object positioning based on three different planes: background, midfield, and foreground. Elements are arranged in view of the virtual camera, with scenery at the back, and actors and other objects stacked toward the front. You can adjust distances using Top and Side Views as well as Object Properties.

When your animation is rendered, objects become larger and smaller according to their distance from the camera, and this perspective is maintained as both objects and the camera are moved and manipulated. The

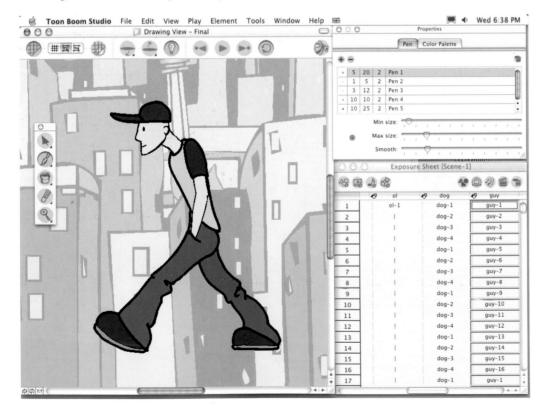

results are really quite sophisticated, and would be tricky and time consuming to produce if you were manually scaling 2D artwork in a single plane.

There are two methods of animating your illustrations. The first is to assign one or more objects to "pegs" that you can then tween inside the Scene Planning timeline, with the motion of the various pegged objects governed by Bézier-style control paths. The second method uses the concept of an exposure sheet, accessed in Drawing mode. Here you can create very complex animations using a single graphic element with multiple layers, each of which is separately animated. Such objects can be incorporated into a larger scene by linking

them into the timeline as they play through their own frames.

Toon Boom's Lip Synchronization feature is unique among vector programs, and makes it far easier to create cartoon characters that talk. The software analyzes imported sound clips, automatically adding example graphics, key points, and labels into the audio track. From there, it is easy to arrange illustrated facial graphics inside the exposure sheet to match, and tie down audio highlights to the visual highlights you have drawn.

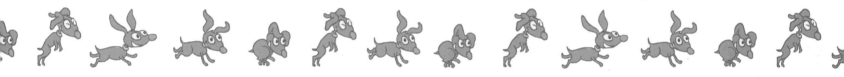

Right: The Scene Planning mode is the heart of Toon Boom Studio. You have access to several views including a camera view, a horizontal timeline, and top and side diagrammatic camera views.

Far right: Once all of your animated elements are complete, it is time to move into Scene-Planning mode, where you have complete control over the motion and position of the camera. One of the convenient features of the camera view is the ability to see a large area of action while using a second camera to select only a section of the scene.

Right: In Drawing mode, Toon Boom's vector drawing tools offer precise control. Onion skinning and a Light Table feature let you see your current illustration in context within the whole animation. One of the neatest features of Drawing mode is that you can rotate the artwork for more precise and ergonomic drawing, just as you might do in real life.

Far right: Control is provided over the tracking of a camera throughout a scene. With the top and side viewing planes, you can move the camera, using complex trajectories, through a flexible and automated multiplane system (back, midfield, and foreground).

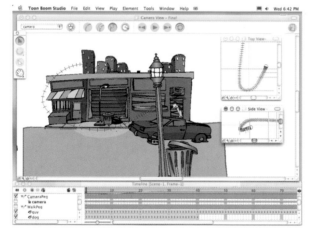

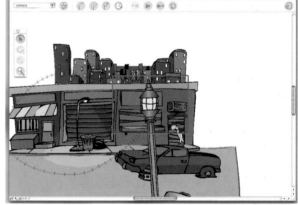

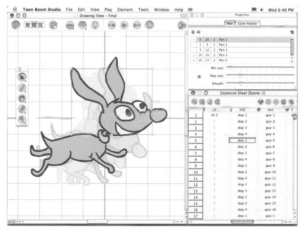

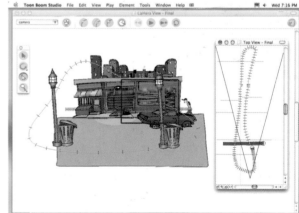

ANIMATED GIFS One of the features that differentiates web pages from printed material is the use of animation. Flash and QuickTime movies are one option, but they rely on the user having downloaded the appropriate plug ins in order to view them. They can also be very memory intensive.

Animated GIFs are a simple, easy-to-make alternative. They load just like regular graphics, and can be "optimized" to make them as small as possible. This process is a trade-off between image quality and file size—generally speaking, the lower the quality, the smaller the file.

Image quality depends on several factors: the number of colors used; the "dithering" method (a way of simulating missing colors by placing similar shades in close proximity); and the overall "lossiness" of the image. The greater the difference between each frame and the previous one, the larger the file size will be. Often, only a tiny change can be enough to gain a sense of movement, as can be seen in the planet example opposite.

Animated GIF files have the additional advantage that they can be viewed from any web browser, without any special software or plug ins being required. They are normally small page elements, and are generally set to repeat or "loop" the animation they contain. Banner advertising on websites usually comprises a single GIF file that repeats endlessly. With many websites insisting that advertisements must be no more than 10K in size, it is down to the skill of the animator to produce the best-looking advertisement in the smallest file size.

There are many programs for creating animated GIF files. One of the simplest to use is Adobe ImageReady, which is bundled with Photoshop and shares a common interface. Animations in this program are created on a frame-by-frame basis. Image elements can be

Above: **This mock-up of a holiday advertisement uses several animation techniques. The plane approaches us through the clouds, and flies overhead. This is accomplished by using three different plane layers at different sizes, with only one visible at a time. The first six frames use the same-sized plane, which is moved a little at each frame to simulate motion. The word "Worldwide" has a layer mask (see page 42), which gradually slides to the right, frame by frame, to reveal the whole word; the word "holidays" is faded in gradually over three frames until it reaches 100% opacity. The sunburst is created as three separate applications of the Lens Flare filter, increasing the strength of the filter each time.**

moved between frames, and their position logged for that frame only. Other transformations, such as scaling and rotation, apply globally; so in the Worldwide Holidays mock-up shown above, three different versions of the plane are required since it appears at three sizes.

ImageReady can apply visibility of objects on a frame-by-frame basis, which makes it easy to assemble all the components of the animation in Photoshop and then switch to ImageReady to animate the image. The program enables you to experiment with different output settings in order to optimize the resulting file, showing an indication of the file size (and the time it will typically take to download), together with a preview showing the degradation of the image caused by the compression technique. Using a 4-x-4 inch window, it is possible to judge the trade-off between quality and size, enabling a happy medium to be found.

ImageReady is not alone in this arena. Many vector- and bitmap-based 2D applications, 3D modeling packages, and other animation programs can export animated GIF files. However, none can rival it for ease of use or boast the same, highly sophisticated preview features.

Right: ImageReady's four-way view lets users experiment with different methods of lowering image quality in the attempt to make the final file as small as possible.

Below: In this simple animation, the moons move a small amount in each frame as they appear to circle the planet. Although there is relatively little movement in the whole animation—the planet itself is stationary throughout—the impression is that of continuous motion. The low amount of actual movement keeps the file size down, as most of each frame is a repeat of the previous one.

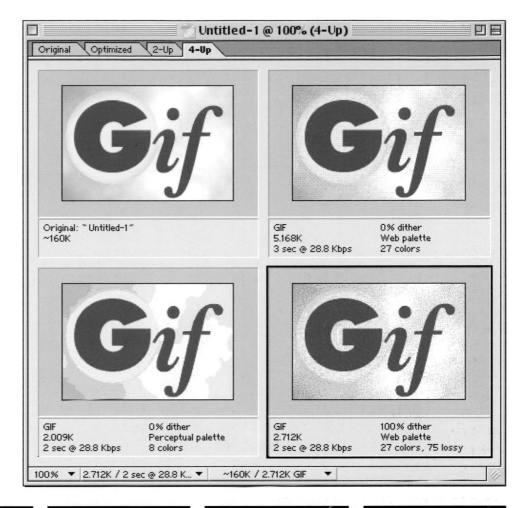

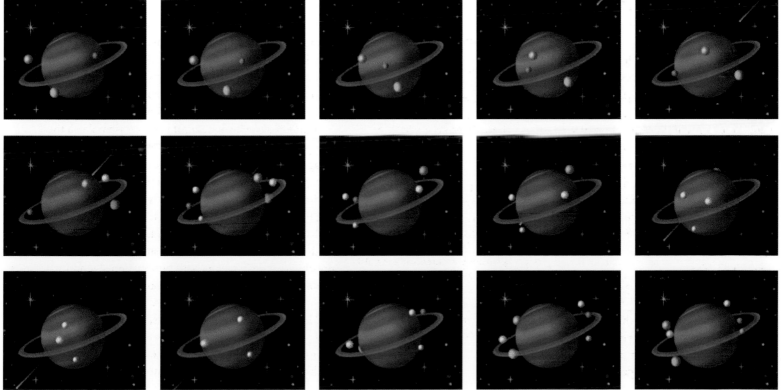

3D ANIMATION offers the most creative opportunities of any digital medium, but it also imposes one of the steepest learning curves. Various special techniques are used to help you control the way animation occurs over time. It works pretty much like animation in other kinds of programs, in that you start with a timeline and keyframes, which are interpolated over time to create motion. What makes it a lot more complex is that there are three spatial dimensions in which objects, cameras, and lights can all move and rotate.

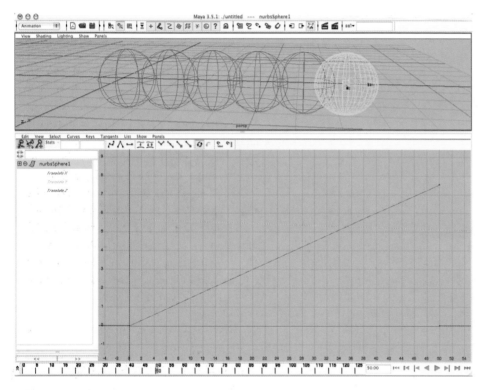

Above: **Function curves display the interpolation between keyframes as a curve in a graph. The shape of the curve helps you to visualize the way the object moves between keyframes. A straight curve means there is no acceleration or deceleration.**

Left: A typical function curve shape is an S, or ease-in, ease-out curve. This results in an object having a smooth motion that starts and stops naturally, without any jerkiness. The way you shape your curves can strongly influence the dynamic feel of your animations.

To help control the way animation occurs over time, 3D programs often use function curves. In the case of the movement, or translation, of an object in space, these curves control the x, y, and z directions. For example, if an object is set at x = 10 at frame one, and x = 30 at frame 50, its motion will be described by the shape of a function curve between these two keyframes.

If the motion is linear—that is, the object moves at a constant rate and does not speed up or slow down as it travels—the function curve will be a straight line. To create an "ease in, ease out" animation, where the object accelerates smoothly from a standing start, travels linearly, and then decelerates to a standstill again, you would manipulate the function curve into an S shape. Function curves are usually controlled via Bézier handles, although many 3D programs also let you use other kinds of keyframe interpolation, such as stepped, linear, cubic, and TCB (tension, continuity, and bias).

Animation in 3D is heavily dependent on hierarchies. A hierarchy is a grouping of objects that provides a child–parent relationship between the occupants of the group. If you move or animate a parent, its children will move along with it. Hierarchies also enable you to build complex jointed objects whose limbs can easily be animated.

Traditional animation uses a process called forward kinematics, or FK. To animate a leg taking a step, you keyframe the hip, then the thigh, then the shin, then the foot, at each section of the animation, one by one until the step is mapped out. It works, but is cumbersome.

Now, though, 3D programs enable you to animate using inverse kinematics, or IK. To take a step using IK, you just move the foot—the shin, thigh, and hip then move right along with it. Or, rather, they rotate. The beauty of IK is that the hierarchy does not fall apart when you pull on one end of it. An IK'ed leg requires keyframes only for the foot; the rotations of the other joints are calculated on a frame by frame basis by the software.

Using IK is all very well for a jointed hierarchy, but how do you go about animating a character, for example, that is made of a single mesh without jointed sections? In this case, you build a hierarchy out of special non-rendering objects known as bones (or sometimes joints). The bones form a skeleton inside the single-skinned character, and the skin is bound to the bones so that, as they rotate, the skin surrounding them deforms at the joints. FK and IK are then used as normal to animate the skeleton, which in turn deforms the mesh to produce the rendered animated character.

Not only objects can be animated. The camera and lights can be animated, too, and to help with the process you will often find special objects, called nulls, in use. A null is another kind of non-rendering object, and is really just a location in space defined by a set of axes and usually displayed as a cross. Objects can be parented to nulls, which are then animated. This eases the complications that arise from rotating axes in three dimensions.

Gimbal lock is one common problem, often associated with the camera, which can be solved with nulls. Here, one

Above: 3D software lets you build all sorts of complex animations from simple components. For example, a basic logo animation can be enhanced by applying a special deformer that explodes the mesh. The parameters of the explosion can then be animated to reassemble the logo over time.

Below: Hierarchies enable you to make complex animations without trying to keep impossible numbers of objects in sync. By grouping objects in hierarchies, you can create jointed structures such as a mechanical arm. Each object rotates where it is joined to its parent, so the whole group can be manipulated together.

axis becomes rotated so that the other two axes are in the same plane; rotating either one then causes exactly the same rotation, whether you want it or not. By linking a camera to two or three nulls in a cascading hierarchy, gimbal lock is avoided. Null one is animated around the x-axis only, null two around the y-axis only, and the camera is free to be rotated in around the z-axis. If this all sounds a little tricky, that is because it is: 3D animation offers some incredible creative opportunities, but is the most demanding of all digitial media when it comes to grasping more than the basic concepts.

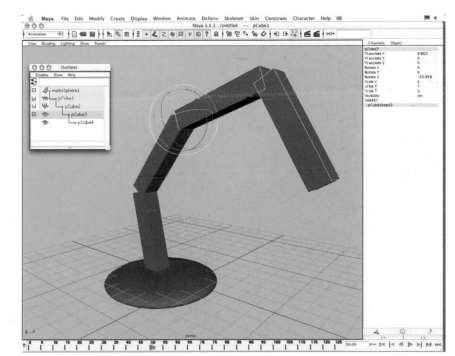

05.02
ANIMATION
SHOWCASE

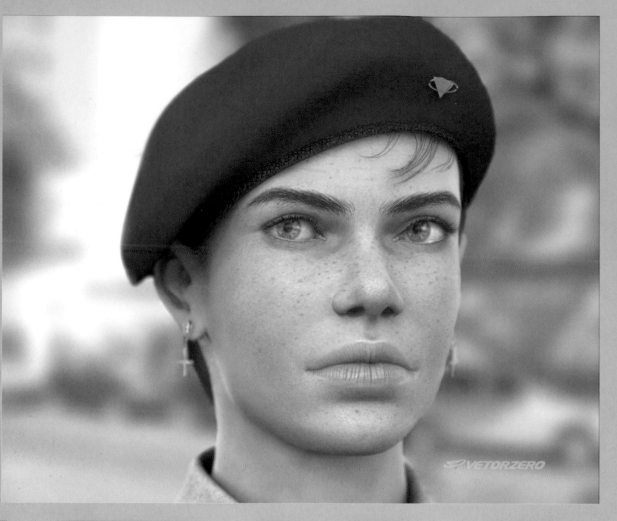

Right: **Kaya** is an award-winning project by Alceu Baptistão, a founding director of production company Vetor Zero, to create an animated human face that appears natural and "alive." Rather than dedicated facial modeling tools, the standard functions of Maya were used in conjunction with textures painted in Photoshop.
Alceu Baptistão
www.vetorzero.com/kaya/

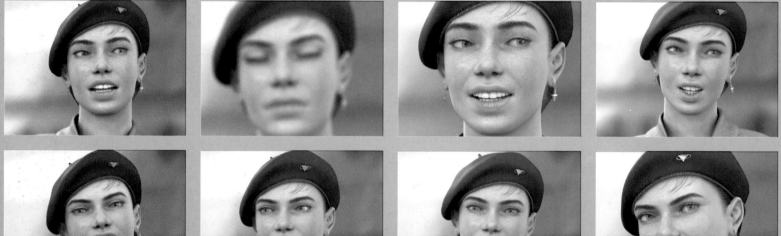

Above: **Vetor Zero's turtle starred in a series of commercials for Brahma beer (Companhia Brasileira de Bebidas). The turtle was rendered within Maya, then composited with live footage.**
Vetor Zero
www.vetorzero.com

Below: **Swarm Interactive produces interactive animations of surgical procedures for education. The creation process includes the use of LightWave, Poser, Photoshop, Fireworks, FreeHand, and Flash.**
Scott Horner and Daniel Niblock
www.swarminteractive.com

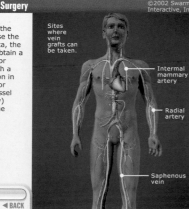 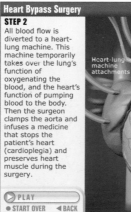

Heart Bypass Surgery ©2002 Swarm Interactive, Inc

STEP 1
After opening the chest to expose the heart and aorta, the surgeon will obtain a healthy vein (or artery) through a surgical incision in the leg, arm, or chest. This vessel (vein or artery) will become the bypass graft.

Sites where vein grafts can be taken.

Internal mammary artery

Radial artery

Saphenous vein

▶ PLAY
● START OVER ◀ BACK

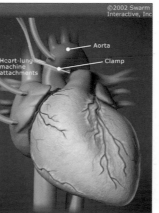

Heart Bypass Surgery ©2002 Swarm Interactive, Inc

STEP 2
All blood flow is diverted to a heart-lung machine. This machine temporarily takes over the lung's function of oxygenating the blood, and the heart's function of pumping blood to the body. Then the surgeon clamps the aorta and infuses a medicine that stops the patient's heart (cardioplegia) and preserves heart muscle during the surgery.

Aorta

Heart-lung machine attachments

Clamp

▶ PLAY
● START OVER ◀ BACK

Heart Bypass Surgery ©2002 Swarm Interactive, Inc

STEP 5
If a mammary artery is used, only one end needs to be attached to the artery below the blockage. Use of the left and or right internal mammary arteries in the chest is common, since it can be done through the same incision used expose the heart and aorta.

Bypass

Blockage

Restored flow

▶ PLAY
● START OVER ◀ BACK

Above: Broadcast design company Lobo combines traditional and digital techniques in its work. A sequence for the Disney Channel (top) recreated the "realejo", a traditional Brazilian street entertainment, in a modern style that children could relate to. For a Ford TV spot the car (below), and urban landscape were animated in a flat-color, vector style for a 2D feel.
Lobo
www.lobo.com

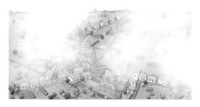 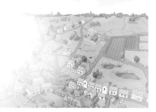 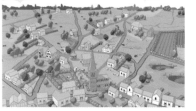 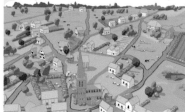

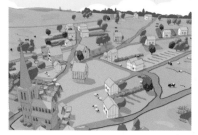 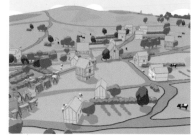 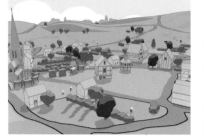 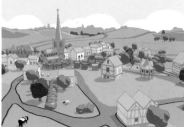

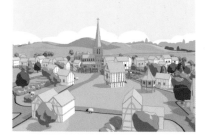 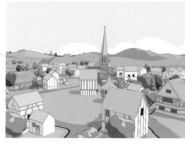 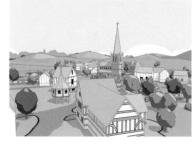 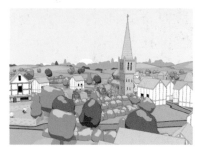

Above: This animation for Britain's National Science Centre, showing the city of Birmingham as it would have appeared in 1066, resembles traditional hand-drawn animation; but to draw it would have taken months, and the draughtsmanship of a genius. In fact, this 40-second piece was created in just two weeks using 3ds Max and the Illustrate! plug in from David Gould.
Studio Liddell
www.studioliddell.com

Below: Created by Preloaded for video directors Hammer & Tongs, Tongsville is a sprawling digital city that browsers can interact with online. This Flash animation was influenced by memories of 1980s computer games, with parallax scrolling—where foreground and background objects slide past at different speeds—adding depth.
Preloaded
www.preloaded.com
www.tongsville.com/city/

SHOWCASE

part 05. animation

Above: **Save the Children**, the UK-based international charity, wanted to represent the threat of poverty to children around the world. Eye Animation Studios composited 2D characters and backgrounds in a low-tech collage style into 3D scenes, creating an emotively creepy commercial. After invading the family home, poverty is beaten back in the final frame.
Eye Animation Studios
www.eye-animation.com

PROFESSIONAL PRACTICE

06

A few years ago, artists had to compile portfolios containing the best samples of their work. Keeping these portfolios up to date with the latest clippings was one problem; getting them to clients—which often meant ordering couriers or transporting them personally—could be both time consuming and costly.

Today, a digital artist can display their work on an individual website, which has the twin advantages of being instantly available to multiple recipients, and of being easy to update as the need arises. Web design programs are becoming much easier to use, and even with no technical expertise, it is possible for the novice to put together a convincing site.

In order to create your own website, you need two things: a domain name, and the web space itself. Buying a domain with your own name is easy if you are called, say, Vladimir Borowyczyk, since the chances of www.vladimirborowyczyk.com being taken are fairly slim. But if you are John Smith, you will need to take a different approach. Either way, the name needs to be obvious and memorable; the default names that come supplied with some webhosting and e-mail packages, usually along the lines of www.jsmith24.cutpricewebspace.net, are not likely to portray the professional image you would wish for.

Domain names at the "top level"—those ending in .com—cost around $25 for every two years of registration, and country-specific names cost slightly less. The cost of webspace itself varies from free to around $40 a year for basic hosting. If you take the free option, be aware that your site will probably be swamped with ugly banner advertising. You can pay much more than $40 to have your web traffic monitored and statistically evaluated, but these additional services will be of little use to the typical illustrator.

PART 06. PROFESSIONAL PRACTICE

THE WORKING ILLUSTRATOR

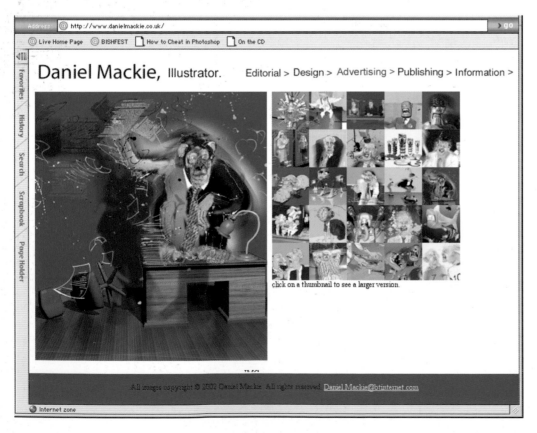

Daniel Mackie's frenetic illustrations are displayed within a regular, colorful grid. The thumbnail images give a good impression of the large illustrations that will be displayed when you click on them.

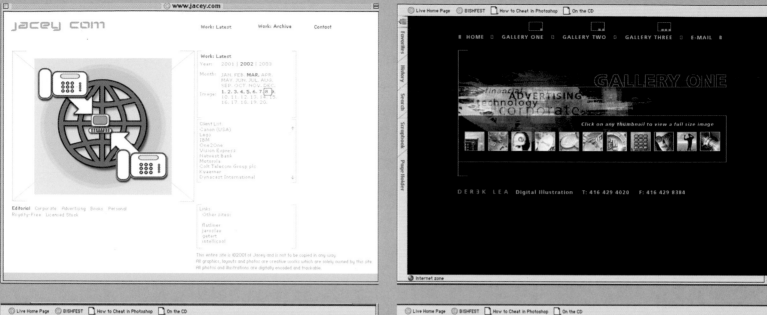

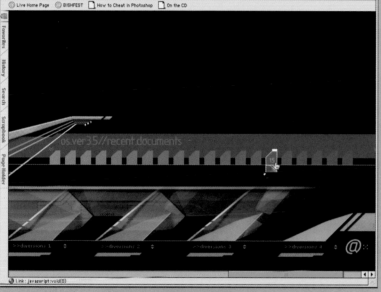

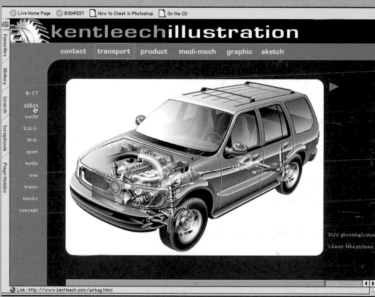

Another method of distributing your work is on CD ROM. You will need to compile some sort of front-end application to let users browse the work easily. There are many multimedia applications that will enable this, but you have to be certain of cross-platform compatibility (in other words, that the application will work on both Macs and PCs). Building a website solely for CD distribution is often a better option. With the blank media costing just a few cents, you can send CDs out to prospective clients and not worry about getting them back.

But without doubt, the best way of getting your name in front of prospective clients is for them to see your byline in a reputable publication—which means convincing an art editor to take a chance on your work. As ever, the first rung of the ladder is the hardest to reach.

Top left: Jacey's site is categorized by year, month, and image. This ultra-logical approach works only if you are prepared to update regularly, since readers will tend to go straight to the most recent work.

Above left: The website for avant-garde design house Aeriform offers no solace to the user. It is tight and dynamic, and only the tiniest preview offers any clue as to the illustration that will pop up when a number is selected.

Top right: Derek Lea's high-tech work is displayed within a suitably modern environment. The thumbnails show details from the illustrations they lead to, rather than reduced versions of the whole.

Above right: Kent Leech takes a serious, departmental approach, categorizing his work and sub-dividing those categories into individual illustrations. It is the perfect solution for his business-like, meticulous work.

WORKING WITH CLIENTS Raw talent and advanced technical skills are not enough to guarantee a steady stream of work for the digital illustrator. No matter how good you are, it is vital that you adhere to a few simple rules if you want repeat work from a client.

Before any art editor is prepared to commit to a new or untried illustrator, he or she needs to be satisfied that certain conditions can be met. The chief criteria are:

1. Is the style original?
2. Is the work of a sufficient standard for publication?
3. Can the illustrator interpret a brief?
4. Will the illustrator be sure to meet the deadline?

It is perhaps a sad fact that the above points have been listed in reverse order of importance. No matter how inspired or talented you may be, failing to meet the deadline will guarantee you will not be asked again. When working for magazines, artists are frequently given between two days and a week to complete an illustration. If you work for daily newspapers, the time between receiving the commission and delivering the finished artwork can be as little as a couple of hours. Miss this deadline, and the paper will be left with a blank page—which will generally be filled with a stock photograph. The cardinal rule is: Do not miss deadlines.

Art editors work in a variety of ways. Some will supply you with a pencil sketch of the illustration they want, and it is up to you to make whatever changes are necessary—you are the illustrator, and you will know what works and what does not. Some art editors will simply send you the copy for the story to be illustrated, and wait for you to come up with ideas. In this case, you will either have to describe your solution over the phone (usually the way when working on tight deadlines) or supply a rough. Bear in mind, though, that if you work with photomontage, the end result will depend on what images are available, so make sure you know which elements you will want to include before drawing the rough.

Interpreting a brief means finding a new, original take on a story. Avoid hackneyed or obvious solutions, and wherever possible try to avoid labeling objects within the scene. The days of a politician sitting in a boat labeled "social responsibility" tossing out a lifebelt labeled "overseas aid" are rightfully long gone.

Art editors will frequently want to make small changes to the work you supply. Keep your work in layers to maximize your ability to make adjustments, and be receptive to their suggestions—although you can argue your corner if you believe strongly that your solution is preferable. Ultimately, it is the art editor's job to get the work that he or she wants.

Advertising agencies are the most demanding of clients. Agency work will frequently go through a dozen or more alterations as everyone in the hierarchy, from the account manager to the client, pitches in with their own ideas. Ad agencies pay more than anyone else, and the sums involved can be tempting, but you will often start the job as an illustrator and end up as a mechanic, making what seem to be irrelevant and irritating changes while the art director peers over your shoulder. In cases like this, it is important that you swallow your pride and just do the job they want.

Finished artwork can be supplied by e-mail or on CD. Work to be sent by e-mail should be saved in highest quality JPEG format for speed of transmission, but it is not uncommon for art directors to request finished artwork in its original, layered format on a CD ROM so that they can tweak it themselves if necessary.

Above: This is the client's original sketch for a poster for the London Zoo, to be placed on the side of a bus. The irregular shape is to fit in with the bus panels.

Above left: Because the placing of the T-section is critical, it was important to obtain precise dimensions for the shape.

Above right: The original photographs of the children at the bottom were brought together to show the arrangement—but before any facial distortions were applied.

Above: The finished image with every element in place—after all of the client's amendments.

TAKING THE MONEY At some point, you will have to discuss money with your clients. For most artists, this can be the most difficult part of the job. Pitch too high and you may price yourself out of the market; too low and your work may not be valued.

Magazines and newspapers generally have standard rates for illustrations, depending on the size of the work used and the position within the publication—so an illustration for a cover, for example, will pay a premium rate. For historical reasons, publications still pay less for black-and-white (known as "mono") illustrations than for full-color work. This harks back to the days when pictures were hand drawn, and adding color was an additional process. Today, however, it is as quick to work in color as it is in mono; in fact, mono illustrations are much harder to create, as the color element—which enables us to make the focus of the image stand out—is missing. Creating an eye-catching illustration in black and white is a far more difficult process.

Advertising agencies generally have no fixed rate for illustration work. When discussing money, you will not be dealing with the art director, but with the account executive (the person responsible for the entire campaign) or, in larger agencies, the "traffic manager" (the person responsible for ensuring that everything arrives on time, in the right place). These people will have a figure in mind for the job, but they will never tell you what it is. It is up to you to come up with a price and pitch it to them. If they accept straightaway, you will know that you have pitched too low. But by that time it is too late—you cannot bargain upward. The trick is to think of the maximum amount you think the job could be worth, and then double it. Then double it again, and practice saying the amount you want in front of the mirror until you can pitch it with a straight face. When working for ad agencies, the more you charge, the more they will think you are worth.

Sending out invoices—and collecting the checks—is another important task. Invoices can be set up using a simple word processor, and printed out, but be sure to keep copies of all the invoices you send, both in order to send reminders when they become overdue (a far too common occurrence)

Agents can find you new work, and will take care of the administrative side of the business—in return for 30% of your fees.

A good accountant will save you more than he or she costs you. At the very least, your accountant will save you the pain of filling in your own tax return.

and to keep records for tax purposes. A better solution is to use a database application to create an invoicing system, which will automatically store new invoices as separate records, and will let you sort them by date, client, paid date, and so on. There are several dedicated packages for producing invoices, but even the most basic database applications will generally suffice.

One solution to all this is to employ an agent. Agents have two main functions: to get you work, and to deal with the administrative side of the business. They get work for you by promoting you through their own websites, through mailshots and visits to advertising agencies, and by advertising in trade annuals. They will also negotiate fees and contracts, invoice clients, and chase payments. A typical fee for this service is 30% of the revenues you receive for each job they negotiate for you.

Working with an agent can be a good way for the novice illustrator to get into the business. The better agents will assess your work and may suggest ways to make it more commercially appealing, which can be a useful asset for the beginner. Some agents specialize in particular illustrative styles, while others will attempt to create a rounded portfolio consisting of a variety of styles. Before you approach an agent, check out their website to see if they seem appropriate. An Internet search for a topic such as "illustration" will turn up dozens of agency sites.

Unless you are adept at tax evasion, you will need the services of an accountant. Good accountants can save you more than they cost you, but be sure to firm up the fee situation before you commit yourself to any individual or company.

COPYRIGHT AND IMAGE SOURCING Enshrined in the intellectual property laws of most countries, copyright protects you from plagiarism and unauthorized exploitation of your work. At the same time, it limits your own use of work originated by others.

The advent of digital technology has had less impact on the fundamental principles of copyright than is popularly assumed, but the ease with which material can now be copied and published does make it more essential than ever for both illustrators and their clients to understand those principles.

In general, when you create any original artistic work you automatically become its copyright holder, and it may not be reproduced without your permission. Copyright in work produced in the course of employment, however, normally resides with your employer.

Although it is more usual for illustrators to work on a self-employed basis, the dividing line between freelance and employed work, or "work for hire," varies between countries, and it is important to be clear which side you are on.

Above: **Using an online royalty-free library, such as Stockbyte, you can search the catalog by keyword (left) to generate a list of pictures that match your criteria (center), shown with thumbnail images. These can be organized and saved in your personal lightbox (right). Having selected the images you want, you can pay for them and download them immediately via a fast Internet connection, or have them burned onto CD ROM and mailed to you. Each image is available at different resolutions, priced accordingly.**

When you sell work to a client, you are usually offering a limited license to reproduce it. A publisher would traditionally license an illustration for single use in a book or magazine; any future use in other products would require a new fee to be negotiated with the illustrator. In advertising, it is more common to buy "all rights." Copyright in your work is assigned to the client, who then has unlimited exclusive use.

As media owners take advantage of the Internet to repurpose their products, even editorial clients are likely to ask for all rights. Find out the usual terms for your local market, and ask what the client expects before agreeing to a price.

If your work is reproduced in print, on the Internet, or anywhere else, by someone who has not licensed it, this is usually an infringement of your copyright. It does not matter where, how, or why the reproduction was made, how many people saw it, whether or not someone profited from it, or whether or not you were credited as the author of the work (though these factors could affect the exact outcome of a lawsuit). You can order the person responsible, or anyone involved in the reproduction and distribution of the work—such as a printer, Internet service provider, or bookseller—to desist, and demand appropriate compensation.

By the same token, if you take artistic material from any source—for example, by scanning or downloading it—and incorporate it into your work, this is likely to infringe somebody else's rights.

Many digital illustrators use "found" imagery as part of their style of work, and there are two legal ways of doing so. The first is to obtain permission from the copyright holder. The second is to use work that is explicitly released from copyright—for example, books and CD ROMs of "clip art," or books whose author has been dead for more than 70 years, so that copyright has expired. It is often assumed that unauthorized use is acceptable if the source is disguised, perhaps by using only

Right: Rather than buying individual images, it is often worth investing in ready-made collections supplied on CD ROM. Each represents a particular style of material on a given theme, and offers a dozen or more pictures for the price of two or three.

Right: Specialist catalogs can be invaluable to the illustrator. Hemera Photo-Objects, at Ablestock.com, offers pictures of everyday items cleanly shot from a number of angles. These images are also available in large CD ROM albums.

Left: Some services, such as Getty Images, represent a number of different catalogs, providing a single source for various genres of photos, illustrations, and video clips, rights-managed and royalty-free terms, and so on.

fragments of the material or heavily manipulating it. But this does not avoid infringement, it only reduces your likelihood of getting caught. A number of digital illustrators have failed to get away with it, including map makers who have traced over existing maps and illustrators who have created homages to 20th-century artists. If your work is going to be published, it is best not to take any risks.

Image libraries offer an accessible source of properly licensed material. Rights-managed libraries charge different prices according to the intended use of the image; this is rarely suitable for illustrators because use of your finished work will

Above: Rights-managed licensing is much more complex. Here, the cost of an image is calculated based on when and for how long it will be used; where in the world it will appear; in exactly what media; how many times; and for what type of client. If a period of exclusivity is required, during which others are prevented from using the image, this will further add to the price.

be limited by the same terms. Royalty-free libraries charge a fixed price per image for unlimited use. On the Internet, you can search each catalog yourself (rather than paying the owner to do so, as in the past), then pay by credit card and download the images immediately. For single-use illustrations, this is an ideal solution. If, however, you need multiple pictures on a given theme for a larger project, royalty-free collections on CD ROMs will be significantly more cost effective.

ESSENTIAL REFERENCE

GLOSSARY

BIBLIOGRAPHY

INDEX

07

At 300dpi, this image—500x500 pixels—appears a little smaller than two inches square. Its size could be increased a little beyond this without visibly compromising quality, but not too far.

72dpi reproduction may look fine on the monitor, but it would be unacceptable in print. At first glance, the image looks wrong. On closer inspection the square pixels are all too visible.

When an image is halftoned, the extra resolution of the printing process is used to place many dots of different inks within each pixel of the image, enabling the full color gamut to be reproduced.

Right: When setting pixel dimensions, don't forget to allow for cropping. If you're buying an image from a library, remember it's the portion of the image that you plan to use—not the whole image—that must meet or exceed your planned output size. Similarly, having set up a blank canvas for an illustration, it's no good painting in a smaller area within it, as your finished image won't fill its intended space at the desired resolution. If you want extra working space, add it to the pixel dimensions at the start, then crop it off at the end.

This image, as it stands, contains sufficient pixels to create a density of 300 dots per inch when reproduced at its current size.

Cropping the image down to a small portion of the original area reduces the number of pixels. If we use the cropped image to fill the same space, the enlarged pixels become visible.

In Photoshop's Image Size dialog box (below left), we can see the reduced width and height of the cropped image. If we re-enter the original dimensions and select Resample with Bicubic interpolation, Photoshop will recreate the cropped image with the original number of pixels. Because the missing pixels have been artificially generated, the result is not completely smooth and sharp.

Bottom row: Monochrome line art is a special case for print resolution. Because a black line is printed using only black ink, no halftoning is performed, and artwork pixels translate directly into hard-edged areas of black ink. Without the slight blurring of a halftone screen, pixels may be visible as tiny steps even at 300dpi. To show this, the artwork above has been vector drawn. Printed from the original vector file (left), the lines are rasterized by the imagesetter at its full native resolution of around 2500dpi, and appear completely smooth. If we store the artwork as a 300dpi bitmap, output (middle) is not as clean. Line art that has to be reproduced in bitmap form should ideally be saved at 1200dpi or higher, but anti-aliasing can give smooth results, albeit not as sharp, at 300dpi (right).

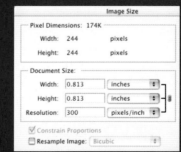

Image Size

Pixel Dimensions: 744K (was 174K)
Width: 504 pixels
Height: 504 pixels

Document Size:
Width: 1.68 inches
Height: 1.68 inches
Resolution: 300 pixels/inch

☑ Constrain Proportions
☑ Resample Image: Bicubic

Image Size

Pixel Dimensions: 174K
Width: 244 pixels
Height: 244 pixels

Document Size:
Width: 0.813 inches
Height: 0.813 inches
Resolution: 300 pixels/inch

☑ Constrain Proportions
☐ Resample Image: Bicubic

RESOLUTION Before starting work on an illustration in bitmap software such as Photoshop, it's essential to know how the final artwork will be reproduced and at what size. From this information you can calculate the necessary pixel size of the image, which is set when you first create your document.

RESOLUTION AND PRINT SIZE GUIDE

Number of pixels	800 x 600	3000 x 2000
Digital camera resolution	0.5 megapixel	6 megapixel
IMPERIAL		
Nominal monitor size (72 dpi)	11 1/8 x 8 1/3"	41 2/3 x 27 3/4"
Maximum print size (300 dpi)	2 2/3 x 2"	10 x 6 2/3"
METRIC		
Nominal monitor size (72 dpi)	282 x 212mm	1058 x 706mm
Maximum print size (300 dpi)	68 x 51mm	254 x 169mm

Images destined for the World Wide Web, to be viewed on computer monitors, are commissioned to a pixel size, such as 470 x 60 pixels, for an advertising banner. To maintain finer control over your material, you may wish to work at a higher resolution—perhaps double this size—before reducing the finished piece to the required dimensions.

Print work demands much higher resolutions. In CMYK output, color images are made up from dots of the four ink colors by a process called halftoning. Depending on the mechanical equipment used, output resolution may be determined by the press itself, if digital; the platesetter, which creates printing plates from digital artwork; or the imagesetter, which outputs color-separated films from which plates are manufactured. The native resolution of this device determines the number of dots of each ink that can be printed per linear inch, usually around 2,500.

To produce any given color, however, multiple dots of different inks must be combined, and this means the smallest area that can be resolved—the printed equivalent of a pixel—is much larger than a single ink dot. This is called the screen ruling, and is measured in lines per inch (lpi). Commonly used screens in high quality color printing, as in magazines and books, are 133 lpi and 150 lpi. For optimum results, the image to be output should be of a higher resolution than the screen ruling, but no benefit will be seen beyond about twice this value. Hence the figure of 300 pixels per inch that's used as a general guide for printed material. (Newspapers may use a coarser screen, requiring fewer pixels.)

We have correctly described image resolution in pixels per inch (ppi), but dots per inch (dpi) is often loosely used to refer to resolution regardless of context. So images for print are typically specified as "300 dpi." Physical dimensions must be given along with this figure to determine the number of pixels, which will be equal to the printed size (in inches) multiplied by the resolution.

The use of pixel dimensions for on-screen work makes monitor resolution irrelevant, but for the sake of argument it's traditionally given as 72 dpi (in practice though it varies depending on the user's preferences, and today is often nearer 90 dpi). So "72 dpi" is used as a shorthand term for images sized for on-screen viewing. It's also used by print production staff to refer to any image mistakenly supplied at low resolution, and thus unsuitable for printing at the intended size.

You can change the resolution of an image at any time by entering new dimensions. This is known as resampling. In Photoshop, it's done via the Image Size command. A process of interpolation is used by the software to build a smaller or larger number of pixels from the existing data. This is very effective when reducing sizes, although you may need to apply a little sharpening afterward. Enlarging is much less satisfactory, as the software is being asked to invent data that doesn't exist within the picture, and a degree of fuzziness is unavoidable. Working at the correct resolution, or higher, is the only way to produce clean, sharp images.

Vector drawings have no inherent resolution, since they consist of scalable geometric descriptions. Even so, resolution issues can arise in drawing programs. When you blend between two objects to create a graduation between colors, for example, the number of steps in the blend should be set according to the intended output size of the artwork. The exact figure is hard to determine, since it depends on the degree of tonal variation, but you should allow at least 24 steps per inch. Resolution also rears its head when advanced vector effects, such as soft glows and shadows, have to be rasterized for output.

Above left: The table shows the size at which two images of different pixel dimensions would appear on the monitor, and the maximum size at which they could properly be printed. Note the dramatic difference between the two—an image may look huge when viewed at 100% in software, but that doesn't mean it can be output at a large size. For a rough idea of printable size, view images at 25% magnification.

We have also shown the image size in megapixels, often used to describe the resolution offered by digital cameras. This figure is obtained by multiplying the linear pixel dimensions to give the area, then dividing by 1 million. You can see that 6 megapixels—quite a respectable digital camera specification—is still barely enough to fill a magazine page, even without cropping.

COLOR MODES

COLOR MODES It can often be a source of frustration to illustrators that they create bright, vibrant colors on-screen, but these colors turn out dull and flat when the work is printed on paper. This is not a fault with their printer or their bureau—it is inherent in the way color works.

Computer screens and printing inks create colors in precisely opposite ways. Monitors, like televisions, use light to create color; the more colors you add, the brighter the result. This is known as "additive" color, so if you add all the colors together at full strength, you get white. The colors used are Red, Green, and Blue, so the color model employed by monitors is known as RGB.

With printing ink, however, the more color you add, the darker the result. This is known as "subtractive" color, so if you add all the colors together, you get black—actually, you get a rather murky brown, which is why the standard Cyan, Magenta, and Yellow printing colors are joined by Black to give depth. This color model is known as CMYK—where K stands for "Key" ("B" for Black would cause confusion with Blue).

The problem is that users want to see on-screen an accurate representation of how their color will look when it is printed. Using a complex conversion process, design programs simulate printed colors fairly well—but few of them limit you to just the range of colors that are printable. Your computer will also let you create dazzling greens, fluorescent pinks and startling blues—all of which are easily created using red, green, and blue lights, but which are simply impossible using CMYK inks.

The problem also arises when scanning color photographs. All scanners, like all monitors, work in RGB, but it is up to the

Above: **Printed colors use cyan, magenta, and yellow inks to create the different hues; black ink is added only to create depth in the shadow areas.**

Above right: **Computer monitors create color by adding red, green, and blue lights to a black screen. The more color is added, the brighter the result.**

user to recognize the colors that are "out of gamut" (that is, unprintable using CMYK), and to de-saturate or change them. When working in Photoshop, it is a frequent occurrence to see your work suddenly look dull when you change its mode from RGB to CMYK—this is not a shortcoming of Photoshop, but an attempt to show you how your work will look when printed. Fortunately, Photoshop employs a special CMYK Preview mode, which simulates the way colors will look when printed, thus letting you to make adjustments as appropriate.

The lack of scope of CMYK printing inks (also known as "process colors") is particularly apparent when you compare, say, a painting in a gallery to its printed version in a book or on a postcard. Process color printing may enable a CMYK printer to approximate a wide range of color, but it is just an approximation—and there are times when the comparison falls far short.

A point of interest is the overlap that occurs when colors are mixed. Red and green lights create yellow; blue and green create cyan; and red and blue create magenta. The opposite is true of CMYK colors: magenta and yellow make red; cyan and yellow make green; and, magenta and cyan make blue. As the examples on this page show, the RGB and CMYK models are almost diametrically opposed color systems.

Above: The cyan, magenta, yellow, and black plates in a printed CMYK image make up the color picture. Note how the red quadrant on the shirt is composed of solid magenta and yellow, with just the barest touch of cyan and black.

Right: The red, green, and blue channels in an RGB image make up the full-color final image. Here, light areas add to the color and dark areas are neutral, so the red quadrant on the shirt shows up as black on the green and blue channels, since no light is added in those areas. The white background is made up of solid red, solid green, and solid blue.

COLOR MANAGEMENT

COLOR MANAGEMENT Far from being incapable of error, computers just make mistakes more predictably than the rest of us. Nowhere is this truer than in the digital representation of color.

It is easy to create any color you like in software, but that does not mean that what you see on your monitor will be precisely reproduced on anyone else's, let alone in print. Each program has its own way of handling color, and every digital device is susceptible to its own inaccuracies. Color management attempts to compensate for these differences and match colors as precisely as possible.

The International Color Consortium is an industry body established to research color technology and maintain internationally agreed standards. Central to its efforts is the principle of color space translation. On the previous page, we saw how the RGB system used for monitor display differs from CMYK printing. In fact, there are many and various RGB and CMYK models, in addition to several completely different ways of representing color. The ICC has chosen a model known as CIE-Lab as its fundamental "connection space."

Because its gamut is wide enough to encompass most RGB and CMYK spaces, the color values used by almost any device can be accurately translated into CIE-Lab, as long as the software that makes the translation is given specific information about that device. This information is provided in a standard form known as an input profile. Similarly, CIE-Lab color values can be translated into those of any device using an output profile.

Once you have profiles for all your equipment, it is theoretically possible to maintain accurate color. Images captured by a scanner or digital camera are translated via the color management system into the working space of your software. While you work, image data remains stored in this form, but is displayed on-screen translated into the RGB space of your monitor. If you print proofs of your work, colors are translated into the printer's CMYK color space. When clients receive your work and check it on-screen, it is translated into the working space of their software, and into the RGB space of their monitor. Finally, your artwork is translated into the CMYK color space of the printing press. The appearance of colors should remain the same throughout.

This is all very well in principle, but it depends on every device having an accurate ICC profile, and every piece of software being correctly set up. This is hard to achieve. Most imaging devices come with ICC profiles, but these are generic; they describe the characteristics of the hardware as designed, but not the vagaries of the individual unit. The only way to ensure precision is to create profiles calibrated to your own devices, and update them to account for variation over time. This requires additional software and skills. You also need to understand the color management facilities of your software in order to make settings that improve color conversion, rather than further confusing it.

In any case, even perfect color management cannot guarantee perfect results. Clients might take your carefully calibrated work and output it without any color management at all. If your work is destined for print, the limited gamut of CMYK output will always prevent certain colors appearing accurately. Work for on-screen viewing on the Internet is entirely dependent on the hardware and software used by viewers.

In practice, most illustrators are content to calibrate their monitor by eye, so that they can be reasonably confident of seeing colors correctly on screen, and to use the profiles supplied with any other imaging hardware they may use, such as scanners and color printers. ICC color management is supported on Macintosh computers by Apple's ColorSync, and on PCs running Windows by Microsoft's ICM. It is also implemented within most professional graphics programs.

MONITOR CALIBRATION

Ideally, monitors should be profiled using a hardware calibration device, but these are too expensive to be considered a must-have for illustrators. Basic calibration can be performed in software by visual feedback. On Macintosh systems, this is done using Apple's Display Calibrator Assistant.

1. We are using the Display Calibrator Assistant in Expert Mode. The first step is to maximize the overall tonal range displayed. Using the monitor's onboard controls, contrast is increased to maximum. Brightness is then balanced by reference to a black point comparison displayed within the Assistant.

2. Gamma refers to the position of the midpoint between white and black. Changing this value biases the display toward lighter or darker tones. The monitor's existing gamma is determined by moving sliders, which adjust the brightness of color blocks until they appear to match black-striped backgrounds.

3. The desired gamma is then entered—the display will achieve this by adjusting output relative to the native gamma. As shown on the scale here, the typical gamma of unmanaged PC monitors is higher than that of Macs; this is why images appear darker on PCs. Mac users may wish to emulate PC gamma to test how their work will look on PC screens.

4. Color temperature refers to an overall bias toward blue, at the "cold" end of the scale, or red, at the "hot" end. Changing this has an effect similar to viewing materials under different lighting. Most monitors are now set to very cold values, but a warmer setting will better reflect the appearance of artwork on printed pages.

5. A conversion table is created based on the values entered, and saved as an ICC output profile. This is automatically selected as the display profile in the system preferences of Mac OS. You can change the profile at any time, or maintain several profiles for different purposes—such as on-screen and print work—and swap between them as required.

Right: The very cold color temperatures commonly applied to monitors, such as 9300K (left), tend to make images appear bluish and slightly washed out. Warmer temperatures, such as the prepress standard D65 (right), provide a better simulation of printed output, but may look unnaturally yellow to eyes accustomed to on-screen settings.

FILE FORMATS

FILE FORMATS One of the advantages of working digitally is that you can keep a lifetime's work, including early drafts and multiple versions, in a space smaller than a shoebox. It's still important, however, to think about exactly how you store it, and when you send work to clients you'll need to be sure it's in a form they can use.

There are many different formats for bitmap, vector, 3D, and animation files. All of them can be categorized into three groups: native formats, transfer formats, and output formats. Native files store data specifically for the program you're using, often including a large amount of information beyond the artwork itself. When you save from Photoshop, for example, its PSD file format records all the layers, masks, channels, paths, and guides in the current document, so that everything is present and correct when you load it back in.

Few other programs would be able to understand all of these components, and they are not necessary for final output, so you would normally store and supply finished artwork in a simpler output format containing just the image data. If you needed to import your artwork into a different application with some non-image features kept intact, such as alpha channels, you could use a standard file type capable of storing limited non-image information in a widely readable form. That would be a transfer format.

Despite the steadily increasing storage capacities of computers and media, artwork files can still prove cumbersome. Vector files are the smallest, usually taking a few hundred kilobytes at most. A multilayered Photoshop bitmap of a full-page illustration, by contrast, can exceed 100 MB. Even if you have enough storage space to cope with such files, moving them around is a problem: a 100 MB file would take about an hour to upload using a broadband Internet connection, and would exceed the limit of most e-mail accounts.

The solution is compression. Using various mathematical processes, the data contained in a bitmap can be represented more efficiently. For example, a series of identical pixels can be described by storing the color value just once, along with the number of instances. This is known as lossless compression, and is used by many native and transfer formats, including PSD and TIFF. Lossless compression can be used to save files that you may want to work on again, including backup copies for archive purposes, as long as your chosen file format can accommodate all the aspects of the document that you need to preserve for editing.

To generate even smaller files, more aggressive compression can be allowed to throw away data. Methods are designed to preserve pixel values that have the greatest impact

COMPARISON OF COMMON IMAGE FILE FORMATS

FORMAT	BITMAP/ VECTOR	COMPRESSION	FEATURES A	L	P	C	SUITABILITY T	O	P
AI	Vector	n/a	N	Y	Y	Y	Y	N	X
EPS	Both	None	N	N	Y	Y	Y	N	Y
GIF	Bitmap	Lossy*	N	N	N	N	N	Y	N
JPEG	Bitmap	Lossy	N	N	Y	Y	N	Y	Y
PNG	Bitmap	Lossless	N	N	N	N	Y	Y	N
PSD	Bitmap	Lossless	Y	Y	Y	Y	X	N	N
TIFF	Bitmap	Lossless	Y	Y	Y	Y	Y	N	Y

*GIF reduces color depth to 8 bit but is otherwise lossless
Y = yes, N = no, X = sometimes
Key to features: A = alpha channels, L = layers, P = paths, C = CMYK
Key to suitability: T = transfer, W = on-screen output (e.g. web), P = printed output

on appearance, so that the amount discarded is disproportionate to the impact on image quality. Files can easily be reduced to a fifth of their size, and often more. This lossy compression is suitable only for output formats, since image quality degrades cumulatively if you repeatedly load and save files. While working it is safer to stick with TIFF or PSD. JPEG is the most popular lossy format, and offers a scale of quality levels.

Although vector files are more straightforward than bitmaps, there are fewer satisfactory non-native formats. The only truly reliable vector transfer and output format is EPS, a form of the PostScript language on which vector handling in most software and output devices is based. Adobe Illustrator's native file format (AI) is closely derived from this, and is often acceptable for delivery to clients.

With moving pictures, compression is almost unavoidable, since the amounts of data involved would be impractically large without it. Vector formats such as Flash neatly get around this, but bitmapped material will need to be compressed using one of various codecs (compressor/decompressors). These are usually asymmetrical, meaning more processing is involved in compression, (which may take a long time) than in decompression, which in most cases happens in real time as the movie plays. Advanced compression techniques may require expensive software and additional hardware, but many good codecs are supplied with the most widely used video-editing programs. Your choice will depend on the delivery format, which should be specified by the client. A website, for example, might specify Apple QuickTime format encoded with Sorensen Video 3.

FILE SIZE VERSUS VISUAL QUALITY

Saved as an uncompressed TIFF, this full-quality image in standard 24-bit color occupies 844 K of disk space.

Using LZW compression within the TIFF format, file size is reduced to 536 K without any reduction in quality.

As a GIF, the image takes just 168 K, but this format's 8-bit color depth can't render subtle tonal changes, as in the red background.

Dithering the GIF (a sort of random halftone) smooths transitions, but is noticeable as speckling, and increases file size to 212 K.

Saved in JPEG format at a quality rating of 10, close to the top of the scale, the image is reduced to 204 K without obvious degradation.

At a JPEG quality of 5, file size falls to 148 K, and blocky artifacts are starting to become visible around edges and in dark areas.

At a quality of 0, this 116 K JPEG doesn't look as bad as you might expect, but would be unacceptable for publication.

FILE FORMAT PRONUNCIATION GUIDE

Before discussing file formats with clients, you'll need to get both your head and your tongue around all the acronyms.

Name	Stands for	Pronunciation
EPS	Encapsulated PostScript	"Ee-pee-ess"
GIF	Graphics interchange format	Officially "jiff," usually "giff"
TIFF	Tagged image file format	"Tiff"
JPEG	Joint Photographic Experts Group	"Jay-peg"
MPEG	Moving Picture Experts Group	"Em-peg"
PNG	Portable network graphic	"Ping"

ESSENTIAL PHOTOSHOP FILTERS Photoshop comes with a huge range of "filters"—image modifications based on dialog boxes, which show a preview of the filtered image, together with a set of sliders that change the intensity and type of effect. Many of these filters are for specialized use, producing artistic and sometimes zany results. Some, however, will be needed on a more regular basis.

1. This is the original globe image, with no filters applied.

2. An application of the Unsharp Mask filter, used at 100% with a radius of 2 pixels. This setting is enough to bring out the detail in the globe, letting some of the text be more easily read.

3. With the Unsharp Mask filter set to 300% at a radius of 5 pixels, the effect is greatly exaggerated. Although this works well on some areas—the stand, for example, is now bright and shiny— the colors in the globe have become over-saturated, and the image is starting to look quite artificial.

4. Here, we have used the same settings as the previous example, but increased the Threshold setting from 0 to 40. This retains the sharpening where it is needed—making the text more legible— but lowers it on areas of flat color.

The two main everyday filter sets are Sharpen and Blur. Sharpening is used to add contrast and definition to soft images—most scanned photographs can be improved with the judicious use of sharpening. Although there are simple Sharpen and Sharpen More filters, the best results are gained using the curiously named Unsharp Mask. This filter works by comparing each pixel to its neighbors, using parameter sliders to change the intensity of the sharpening process. Likewise, although there are Blur and Blur More filters, Gaussian Blur will give more controllable results. Other Blur filters include Motion Blur and Radial Blur; the latter can be set to produce either a spinning or zooming blur effect.

Blur filters are commonly used for removing unwanted noise—either the moiré pattern caused by scanning printed images, or the "blockiness" created when images, typically those captured by digital cameras, over-compress the results in order to fit them onto their storage medium. A variety of filters found under the Noise category can also assist in this task.

1. This image is typical of those captured with digital cameras.

1. Blur filters can be used to add life to static images. Here, we'll use a couple of Blur filters to make this sports car move. The car, incidentally, is on a different layer from the background, so the filter will only affect that element.

2. With Motion Blur applied, the whole car appears to be whizzing by too fast to see it clearly, but there is certainly a sense of movement there.

3. When the Motion Blur filter is applied to a duplicate of the car layer, we can use a Layer Mask (see page 42) to selectively hide parts of the blurred layer, letting the original car show through.

4. A final touch is to add Radial Blur to the front wheel, which previously looked too static. Now, it is spinning as fast as the car is moving.

1

2

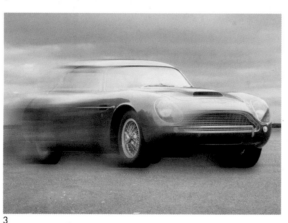
3

4

2. The blockiness (here exaggerated to show the effect) is created by JPEG compression of the original image.

3. Gaussian Blur, here used at a radius of 2 pixels, smoothes out the blocks, but the entire image now looks fuzzy.

4. The Median filter—also applied with a 2 pixel radius—does a similar job, but hard edges, such as the cap badge, remain sharp.

5. The Dust and Scratches filter is designed for removing marks from old photographs—but here, again with a radius of 2 pixels, it smoothes out the blockiness without smudging the edges.

SPECIAL EFFECTS FILTERS

SPECIAL EFFECTS FILTERS As well as the everyday filters outlined on the previous pages, Photoshop includes a wide range of filters for producing special effects. All can be applied to varying extents, and many of them have multiple sliders so that the effect can be tweaked to a high degree.

ARTISTIC FILTERS

Dry Pencil creates the effect that the image has been drawn using loose pencil strokes on a gray background.

Fresco reproduces the effect of an image painted onto wet plaster.

Paint Daubs creates a roughly painted effect, using a variety of textures.

Plastic Wrap makes an object look like it is encased in polythene, and is useful for creating liquid and glass effects, too.

Sponge imposes a random, tight texture, as if the image has been painted with a natural sponge.

Poster Edges superimposes a degraded photocopy effect on the image, with added grain.

DISTORTION FILTERS

Pinch pulls the image in toward the center, performing an effect opposite to that of Spherize.

Spherize makes an object look as if it has been photographed through a fish-eye lens. It is useful for making objects appear spherical—such as turning rock images into planets.

Zigzag applies rippled distortions to make an object appear as if multiple Twirl filters had been applied at different radii. It is useful for creating pond effects on water.

Twirl spins an object around, producing a stronger effect at the center than at the edges. Use it for making wheels appear to be in motion.

Glass makes an object look as if it has been photographed through a rippled glass window.

Polar Co-ordinates creates an object that would look like the original if viewed reflected in a cylindrical mirror placed at its center. It is useful for bending straight objects around curves.

PIXELLATE FILTERS

Color Halftone simulates the effect of four-color printing. By setting all the colors to the same screen angle, an image can be converted to an array of regular dots.

Crystallize creates an array of random, single-color shapes from an image that follow the hues of the original.

Mezzotint simulates the effect produced by antique printing techniques, before halftone screens were invented.

Mosaic produces an exaggerated bitmap effect, as if a tiny object had been greatly enlarged. It is useful for simulating images viewed on screens.

Pointillize simulates the dot-painting effect pioneered by Seurat and the other Pointillist painters.

Fragment creates multiple superimposed copies of an image, as if the object had been shaken violently while being photographed.

SKETCH FILTERS

Bas Relief makes an object look as if it has been carved in stone on a flat surface.

Chalk & Charcoal makes an object seem to have been drawn with those materials. The foreground color is applied to dark areas, the background color to light areas, and those in between are filled in with a mid tone gray.

Conté Crayon simulates drawing with crayons on a textured surface. Any grayscale image can be used for the background texture.

Notepaper creates a threshold effect, as if the object has been embossed onto textured paper.

Photocopy makes an object look as if a picture of it has been photocopied. The foreground color is the ink color, the background color the paper color.

Water paper simulates the effect of painting onto a textured, absorbent surface, as if the paint had run along the paper grain.

STYLIZE FILTERS

Diffuse roughens the edges of objects, both internally and externally.

Emboss raises the outlines between light and dark areas in an object, as if they have been impressed onto paper and sharply lit from the side.

Extrude makes an object appear to be made of blocks or pyramids that radiate from the center. The height and number of blocks are both controllable.

Glowing Edges selects just the borders between light and dark areas, and makes them appear as if made of neon lighting.

Tiles makes an object appear as if made of irregularly placed tiles in a regular rectangular mosaic.

Wind streaks an object from left to right or right to left, producing a stylized blur effect.

TEXTURE FILTERS

Craquelure simulates the cracking effect seen on very old paintings.

Grain makes an object appear to have been printed on a distressed surface. A variety of grain types may be selected.

Mosaic Tiles gives the impression of the object having been constructed from irregularly damaged tiles, with darker grouting between the tiles.

Patchwork makes an object look as if it has been sewn in the style of a Victorian sampler.

Stained Glass breaks an object down as if it were made into a stained glass window, with leading between each pane.

Texturizer applies any grayscale image as a texture on an image, as if it has been lit from the side.

GLOSSARY

4-bit The allocation of four data bits to each pixel, giving an image or screen display of 16 grays or colors.

8-bit The allocation of eight data bits to each pixel, producing a display or image of 256 grays or colors.

16-bit color A facility in some image-editing applications, such as Photoshop, that allows you to work on images in 16-bit-per-channel mode rather than 8-bit mode. RGB (qv) images use three 8-bit channels (totalling 24 bits), while CMYK (qv) images use four 8-bit channels (totalling 32 bits). A 16-bit-per-channel image provides finer control over color, but the resulting file size is much larger.

24-bit color The allocation of 24 bits to each pixel, giving a screen display of 16.7 million colors.

aliasing The term describing the jagged appearance of bitmapped (qv) images or fonts as a result of insufficient resolution or excessive enlargement.

alpha channel A grayscale channel containing information regarding the transparency of pixels. In image files this is a separate channel—additional to the three RGB (qv) or four CMYK (qv) channels—where masks (qv) are stored.

animated GIF A GIF (qv) file containing more than one image. Many programs, including web browsers, will display each of the images in turn, thus producing an animation. The only file format for animated sequences that does not depend upon the presence of a browser plug-in for playback on web pages.

animation The process of creating a moving image by rapidly moving from one still image to the next.

antialiasing A technique for eliminating the jagged effect of bitmapped (qv) images or text reproduced on low-resolution devices such as monitors. This is achieved by adding pixels of an in-between tone, blending the rough edges of the object's color with those of the background.

artifact A visible flaw in an electronically prepared image, usually occurring as a result of the imaging technique employed.

artwork Any drawings, paintings, photographs or other graphic materials—in either physical or digital media—that are prepared for use in an animation.

background The area of an image on which the principal foreground subject sits.

bevel A chamfered edge applied to type, buttons, or selections as a 3D effect.

Bézier curve A curve whose shape is defined by a pair of "direction lines" at each end. These specify the direction and rate at which the curve leaves or enters the corresponding end point. By manipulating the lines you can change the shape of the curve.

bit A contraction of binary digit. The smallest piece of information a computer can use. Expressed as one of two values: 1 or 0.

bit depth The number of bits assigned to each pixel on a display or in an image, affecting the range of colors that can be reproduced.

bitmap An image formed from a matrix of pixels, each with its own specific color value.

bump map A bitmap image file, normally grayscale(qv), which is most frequently used in 3D applications for modifying surfaces or applying textures. The gray values in the image are assigned height values, with black representing the troughs and white the peaks.

byte A single group made up of eight individual bits (0s and 1s) of data, which can be processed together as one unit.

CAD Abbreviation for "computer-aided design." Strictly speaking, any design carried out using a computer, but generally used with reference to 3D technical design.

calibration The process of adjusting a piece of hardware to conform to a known scale or standard so that it performs more accurately.

capture The action of getting an image in digital form by taking a photograph, scanning an image into a computer, or "grabbing" an image using a frame grabber.

clip art / clip media Collections of (usually) royalty-free photographs, illustrations, design devices and other multimedia objects—including movies, sounds, and 3D wireframes—that are designed to be used in other projects.

clipping Limiting an image or any part of an image to the bounds of a particular area.

clipping path A Bézier (qv) outline that defines which area of an image should be considered transparent or "clipped." This lets you isolate the foreground object and is particularly useful when images are to be placed over new backgrounds.

CMYK Abbreviation for "cyan, magenta, yellow, and black." The four printing-process colors based on the subtractive color model (black is represented by the letter K, standing for key plate). In color reproduction most of the colors are created from cyan, magenta, and yellow; the theory being that when all three are combined, they produce black. However, this is rarely achievable and usually undesirable—true black ink produces better results, too much CMY ink would be used, and drying times would be increased.

collage An image assembled from elements drawn from different sources. Originally used to describe those pieces produced by pasting together images culled from magazines (say) or fabric swatches. It now also describes images built in digital image-editing software, where the disparate origins of the separate components remain obvious. Also known as a montage or (in the case of photographic subjects) a photomontage.

color correction The process of adjusting color values during the reproduction process in order to achieve a desired result.

color depth Like bit depth (qv), the number of bits required to define the color of each pixel.

color-management system A method devised to provide accuracy and consistency of color representation across all devices in the color-reproduction chain.

color picker (1) A color model displayed on a computer monitor. Color pickers may be specific to an application (such as Adobe Photoshop), a third-party color model (such as PANTONE®), or to the operating system.

color picker (2) A book of printed color samples, carefully defined and graded, from which you can select spot colors. Color pickers generally conform to a color model, such as PANTONE® (qv), so you can be confident that the color chosen will be faithfully reproduced when printed later on.

color temperature A measure of the composition of light. This is defined as the temperature—measured in degrees Kelvin—to which a black object would need to be heated in order to produce a particular color of light. The temperature of direct sunlight is around 5,000 K and is considered the ideal viewing standard in the graphic arts.

compression The technique of rearranging data so that it either occupies less space on disk or

transfers more rapidly between devices or across a network.

constrain A facility in some applications to contain one or more items within another. For example, in a page layout application, a picture box (the "constrained item") sits within another picture box (the "constraining box").

continuous tone An image that contains infinite shades between the lightest and darkest tones. Most commonly used in reference to conventional, film-based photography.

contrast The degree of difference between adjacent tones in an image (or computer monitor) from the lightest to the darkest. High contrast describes an image with light highlights and dark shadows but with few shades in between, whereas a low-contrast image is one with even tones and few dark areas or highlights.

copyright The right of a person who creates an original work to protect that work by controlling how and where it may be reproduced. Note that ownership of the work does not automatically signify ownership of copyright or vice versa—copyright is only transferred if the creator of the work assigns it in writing.

copyright free A misnomer used to describe ready-made resources such as clip art. In fact, these resources are rarely, if ever, copyright free—in most cases only a license to use the material is granted by purchase. The correct description would normally be "royalty free:" material that you can use—under license—free from payment of further fees or royalties.

crop To trim or mask an image so that it fits a given area, or to discard unwanted portions of an image.

cross-platform The term applied to software that will work on more than one computer platform (Mac OS and Windows, for example).

definition The overall quality—or clarity—of an image, determined by the combined subjective effect of graininess (or resolution *(qv)* in a digital image) and sharpness.

density The darkness of tone or color in any image. In a photographic transparency this would refer to the amount of light that could pass through it, so determining the darkness of shadows and the saturation of color.

density range The maximum range of tones in an image, measured as the difference between the maximum and minimum densities (the darkest and lightest tones).

desaturate To reduce the strength or purity of color in an image, thus making it look grayer.

descreening The technique of removing a halftone dot pattern from an image to avoid an undesirable moiré *(qv)* pattern occurring when a new halftone screen is applied.

digital image Image converted to (or created in) the digital domain. Elements of the image are represented by pixels with discrete color and brightness values.

digital photography The process of capturing an image with a digital camera. The term can also refer to the manipulation of photographic images on a computer.

dots per inch (dpi) A unit of measurement used to represent the resolution *(qv)* of devices such as printers and imagesetters and also, erroneously, monitors and screen images, where the resolution should more properly be expressed in pixels per inch (ppi).

drawing application Software used to create graphics from complex arrangements of objects, which are themselves definied using vectors.

drop shadow A shadow projected onto the background behind an

image or character in order to lift it off the surface.

electronic media General term to describe media that uses electronic means for the dissemination and delivery of information.

EPS Abbreviation for "encapsulated PostScript." A standard graphics file format used primarily for storing the object-orientated, vector graphics files generated by a drawing application such as Adobe Illustrator or Macromedia FreeHand.

export A feature provided by many applications to allow you to save a file in a format so that it can be used by another application or on a different operating system.

eyedropper tool In some applications, a tool for gauging the color of adjacent pixels.

fill In graphics applications, the content, such as color, tone, or pattern, applied to the inside of a shape (including type characters).

file format The way a program arranges data so that it can be stored or displayed on a computer. File formats range from unique formats peculiar to a particular application, to standard formats recognized by many different software programs.

filter A component of an application that processes or converts data. In graphics applications, the term is employed to describe the features used for the application of special effects to images.

final rendering The final computer generation of an image, once you have finished editing or modeling, most commonly used to refer to the application of final surface textures, lighting, and effects to complete a 3D object, scene, or animation.

Flash Software designed by Macromedia for the creation of vector graphics and animations for web presentations. Flash generates

small files, which are quick to download and—being vector *(qv)*—scalable to any dimension without an increase in the file size.

fractal Infinitely variable shapes often characterized by extreme irregularity and defined by complex but precisely defined mathematical expressions. Some Photoshop filters make extensive use of fractal mathematics and patterning, allowing users to make bold graphics from scratch using image elements to create the pattern.

frame A single still picture from a movie or animation. Also a single complete image from a TV picture.

frame-rate The speed at which the individual frames of an animation are substituted for one another—that is, the speed at which the animation is played. Usually specified in frames per second.

gamma A measure of contrast in a digital image, a photographic film or paper, or a processing technique.

gamma correction Modification of the midtones *(qv)* of an image by compressing or expanding the range, thus altering the contrast.

GIF Acronym for "graphics interchange format." One of the main bitmapped *(qv)* image formats used on the Internet. A 256-color format with two specifications, GIF87a and, more recently, GIF89a, the latter providing additional features such as transparent backgrounds. The GIF format uses a lossless *(qv)* compression technique, and thus does not squeeze files as much as the lossy *(qv)* JPEG format.

Gouraud shading A method of adding shading to a 3D graphic through the selective manipulation of colors and shades along the lines of certain vertices, which are then averaged across each polygon face. Faster than Phong shading *(qv)*, but the results are not as realistic.

GLOSSARY

graduation / gradation A smooth, continuous transition from one color or tone to another.

graphic A general term describing any illustration or drawn design.

gray Any neutral tone in the range between black and white, with no added color.

grayscale The rendering of an image in a range of 256 levels of gray from white to black.

highlight To mark an item, such as a section of text, an icon, or a menu command, to indicate that it is selected or active.

HSL Abbreviation for hue, saturation, lightness: a color model based upon the light transmitted either in an image or in your monitor. Hue (qv) is the spectral color (the actual pigment color), saturation the intensity of the color pigment (without black or white added), and brightness represents the strength of luminance from light to dark (the amount of black or white present).

hue The pure spectral color that distinguishes a color from others. Red is a different hue from blue; and although light red and dark red will contain varying amounts of white or black, they both have the same basic hue.

icon A graphical representation of an object (such as a disk, file, folder, or tool) used to make identification and selection easier.

image area The area within a final graphic document in which a particular image or group of images will have to fit.

image library A source of original transparencies and pictures that can be used for virtually any purpose on payment of a fee. The sums vary according to usage.

image size A description of the dimensions of an image in terms of linear dimensions, resolution (qv), or digital file size.

imaging device A general term describing any dedicated piece of equipment that captures an image from an original, such as a scanner or camera, or generates an image from a previously captured original.

import To bring text, pictures, or other data into a document.

indexed color An image mode of a maximum of 256 colors that is used in some applications, such as Adobe Photoshop, to reduce the file size of RGB (qv) images so that they can be used in multimedia presentations or on web pages. This is achieved by matching the colors used in an image to an indexed table of colors ("a color look-up table," or CLUT). If a color in the image does not appear in the table, then the application selects the nearest color or simulates it by arranging the available colors in a pattern.

interpolation A computer calculation used to estimate unknown values that fall between known ones. One use of this process is to redefine pixels in bitmapped (qv) images after they have been modified in some way, for instance, when an image is resized (called "resampling") or rotated, or if color corrections have been made.

inverse kinematics A method of animating structures that form a chain of links, such as a human arm. The position of all the elements in the chain—for example, forearm, elbow, upper arm—are computed to fit the position of the final element—the hand.

inverting A feature of many applications whereby an image bitmap is reversed—so that, for example, the black pixels appear white and vice versa, making a negative image.

JPEG, JPG Acronym for "joint photographic experts group:" an ISO (International Standards Organization) group that defines compression (qv) standards for bitmapped (qv) color images. The abbreviated form gives name to the widely used file format (qv).

layer In some applications and web pages, a level to which you can consign an element of the design you are working on, enabling you to work on it independently of the rest of the image.

keyframe A single animation or movie frame (qv) in which information is stored as a reference, so that subsequent frames only store changes in the frame rather than storing the whole frame each time. This makes animation and movie files much smaller.

keyline A line drawing indicating the size and position of an illustration in a layout.

landscape format An image or page format in which the width is greater than the height. Also called "horizontal format."

layout A drawing that shows the general appearance of a design, indicating, for example, the position of text and illustrations.

line weight The thickness of a line or rule in an image.

lossless compression Methods of file compression (qv) in which no data is lost during the process, meaning that quality is maintained.

lossy compression Methods of file compression (qv) in which some data may be irretrievably lost during the process. This can result in a drop in quality or the appearance of digital artefacts in the image.

LZW Abbreviation for Lempel-Ziv-Welch: A widely supported lossless compression (qv) method for bitmapped (qv) images.

mask A selected portion of an image, blocked out to protect it from alteration during all or part of the image-editing process.

midtone The range of tonal values in an image, covering the area between the darkest and lightest but usually referring to those that appear halfway.

moiré An unintended pattern that occurs in halftone reproduction when two or more colors are printed and the dot screens are positioned at the wrong angles.

monochrome An image of varying tones reproduced in a single color. Not necessarily black and white.

MPEG Abbreviation for Moving Picture Experts Group, the organization in charge of the development of standards for the coded representation of digital audio and video. Established in 1988, the group produced MPEG-1, the standard on which video CD and MP3 are based; MPEG-2, the standard used for digital television and DVD; and MPEG-4, the standard for multimedia (qv) on the web.

multimedia Any combination of digital media, such as sound, video, animation, graphics, and text, incorporated into a software product or presentation.

online Any activity that takes place on a computer or device while it is connected to a network, including the Internet.

orientation The print direction of a page, or format of an image (portrait or landscape).

painting applications Applications that use bitmaps (qv) to create images rather than vectors (qv).

PANTONE® The registered trademark of Pantone Inc.'s system of color standards and control and quality requirements, in which each color bears a description of its formulation (in percentages) for subsequent printing.

perspective A technique of rendering 3D objects on a 2D plane, duplicating the "real world" view by giving an impression of the object's relative position and size when viewed from a particular point.

Phong shading A superior but time-consuming method of rendering 3D images that computes the shading of every pixel. Usually reserved for the final rendering *(qv)*.

pixel Abbreviation for picture element. The smallest component of any digitally generated image, including text. A single dot of light on a screen.

pixel depth The number of shades that a single pixel can display, determined by the number of bits used to display the pixel.

pixelation / pixelization The term used to describe an image that has been broken up into square blocks resembling pixels, giving it a "digitized" look.

plug-in Software, usually developed by a third party, that extends the capabilities of another piece of software. Plug-ins are common in image-editing and page-layout applications, providing specialized tools or unique effect filters.

PNG Abbreviation for "portable network graphics." A file format for images used on the web that provides 10–30% lossless compression, and supports variable transparency through alpha channels, cross-platform control of image brightness, and interlacing.

portrait format An image or page in a vertical format.

posterize/posterization To divide, by photographic or digital means, a continuous-tone image into a predefined or arbitrary number of flat tones.

PostScript Page-description language. PostScript code tells an output device how to construct a page from various text and graphic elements.

primary colors The pure colors from which—theoretically—all other colors can be mixed. In printing, they are the "subtractive" pigment primaries (cyan, magenta, and yellow). The primary colors of light, or "additive" primaries, are red, green, and blue.

QuickTime Apple's software program and system extension that enables computers running either Windows or the Mac OS to play movie and sound files, particularly over the Internet and in multimedia applications.

raster image An image defined as rows of pixels or dots.

rasterize The conversion of a vector graphics image into a bitmap. This may introduce aliasing, but is often necessary when preparing images for the web.

raytracing A rendering algorithm that simulates the physical and optical properties of light rays as they reflect off a 3D model, thus producing realistic shadows and reflections.

real-time The actual time in which things happen; on your computer, therefore, an event that corresponds to reality.

rendering The process of transforming raw image data and a set of program instructions into a new image or animation. In 3D applications, the term refers to wrapping a surface texture over a 3D body created as a "wire frame" in order to create realistic landscapes or turn wire-frame figures into characters. The wrapping is usually combined with other effects (such as lighting effects) to increase the realism.

rescale Amending the size of an image by proportionally reducing its height and width.

resolution The degree of quality, definition, or clarity with which an image is reproduced or displayed, for example in a photograph, or via a scanner, monitor screen, printer, or other output device.

retouching Altering an image, artwork, or film to modify or remove imperfections. Can be done using mechanical methods (knives, inks, and dyes) or digitally, using Photoshop and similar packages.

RGB Abbreviation for "red, green, blue." The primary colors of the additive color model—used in video technology (including computer monitors) and also for graphics that will not be printed by the four-color (CMYK) process. Web graphics are one example.

rough A preliminary drawing showing a proposed design. Also called a "scamp" or "visual."

scanning An electronic process that converts a hard copy of an image into digital form by sequential exposure to a moving light beam such as a laser.

shading In 3D applications, the resulting color of a surface due to light striking it at an angle.

shadow areas The areas of an image that are darkest or densest.

shareware Software available through user groups, magazine cover disks, etc., which is usually only paid for by those users who decide to continue using it. Shareware should not be confused with Freeware, which is free to use for an unlimited period of time.

sharpening Enhancing the apparent sharpness of an image by increasing the contrast between adjacent pixels.

smoothing The refinement of bitmapped *(qv)* images and text by antialiasing *(qv)*. Smoothing is also used in some drawing applications, where it is applied to a path to smooth a line, and in 3D modeling applications, where it is applied to the individual polygons to tweak resolution in the final rendering.

thumbnail A smaller representation of an image used for selection or identification purposes.

TIFF, TIF Abbreviation for "tagged image file format." A standard graphics file format *(qv)* originally developed by Aldus (now merged with Adobe) and Microsoft. Used for scanned, high-resolution, bitmapped *(qv)* images and for color separations.

tiling The repetition of a graphic item, with the repetitions placed side-by-side in all directions so that they form a pattern—just like tiles.

tint The resulting shade when white is added to a solid color.

transparent GIF A feature of the GIF89a file format that allows you to place a non-rectangular image directly on the background color of a web page.

transpose / transposition To exchange the position of any two images, either by design or because they are in the wrong order. For example, image layers may be transposed when a lower layer and higher one are positionally reversed. Animation cells can be transposed in a similar way.

tweening A contraction of "in-between." An animator's term for the process of creating transitional frames to fill in between key frames *(qv)* in an animation.

unsharp masking (USM) A traditional film-compositing technique used to sharpen an image. Some image editing applications feature filters that replicate the effect.

vector A mathematical description of a line that is defined in terms of physical dimensions and direction. Vectors are used in drawing packages to define shapes (vector graphics) that can be repositioned or resized at will.

BIBLIOGRAPHY

ILLUSTRATION

Illustrators, American Society of Illustrators, New York, annual

Bell, Roanne, Hyland, Angus, *Pen and Mouse: Commercial Art and Digital Illustration*, Watson Guptill, New York, June 2001

Chwast, Seymour, Heller, Stephen, *Graphic Style: From Victorian to Digital*, Harry N Abrams, New York, March 2001

Holtzman, Steven R, *Digital Mosaics*, Simon & Schuster, New York, June 1997

Wands, Bruce, *Digital Creativity: Techniques for Digital Media and the Internet*, Wiley, New Jersey, July 2001

Zappaterra, Yolanda, *Illustration*, Watson-Guptill, New York, July 1998

DIGITAL PAINTING

Adobe Creative Team, *Adobe Photoshop 7 Classroom in a Book*, Adobe Press, San Jose CA, June 2002

Against the clock, *Procreate Painter 7: A Digital Approach to Natural Art Media*, Prentice Hall, Paramus NJ, January 2002

Blatner, David, Fraser, Bruce, *Real World Adobe Photoshop 7*, Peachpit Press, Berkely CA, July 2002

Crumpler, Wendy, *Photoshop, Painter, Illustrator: Side by Side*, Sybex, Berkely CA, May 2000

Crumpler, Wendy, Duggan, Sean, Haynes, Barry, *Photoshop 7 Mastery*, Peachpit Press, Berkely CA, July 2002

Little, Jerry, Pollard, Jann, *Creative Computer Tools for Artists*, Watson Guptill, November 2002

Monroy, Bert, Steuer, Sharon, *Creative Thinking in Photoshop: A New Approach to Digital Art*, New Riders Publishing, Indianapolis IN, April 2002

Sutton, Jeremy, *Painter 7 Creativity*, Focal Press, Burlington MA, December 2002

DIGITAL DRAWING

Adobe Creative Team, *Adobe Illustrator 10 Classroom in a Book*, Adobe Press, San Jose CA, February 2002

Against the Clock, *Adobe Illustrator 10: Introduction to Digital Illustration*, Prentice Hall, Paramus NJ, January 2002

Cambell, Marc, *The Complete Idiots Guide to Digital Illustration*, SAMS, Indianapolis IN, June 2002

Choudhury, Subir, Roame, Tony, *Macromedia Freehand 10*, Macromedia Press, San Francisco CA, August 2001

Lourekas, Peter, Weinmann, Elaine, *Illustrator 10: Visual QuickStart Guide*, Peachpit Press, Berkely CA, February 2002

McClelland, Deke, *Real World Adobe Illustrator 10*, Peachpit Press, Berkely CA, March 2002

3D ILLUSTRATION

Ablan, Dan, *Look Inside Lightwave 7*, New Riders Publishing, Indianapolis IN, December 2001

Danagher, Simon, *Digital 3D Design*, Watson Guptill, New York, October 2001

Koenigsmarck, Arndt Von, *Maxon Cinema 4D 7*, Peachpit Press, Berkely CA, December 2001

Mortier, R Shamms, *The Bryce 5 Handbook*, Charles River Media, Hingham MA, May 2002

Mortier, R Shamms, *The Poser 5 Handbook*, Charles River Media, Hingham MA, December 2002

Schlechtweg, Stefan, Strothotte, Thomas, *Non-Photorealistic Computer Graphics*, Morgan Kaufmann, Burlington MA, April 2002

Victor, Isaac, *The Art of 3D: Computer Animation and Imaging*, Wiley, New Jersey, May 2000

Watkins, Adam, *The Cinema 4D XL Handbook*, Charles River Media, Hingham MA, August 2001

DIGITAL ANIMATION

Adobe Creative Team, *Adobe After Effects 5.0: Classroom in a Book*, Adobe Press, San Jose CA, August 2001

Besley, Kris, *Foundation Macromedia Flash MX*, Friends of Ed, Birmingham UK, April 2002

Clark, Kyle, *Inspired 3D Character Animation*, Premier Press, Cincinnati OH, July 2002

Corsaro, Sandro, *The Flash Animator*, New Riders Publishing, Indianapolis IN, June 2002

Dowd, Snow, Reinhardt, Robert, *Flash MX Bible*, Wiley, New Jersey, July 2002

Maestri, George, *Digital Character Animation*, New Riders Publishing, Indianapolis IN, July 2002

Meyer, Chris and Trish, *Creating Motion Graphics with After Effects*, CMP Books, Gilroy CA, September 2002

Rey, Chrissy, *Macromedia Flash MX: Training from the Source*, Macromedia Press, San Francisco CA, June 2002

PERIODICALS

3D world, Communication Arts, Computer Arts, Computer Graphics World, Creative Review, Mac Addict, Mac Design, Mac User, Photoshop User, Wired

WEBSITES

www.adobe.com
www.cgdigitalillustration.com
www.commarts.com
www.computerarts.co.uk
www.corel.com
www.creativepro.com
www.deneba.com
www.jasc.com
www.macromedia.com
www.maxon.com
www.newtek.com
www.procreate.com
www.siggraph.org
www.toonboomstudio.com

INDEX

the complete guide to digital illustration

INDEX